For Sarah with best wishes
Nicky Hamlyn 20/05/11
& Simon Payne

CW00969879

Kurt Kren

Kurt Kren:
Structural Films

Edited by Nicky Hamlyn, Simon Payne and A. L. Rees

intellect Bristol, UK / Chicago, USA

First published in the UK in 2016 by
Intellect, The Mill, Parnall Road, Fishponds, Bristol, BS16 3JG, UK

First published in the USA in 2016 by
Intellect, The University of Chicago Press, 1427 E. 60th Street,
Chicago, IL 60637, USA

A catalogue record for this book is available from the
British Library.

Copy-editor: MPS Technologies
Cover designer: Jane Seymour
Cover image: Kurt Kren, 50/96 Snapspots (for Bruce), courtesy of
 Sixpack (Vienna) © Kurt Kren estate
Production manager: Katie Evans
Typesetter: John Teehan

Print ISBN: 978-1-78320-551-6
ePDF: 978-1-78320-552-3
ePUB: 978-1-78320-553-0

Printed and bound by Gomer Press Ltd, UK

**University
for the
Creative Arts**

Anglia Ruskin
University

Contents

This book is dedicated to the memory of A. L. Rees, 1949-2014;
film historian, teacher, mentor, friend and co-editor.

Acknowledgements

We would like to thank the following for their assistance and support in the preparation of this book: Steve Anker, Martin Arnold, Eve Heller, Aline Helmcke, Malcolm Le Grice, Janis Crystal Lipzin, Steve Polta, Sixpack Film (Vienna), Peter Tscherkassky, Anglia Ruskin University and The University for the Creative Arts.

Introduction: Not Reconciled – The Structural Films of Kurt Kren

A. L. Rees

This book began from our long-standing enthusiasm for the films of Kurt Kren, who has been a continuing influence on new filmmakers from the 1970s to the present day. It is the first English-language study of his structural films, with newly commissioned reviews and a selection of early documents and essays, some long out of print or available only in specialist journals. Also reproduced here are several of Kren's filming scores and some pages from one of the limited edition books he produced during his time in the United States in the 1980s. Of the new essays, some are by critical experts in the Austrian avant-garde cinema, and others are by younger writers – mainly filmmakers themselves – who take up new themes, including Kren as a herald of proto-digital art. The films that are covered in these essays were chosen by the writers whom we asked to contribute to the book. Thus, in some instances, individual films have been covered more than once, but this is a testament to the provocative nature of Kren's structural films, which generate new ideas and approaches even where authors' accounts stem from close formal analysis.

Our aim was to produce a demi-catalogue of the structural Kren, in which all his main films would be reviewed, along with some more ephemeral ones. Though the jury is still out on some of the minor works, made mostly during the 1980s, we do not think our classification is contentious. The invaluable and essential 3-DVD set of Kren's films issued by Index (Austria) is similarly divided into Structural Films, Vienna Aktion Films and documentary/minor works, including those made during his ten-year sojourn in the United States, across which he travelled in his car, working as a labourer, demolition man and finally, for eight years, as a museum guard in Houston. This division of the parts of Kren's oeuvre also mirrors the categorization of his films as 16mm distribution prints from the 1960s onwards.

Our focus is on the structural films rather than on the Vienna Aktionist films that make up the other half of Kren's reputation and even his notoriety, by his association with the groups led by Otto Mühl and Hermann Nitsch. The recent rediscovery of the Vienna group, including Kren's role in it, has impelled vivid and impassioned studies by (among others) the filmmaker Peter Tscherkassky, the cultural critic Stephen Barber and the artist Paul McCarthy. McCarthy's championing of Kren in the 1990s as a 'transgressive' filmmaker and a personal ancestor ushered in Kren's post-structural fame, and unlocked him from a formalist film ghetto to which, some argue, he never belonged. Instead, however, it put him into a gallery context in which he never took part. The scandalous

mayhem of the Aktionists began in risk and improvisation. Their descendants have long been safely installed in the gallery and institutionally validated in performance art as a genre. From these tendencies – and much else – Kren largely fled, first to Germany and then to the United States before returning to Vienna towards the end of his life.

One consequence of Kren's status as a transgressive artist, though, is that his Aktion films and his Structural films are now often shown together in screenings and exhibition, although this was the case in the past too, when the films were projected in cinemas and other venues dedicated to experimental film. No one in the 1970s who saw the work from one half of Kren's output was unaware of the other. The difference today, perhaps, is that the Aktion films have gained a new authority and interest, benefitting from the fascination that this still contentious art movement in post-war Austria holds as one of the origins of today's performance art. But the relation of Kren's Aktion films to the Aktion artists themselves is complex. Tscherkassky and other sophisticated analysts of the Aktion films see them as independent works, as indeed did Kren, Günter Brus and Nitsch, who for their own different reasons each denied that the Kren films are 'documentaries' of any kind. In some ways the films are antithetical in method to the performances they depict, as Tscherkassy demonstrates, for example by showing in rapid single-frame cuts a live event that originally unfolded in long and slow duration.

That Kren had an important, though occasional, presence in Aktion art is not in doubt. Anyone who has seen Mühl's memorably coprophagic *Scheiss-kerl* (1969) is unlikely to forget the brief image of the grinning Kren – who helped shoot the film and took part in it – wearing only a loincloth and waving a handheld camera. However, the Aktion films are not the core of our own interest in Kren, and additionally they have already been discussed from many angles that are not ours, and which are much more sympathetic to them. From our perspective as editors, the psychosexual aggression, and (in the words of one contributor) 'bathetic sadomasochism', of the Aktion artists, whether directed towards men and more specifically towards women, fatally undermines their claims to liberation, catharsis and expiation.

In its own time, the direct art of the Aktion group provoked heated and critical response and protest – as intended. More widely, it was part of an international groundswell of live, mixed media and theatricalized art in the United States, Japan and Europe. For the next generation of film and media artists in the 1970s – Peter Weibel and Valie Export, for example – the Aktionist performances were still inspirational examples of excessive art that challenged the repressive tolerance of bourgeois society, and even now many Austrian avant-garde filmmakers incorporate pornographic and violent imagery that recalls the Aktionists. Marc Adrian mixed sexual violence and abstraction in his films for 30 years, seemingly unaware of, or unimpressed by, the social changes from the 1960s to the 1990s that twisted cultural liberation into commercialized sexual exploitation.

This makes the difference all the more striking between the two parts of the Kren canon: their division into 'structural' and 'Aktion' films. His structural films show no trace of the patriarchy, aggression against women and scenes of violence that characterize

at least one continuing strand in the Austrian avant-garde cinema. Rather, and perhaps alone in this regard among his filmmaking contemporaries, his genres are traditional: the portrait, the landscape and scenes of daily life. It is also true, however, that in his classes at Vienna's University of Applied Arts he made, according to former student Norbert Pfaffenbichler, 'wordless presentations' of Shinya Tukamoto's schlock-horror cyberpunk films and the aptly titled NEKRomantik (1987) by Jörg Buttgereit (Pfaffenbichler 2012: 268, footnote 3). Did Kren show these as examples to follow, or was the act of screening them in a college 'master class' a provocation in itself? Personal taste aside, the evidence of Kren's own structural films is unequivocal. Except for the late film *22/6 Happy End*,[1] which has brief close-up shots of sexual intercourse from an Otto Mühl performance, interspersed with footage shot haphazardly, and presumably furtively, off the screen in various cinemas, they have no violent or sexualized images, however harsh his cinematic assault on the viewer can sometimes be.

Although not colluding with ideologies of power and their counterpart in ritual humiliation, Kren's structural films are historically linked to the Aktion works while being distinct from them. His work as a whole is in this sense a dismembered or disjunct collection of very diverse elements. Here, we selectively focus on what we believe is Kren's most original contribution to film art and frame-based thinking. These skills and attributes he undoubtedly practiced and refined when he collaborated with the Aktionists in the mid-1960s. But in his structural films they take on new meaning, and follow a raw and visceral direction that Kren found from the beginning in his hard-edged and contrarian editing and in his emphatically physical approach to the formal aspects of the film medium.

The rawness that makes so many of his structural films a shock for the eyes defies verbal description and finality. It challenges immediate perception in the act of watching a film – a new kind of 'action' cinema – and resists the fixing of the image flow in memory. Viewers of a Kren film will often not even quite know what it is that they have seen, especially on a first screening. But this is not an artifice of gradual revelation or a metaphysic of concealment in which meaning and content are resolved by seeing the films repeatedly, which is the aesthetic strategy of (say) Stan Brakhage or Gregory Markopoulos. Kren's films are antithetically sceptical of their ambition to high poetic status, even where he sometimes shared similar techniques and tactics, such as constructing shots at the edge of legibility or beyond, or making films that are only a few seconds in length.

On the other hand, the reader of this book will often be made aware that the authors analysed the films by playing them back and forth (on DVD), freezing and notating them, revealing much that was hidden from or invisible to their first viewers, who saw them projected in real time and often only once or at infrequent intervals. In some ways, however, this kind of frame analysis simply updates the ways in which some of Kren's earlier viewers/analysts, such as Malcolm Le Grice, would have studied the films when describing them in the 1970s, by counting and replaying the shots on a 16mm print with the aid of an editing bench or a projector.

But in another sense, this kind of delayed and repeated viewing, explored in the context of the feature film by Laura Mulvey and practiced by countless home-viewers every day, is a quite different experience from that of the pre-digital era. Today, no specialist equipment is needed and no print needs to be physically obtained from film collections or archives. Film analysis as well as filmmaking has to this extent been thoroughly democratized. One consequence is that the viewer no longer needs to take the critic/reviewer's words on trust. Preceded by the transitional medium of videotape, which first gave the option of repeated film viewing to the many rather than the few from the 1980s onwards, digital media have transformed the viewing experience.

Despite this new and welcome accessibility, film may still be the 'unattainable text' defined by Raymond Bellour in 1975, meaning that the time-based flow of film always eludes the frozen, partial and dismembered evidence of the frame still or the filmstrip on the page (and now the computer screen). A film is not an object. It is not finally identifiable with its separated frames, isolated by reproductions taken from the filmstrip or the scanned video field. Kren's films, among many others in the experimental tradition, exploit and foreground such elusiveness in their construction. In projection these films resist the fixity of frame analysis, even though it is such analysis that brings out (makes visible) their hidden structures and their fleeting surfaces.

Kren himself provokes this paradox, since in many of his films the sequencing of frames and shots are sped up or slowed down according to mathematical systems that can at best be intuited, but not analysed in ordinary viewing conditions (Kren sometimes used the first few numbers from the Fibonacci series to determine shot length; 1, 2, 3, 5, 8). For a close analysis we have to turn to Kren's precise and extraordinary diagrams or shooting-plans that preceded and structured many of his key works. These suggest a dialectic, rather than a division, between the making of the films and their later analysis. The notated scores for the films echo or mirror the ways in which the contemporary viewer can study them frame by frame. In each case, however, the integrity and 'unattainability' of the projected film is preserved and even reinforced whenever it is screened in continuous time.

Comparable to musical scores, Kren drew many of his diagrams on the kind of square-ruled or graph paper also favoured by his near-contemporaries, the avant-garde composers Morton Feldman, Christian Wolff and Cornelius Cardew. This puts into new focus the often repeated and no doubt true critical precept that the post-war avant-garde film in Austria, especially via Kren and Peter Kubelka, cinematized the metrical systems and tone rows of the pre-war Second Viennese School, led by Arnold Schoenberg, with Anton Webern as its strictest and most indicative exemplar for many visual artists as well as musicians. Webern's intensified brevity, and his leaps of pitch, based on complex underlying systems, suggested that structure was both form and expression. Kren transmutes the musical score into graphic notation for film, supplanting the traditional film 'score' as the source for a musical soundtrack.

But even before his graphically modelled films, Kren had neutralized and replaced the conventionally added soundtrack when he scratched into the sound area of the filmstrip for *1/57 Versuch mit synthetischem Ton (Test) / Experiment with Synthetic Sound (Test)*, and subsequently painted the soundtrack for his classic *3/60 Bäume im Herbst / Trees in Autumn*. The result was 'direct sound', not sound as an accompaniment to the pictures from another space, but integral and parallel to a shared material world of frames and strip. On the few occasions when he added fragments of existing soundtracks to his later films, as in *44/85 Foot'-age Shoot'-out* , or the penultimate *49/95 tausendjahrekino / thousandyearsofcinema*, respectively citing Morricone's Spaghetti Western music and Peter Lorre's voice, he provokes an ironic contrast between what we hear and see.

It is perhaps not just metrics and notation that is carried over from the Second Viennese School into the abstract films of Kren and others, but also Schoenberg's abrupt and expressive transitions and layering of sound that cannot be immediately rationalized or absorbed. Even so, the Viennese abstract film emerged from a very different post-war climate, on the other side of the fascist era that had exiled or silenced the Vienna School itself. The direct art of the 1950s and 1960s was more raucously aggressive and disruptive than its high-art predecessor 30 years before. Its supercharged expressionism was more at home in painting, theatre, performance or film than in music. Meanwhile, and at this very time, the Darmstadt school in Germany was taming Schoenberg's 12-tone method into a conventionalized modernist genre (breeding its own reaction, in turn, through Cage, Cardew, La Monte Young and others). In his own modest and undemonstrative way, Kren held together the two original strands of the Vienna School. Structural and objective metrics akin to musical schema underlie the subjective non-formal abrasiveness of the films as experienced in projection. For this reason perhaps, Kren's films, like Schoenberg's music, continue to perplex and alienate, as much as they excite viewers who perceive in them a modesty of means in the service of ambitiously organized and complex artworks. Interestingly, Kren's films have never been subjected to the reductive critique that the work of some of the English and American 'structuralist' filmmakers has been, perhaps because what typifies Kren's best work is rigorous formal purity in the service of a sophisticated and open-ended meditation on representation: what it is, how it is formed and how it is understood by its percipient. Ways of looking at or thinking about Kren's films are led by the mode of his filmmaking, but the two sides of this equation are not reconcilable.

When Peter Kubelka was asked by Jonas Mekas, on the former's arrival in New York in 1966, if there were any other interesting filmmakers in Europe he said there were none. When Kren appeared at the newly opened LUX Centre in London, not long before his death in 1998, he was mistaken for a tramp and shown the door. These two incidents typify the neglect he has suffered before and since. We hope that this book will help to raise his profile and foster the appreciation of his films by new generations of artists, students and others interested in the possibilities of film as a radical cultural tool.

Reference

Pfaffenbichler, N., 2012. Weapon of Choice. In: *Film Unframed: A History of Austrian Avant-Garde Cinema*. Vienna: Filmmuseum Synema Publikation.

Note

1. Numbers prefixed to the title of Kren's films refer to the chronological order in which the films were made and the year of their production.

1/57 Versuch mit synthetischem Ton (Test)

1/57 Experiment with Synthetic Sound (Test) (1957, 1:23 min, b/w)

Simon Payne

Versuch mit synthetischem Ton is the first of Kurt Kren's films to be listed in his filmography. It remains one of his most enigmatic films, posing numerous problems for how it might be described. The rhythmic combination of sound and image, which involves cutting repetitively between a handful of images and sounds, suggests a pattern and logic of associative montage, but any interpretation that the film courts hovers between a symbolic resistance to meaning and a level of abstraction that challenges the viewer's capacity to read the film at all. The following account aims to get to grips with this dynamic of the film, in its oscillation between a certain kind of signification and the range of ways in which it tests the characteristics of the medium and counteracts meaning.

The images in the film, each several seconds long, comprise shots of a cactus; different brick walls (at a range of distances); the muzzle of a pistol that is pointing at the camera; and a rapid-fire, single-frame sequence that animates numerous pairs of scissors. The film's sound was created by scratching into the emulsion of the soundtrack area that runs along the edge of the filmstrip. There are broadly two different textures of scratched sound: one is louder and has a higher pitch, and generally accompanies the images of brick walls; the other is duller, more muffled, and generally accompanies the shots of the cactus. A third characteristic of the soundtrack is the use of silence, which usually accompanies the image of the pistol. In conjunction with the scratched sounds, the silent passages become a component in the rhythmic structure of the piece, which prefigures the tighter and more abstract patterns that underpin some of Kren's later films.

A number of the elements in the film have a haptic quality. The abrasive sound is one such element. Ordinarily in sound recording there is a distance between the microphone and the source of a sound. In this instance, however, the sound was produced through a direct contact with the filmstrip and this proximity is audible in its timbre. One might associate the scratched sound with the spines of the cactus, but in its pure physicality the soundtrack is also a testament to film's indexicality. In effect, the scratched sound is a tracing of the action made by the filmmaker's hand. In this respect it is analogous to a shot made with a handheld camera, but even more direct. The significance of sound in this film is, in fact, announced from the start. The title card TEST appears superimposed over a shot of a fading light bulb filament. As the light source, and hence the image, disappear, an abrupt cut introduces the film's prominent soundtrack. Given that the sound derives from an optical soundtrack – which is produced by a light source that shines through the scratched surface of the emulsion – the sound as well as the image relies on light, but this

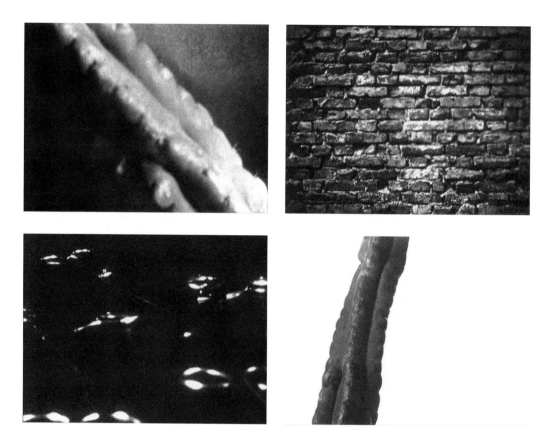

1/57 Versuch mit synthetischem Ton (Test)

first sequence of the film declares a reversal of film's usual order, in which the image is thought of as primary.

The other elements in the film that appeal to touch are the images of objects that would be within one's reach, principally the cactus and the close-up shots of the wall. At the same time, the spines of the cactus are a repellent, and the brick wall, especially in the wide shots, represents an overwhelming barrier. If one thinks of the cactus and the wall as signs, or symbols, they function as images that ward off the viewer. The unaccommodating sound could be thought of as operating in a similar manner. The muzzle of the gun, pointing at the viewer, is more targeted and blunter still. In the last shot of the film, the gun tilts forwards, towards the bottom of the frame, in a dismissive fashion that signals contempt. In these aspects, the act of fending off, or resisting the viewer, is symbolically encoded in the film.

Other readings of the film have gone much further. Peter Tscherkassky, for example, has interpreted it as 'recording feelings surrounding a tragic love'. Having been prompted by a comment made by Kren, regarding the personal and intimate nature of the film, he reads the protrusion and furrows of the cactus as phallus and vulva simultaneously, the wall as the site of an execution, and the scissors as instruments of castration. The film needn't be seen as an abstract psychodrama, but Tscherkassky doesn't necessarily overstate the provocative nature of its imagery, especially in light of some of Kren's subsequent films. One could trace a line between the implied violence in *Versuch* and later films including *20/68 Schatzi* and *24/70 Western*, for example, which depict partial images of a Nazi death camp and the My Lai massacre respectively. Likewise, the suggestion of a castration complex resonates with Kren's films of the Aktionist performances that often hinge on a bathetic sadomasochism. But I also want to suggest that reading *Versuch* as an abstract psychodrama is slightly reductive.

While *Versuch* undoubtedly solicits interpretation, the formal characteristics of the film, which emphasize contrasts in tonality, offset framings, and unusual focal planes, hinder any reading that might be thought of as transparent. The way that the gun is framed and lit, for example, makes it almost unrecognizable, and consequently difficult to decipher. Occupying a small portion of the frame in the bottom right-hand corner, mostly in darkness, the blank black background is the dominant feature of the shot. In so far as the image of the gun functions as a metaphor for the camera's gaze, turned towards the viewer, it is a reflexive image, but one in which the focus is displaced and obscured rather than iconic and self-evident. The scissors are another example of a reflexive image, given that the film is partly about editing, but like the gun/camera they are also difficult to see. Between the highlights and the darkness of the high contrast imagery, there is very little definition in the image that describes the scissors' form. The number of scissors that appear in this sequence is also unclear, made indeterminable by the fact that they were shot using single-frame filming with shifts in position from one frame to the next. This sequence is also something of a joke in the film: it is the fastest cut sequence in the film, and offers a metaphor for the tools of the editor, but it is a sequence that must have been edited in-camera rather than cut and spliced subsequent to shooting.

Various aspects of *Versuch mit synthetischem Ton* reflect the potential of the medium to encompass aesthetic characteristics that are polar opposites. (The same is also true of a number of Kren's later films, including *4/61 Mauern Pos.-Neg. & Weg* and *22/69 Happy End*.) In contrast to the images of the walls, for example, which could well be stills, the scissor sequence reminds the viewer of film's 24 frames-per-second rhythmic pulse. Flatness and depth are similarly opposed: while the shapes made by the scissors appear to race across the surface of a tabletop, most of the other objects in the film are shot in a plane that renders them flat onto the screen. The shots of the wall render the flattest imagery in the film, but a dialectic is set up here too, because the close-ups reveal a significant relief in the surface of the wall across the brickwork, mortar and lichen. Another dynamic of the film concerns framing. Again this is exemplified by the wall,

which carries beyond the edges of the frame at the same time that it limits one's sense of the off-screen space beyond or beside it.

Curiously, in nearly all of the shots featuring the cactus, the dark background is more in focus (or sharper) than the cactus itself. The images of the cactus are primarily examples of the modelling and sculpting of form in light and dark, to produce imagery that spans clarity through to obscurity. In addition, these shots also function as transition between dark and light, or vice versa. In each instance, the cactus starts off out of frame and then it is brought through the frame by a handheld sweep of the camera that pans from a darker patch of wall, across the half-lit surface of the cactus, to a lighter patch of wall. On a purely formal level, the manner in which the cactus arcs through the frame acts as a graphic wipe. A stark contrast to these shots, which are activated by camera movement, is the final image of a cactus, and the penultimate shot of the film. In this shot the tonal quality attributed to figure and ground is reversed, as is the relationship between movement and stasis. A crisp, still shot of the cactus, evenly lit, stands erect against a bright white background. Interrupting this otherwise static image, it is just possible to glimpse a fly speeding through the picture – an incidental feature of the shot presumably, but a happy accident, which takes on significance as the only moving object in the film.

There are two respects in which the film courts abstraction. On the one hand it seems to offer the viewer an abstract message, inviting them to decode the connotations and meaning of its imagery. But if there is a message in the film, paradoxically it is one that iterates ways to fend off the viewer. On the other hand, it engages with abstraction on a formal level (in relation to lighting, focus, framing, movement and depth) and an order of recognition that is quite distinct from any meaning that might be made. This aspect of the film includes those means with which it successfully obfuscates and problematizes its own reading. My suggestion here echoes the claims that Peter Gidal has often made in articulating the aims of structural/materialist film, and his own practice, heralding a dialectic in which a tension would be set up between the material characteristics of a film and its capacity for representation. But in contrast to *Versuch mit synthetischem Ton*, Gidal's films are hardly imagistic at all – tending towards 'signifiers approaching emptiness' – and certainly run counter to anything approaching associative montage. The most significant of Kren's films for Gidal, and Malcolm Le Grice before him, were *3/60 Bäume im Herbst* (Trees in Autumn) and *15/67 TV* – films in which formal processes and structures come to the fore. The imagery in many of Kren's films is charged and resonant, but few could be described as symbolic, and few use strategies that directly imply meaning. An exploration of symbolism is one of the primary tests that Kren undertakes in *Versuch*. In subsequent films, meaning and association are configured rather differently.

Kurt Kren and Sound

Gabriele Jutz

Of the 53 films that Kurt Kren completed between 1956 and 1996, only eight utilized sound. Kren himself repeatedly underscored the deliberate use of silence in his work: 'I am more visual than audio-visual,' he stated in an interview with Peter Tscherkassky (Tscherkassky 1995: 127; see Tscherkassky's *Interview with Kurt Kren* in this volume). For Kren, silence represents a genuine option – not an absence, but rather a predilection for the visual, while added sound always harbours the danger of competing with the image. He was also convinced that sound could be contained within the purely visual realm citing rhythm as an example that is both auditory and visual. In addition to these aesthetic concerns, one can speculate that Kren's concentration on the visual came about due to a chronic shortage of money. In the same way that his method of in-camera editing – or in the case of films edited outside the camera, a shooting ratio close to 1:1 – allowed him to make economical use of filmstock, the lack of sound in most of his films can also be seen as the expression of an extreme economy of means.

In the light of its sparseness, the use of sound in Kren's films is all but ignored by critics and scholars alike. This lack of attention overlooks the fact that Kren has made a significant contribution to the 'audio-visual' aesthetics of film. To reduce this seemingly image-oriented filmmaker to the visual aspect alone means shutting one's eyes and ears to the fact that sound (and its absence) represents as open a field for experimentation as the image itself. A consideration of the sonic dimension of his films complicates the received picture of Kren's oeuvre.

First, it is worth noting that even the screening of a silent film is never a purely visual experience. A number of studies have shown that during the so-called 'silent period' the presence of sound was ubiquitous: early film screenings were often accompanied by a broad range of instrumental, vocal or mechanical sounds that were either improvised or pre-planned. And the practice of adding sounds to an otherwise silent film is not restricted to the silent era; it continues to be an integral part of 'live' cinema practices, including expanded-cinema and its contemporary counterparts. On a few occasions, Kren's silent films were shown accompanied by recorded music or live music. Thanks to Ralph McKay, we have a wonderful record of 'The Kurt Kren Relief Concert', a show organized for Kren's benefit during a time when he was touring with his films in the United States while living out of his car. The benefit was organized by McKay, Bill Steen and U-Ron Bondage, the singer of the Texan punk band Really Red. The event took place in downtown Houston at Studio One on 29 January 1983:

The place was packed when the show started with Trees in Autumn, its soundtrack at maximum volume. Program 1 continued with a selection of Kurt's more formal films – Asylum, T.V., Tree Again, etc. These ran with recorded music, probably African Headcharge (Kurt's usual choice), and finished with the transitional Sentimental Punk. The reception was already extraordinary before the program accelerated into nine Aktion films in thirty-eight minutes – Mama and Papa, Selfmutilation, Leda and the Swan, etc. These were accompanied by a raw industrial live improvisation by Really Red – guitar/Kelly, bass/John Paul, drums/Bob, U-ron/synth, Dennis/sax. The pumped-up crowd, *and* the musicians, were surprisingly jarred by Kurt's films. Kelly was downing a burger while performing and practically lost it when he looked up to see Kurt's 'eating, drinking, pissing, shitting' September 20. [...] The program drove on with a full-force Really Red set and finished with one last film – Keine Donau, in case anyone was left wondering.

(McKay 2000)

46/90 Falter 2

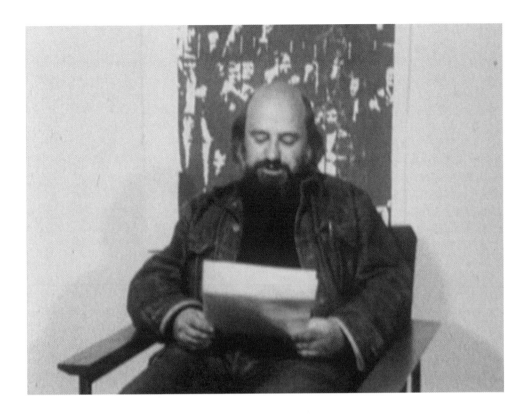

29/73 Ready-made

Really Red even wrote a song about Kren, entitled 'Ode to Kurt Kren'. Its refrain is 'Frame to frame on celluloid. Kurt Kren came from Austria'.[1] After the punk underground's tribute to Kren, whose aesthetics paralleled that movement's own, Kren continued to occasionally show his films alongside the incendiary Texan music scene of the time. For the period that followed Kren's return to Vienna in 1988, only one more screening with live music has been noted: the premiere of *48/94 Fragment W. E.* on 1 June 1995 – a film of only 13 seconds screened as a loop and accompanied by the painter Wolfgang Ernst's improvisations on the violin.

As far as Kren's 'true' sound films are concerned, a standard recorded soundtrack can be found in four films: *23/69 Underground Explosion*, a reportage on an underground festival, accompanied by music by Karl-Heinz Hein; *29/73 Ready-made*, which consists of outtakes from a television studio recording, where Kren reads letters that Groucho Marx had written to Warner Bros.; *46/90 Falter 2*, an advertisement spot for the Vienna city newspaper *Falter*, whose sound was conceived by Wolfgang Ernst; and *47/91 Ein*

Fest (*A Party*), where Kren recorded the ambient noise of a party given by the Austrian broadcasting corporation, ORF, on the occasion of the program series *Kunststücke* celebrating its jubilee. (The latter two of these films were commissioned works, and I will not review them specifically.)

The most intriguing sound practices in Kren's oeuvre are those that free the filmmaker from the use of a recording device. One method to circumvent recording is handmade sound, whether scratched or drawn onto the filmstrip, as shown in *1/57 Versuch mit synthetischem Ton (Test)* (*Experiment with Synthetic Sound*) and *3/60 Bäume im Herbst* (*Trees in Autumn*). Another method is to appropriate pre-existing sound, as *44/85 Foot'-age Shoot'-out* and *49/95 tausendjahrekino* (*thousandyearsofcinema*) demonstrate. These two practices – handmade sound and appropriated sound – establish a distinction between two opposing models of artistic authorship, which relate to Johanna Drucker's characterization of the artist's role as a 'producing subject' in relation to two dominant strains: one 'expressive', the other 'conceptual'.

> This split marks the distinction between the artist as a body, somatic, with pulsations and drives ... and the artist as intellect, thinking through form with the least amount of apparent individual expression, anti-subjective and antiromantic.
>
> (Drucker 1994: 122)

In what follows, I address Kren's most interesting contributions to the acoustic dimension of film by dealing first with handmade sound and second with appropriated sound, from a perspective that addresses formal as well as associated historical, technical and political issues.

Handmade Sound

Kren's two films with handmade sound both originate from his early period. The first, *1/57 Versuch mit synthetischem Ton*, originally entitled *Test*, was made in 1957. This barely one-and-a-half-minute, black-and-white film displays a limited number of repeated shots: a brick wall filmed at various distances, from close-up to extreme close-up; pans of the fleshy parts of a cactus; and static shots of a pistol, which is scarcely identifiable. Towards the end, this rather sluggish film picks up speed and shows a series of quick cuts, which tend towards abstraction due to the fast editing rhythm. These shots, recorded through single-frame registration, anticipate Kren's next films where he would bring this shooting method to mastery. Sound, for its part, was obtained by a purely manual procedure – that is by scratching marks onto the optical soundtrack area of the filmstrip. Starting with a pop, the sounds in *1/57 Versuch mit synthetischem Ton* are of various intensities, with short breaks in between. At times they are reminiscent of the noise made by a dull-edged object rumbling over the uneven grooves of a washboard, or a shovel scraping

on concrete. Occasionally they also conjure up the sound of a heavy piece of furniture dragged over a wooden floor, or an old motor that cannot get started. These scratched tones would conventionally be considered noise.

It is interesting to note that the title of the very first film listed in Kren's official filmography emphasizes the auditory instead of the visual. Moreover, it directs our attention to a particular mode of sound production that radically challenges the dominant model of cinema as a medium of recording. During the 1950s, the term 'synthetic sound' was (and, to a certain degree, still is) most commonly associated with electronic instrumentation. (The science-fiction film *Forbidden Planet*, with Bebe and Louis Barron's electronic score, had been released just a year before *Versuch mit synthetischem Ton* was made.) Kren's film, however, reminds us that sound synthesis can also be achieved by simple optical means – in this case by scratching the surface of the narrow vertical strip that runs parallel to the image track, which is normally reserved for the soundtrack.

Since the prerequisite for Kren's handmade sound is the optical recording process, it will prove useful to briefly describe the technology. Optical sound, or sound-on-film, which became established by late 1929, is based on an optical process whereby sound waves are transformed into graphic patterns of light alongside the picture area of the film print. Since optical sound emanates from visual patterns, it is possible to create sounds by scratching, drawing, or contact-printing directly onto the filmstrip, so that any shape or mark can be made audible. The disturbing, even uncanny, quality of these 'tones from out of nowhere', as Thomas Y. Levin has aptly labelled them, comes from the fact that the tones' origin was not an instrument or a voice, but a graphic mark on the celluloid (Levin 2003).

Initial experiments with optically synthesized sound took place in the early 1930s, particularly in Russia and Western Europe.[2] Though several methods have been employed, the standard procedure consisted of preparing black-and-white drawings of sound waves on long, narrow cardboard strips, then photographing them – frame by frame – with a standard animation camera and contact printing them on the margin of the film strip. In order to achieve accurate control over the quality of the sound with respect to volume, pitch, timbre and so on, various devices were employed, including variations in the exposure or the camera distance. When the film was played back on a suitable projector, the photographed images became audible. Altogether, these early experiments had varying motivations and pursued different goals. In 1933, the British physicist E. A. Humphries, for example, succeeded in imitating a human voice. For this purpose he analysed the phonetic components of the required voice and rendered them visible by graphic sound curves that were photographed on the sound track. In turn, Oskar Fischinger's explorations into synthetic sound, a series of experiments entitled *Tönende Ornamente* (*Sounding Ornaments*, 1933), were motivated by the question of whether the relationships between visual forms and their corresponding acoustic manifestations are purely accidental, or governed by an internal common logic (Levin 2003: 51f). In the same year, László Moholy-Nagy realized his now lost experimental short film *Tönendes*

ABC (*Sounding ABC*). Not unlike Fischinger, but without the 'völkisch' undertone, the Bauhaus artist Moholy-Nagy was also interested in discovering the correspondence between graphic marks (such as alphabetical letters, finger-prints, various types of signs and symbols and even facial contours) and their tonal counterparts.[3]

Another method, discovered simultaneously in 1933 by the New Zealand musician Jack Ellitt in England and the composer Arthur Hoérée in France (and more close to the methods used by Kren), consists of drawing directly on the celluloid without the intervention of a camera at all. Hoérée came to handmade sound by coincidence. While working on his sound montage for the 'storm sequence' in Dimitri Kirsanoff's *Rapt* (1934), he found that the recording changed when ink drawings were added to the optical soundtrack. The French composer was fully aware of the significance of this discovery, which he called 'zaponage' (retouching): 'I invented sounds with the paint brush' (James 1986). One of the pioneers of hand-drawn sound was the Canadian filmmaker Norman McLaren, whose *Dots* and *Loops* (both 1940) utilize this method. As McLaren explains in his short film *Pen Point Percussion* (1951), he would apply serial graphic patterns on the filmstrip's soundtrack by means of a brush and ink. Since his goal was to produce musical tones, he exercised the utmost diligence to maintain control over the audible result: the size of the marks determined the loudness of the sound; their shape the tone quality; and the space between them and the pitch.

It is important to note that all these experiments with optically synthesized sound, prior to Kren's *1/57 Versuch mit synthetischem Ton*, pursued the overriding aim of producing *signifying* sounds, such as speech, music or sound effects, maintaining control over the result. If the desired sound could not be obtained, and instead resulted in a penetrating rattle, as Fischinger had bitterly experienced during the projection of the first series of *Sounding Ornaments*, this was regarded as a problem that had to be fixed. For Kren, however, the lack of apparent signification was all the better. In not producing well-behaved, disciplined, organized sounds, he opened up a space for working with optically synthesized sound as 'noise'.

Noise entered music in 1913 when the Futurist Luigi Russolo published his manifesto *Arte dei Rumori* (*The Art of Noises*). Together with his assistant Ugo Piatti he invented a wide range of machines – the so-called noise intoners – which were able to produce all kind of noises such as howling, crackling, squeaking, shrieking and so on. Besides Russolo, many musicians from the early twentieth century on, such as Eric Satie, Edgard Varèse and the representatives of musique concrète, would integrate noise into their works. As far as the cinematic avant-garde is concerned, Kren, who regarded noise as anything but a problem, seems to have been the first to depart from the meaning-based use of handmade sound and broaden its understanding beyond speech, music and effects.

3/60 Bäume im Herbst is one of Kren's early masterpieces. Based on a preparatory mathematical diagram, indicating the correlations of takes and their durations, the film was made – frame by frame – in camera. An ordering system written down on a sheet of graph paper was used to govern the shooting. *3/60 Bäume im Herbst* explores the

formal relationships among bare branches depicted against the sky. Since no shot is longer than eight frames (1/3 of a second), the rapid succession of cuts flattens out the represented trees. Though the imagery never becomes divorced from the objects filmed, *3/60 Bäume im Herbst* results in a remarkable effect of abstraction, similar to the style of informal painting with which Kren was familiar. This abstract graphic aesthetic provides a compelling contrast to the hand-painted soundtrack 'that does not come across as synthetic but almost sounds organic – as if the wind was knocking an unshielded microphone' (Grissemann 2012: 98f). Unlike the imagery, which is of photographic origin, and hence stands as a witness to the pro-filmic event, the soundtrack does not have an external source, but emanates from the graphic patterns applied onto the filmstrip with India ink. Astoundingly, when watching the film, one is inclined to read the image as if detached from its source, whereas the soundtrack – which is, in fact, pure noise – might be attributed to a source in nature, such as the wind or distant thunder rolling. Thus, Kren's non-naturalistic mode of sound production, which was by no means intended as an imitation of natural sounds, ends up generating a naturalistic soundscape.

Though *3/60 Bäume im Herbst* marked the end of Kren's experiments with handmade sound, he returned to making sounds without a recording device many years later, this time exploring the potential of appropriated sound.

Appropriated Sound

44/85 Foot'-age shoot'-out, Kren's first film with 'found' or appropriated sound, was made during his Houston period, when he worked as a security guard in Houston's Museum of Fine Arts and had almost totally withdrawn from filmmaking. The filmmaker comments on the making of the film thus:

> It came about in the following manner: when I returned home in the evenings I was completely exhausted and unable to do anything. I laid down, and could have slept for a day or two, really. But, surprisingly, I received a letter from the San Francisco Cinematheque. They wanted me to make a film to be screened at the Chinese Theatre – with only a two weeks' warning! A reel of colour negative was included with the invitation. There I was, wondering what to do next. The stress of the situation made me furious: what are they doing to me, it felt to me almost like being raped. That is what the title of the film came from: a film duel, a footage shootout. I was really worked up, and then I met Bruce Conner who was covering a story in Houston. 'Forget it, they are out of their minds!', he said, but I couldn't do that. I just thought, 'Shit, I'm going to do it now!' Furiously, I shot the Houston skyline with my camera – that's all there is in Houston anyway – and then even the film got stuck in the camera. I ripped it out of the camera and shoved it in the express envelope that had come with it, complete with the address of the film laboratory, and mailed it away. They had added the music from

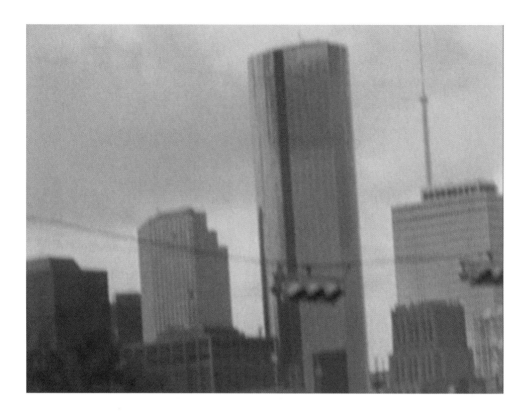

44/85 Foot'-age shoot'-out

Once Upon a Time in the West in 'Frisco. It was less famous in the States. In Europe it is apparently known by everyone, and I hear they even use it in commercials.

Kren's comments, stressing his unwillingness due to the instant, made-to-order production conditions, should not lead us to conclude that the film's images are arbitrarily chosen. On the contrary, the imagery of *44/85 Foot'-age shoot'-out* accurately makes reference to both the context of the screening and the political context of the United States during the 1980s. What it depicts is indeed a *battle*, 'a film duel, a footage shootout', in Kren's words, alluding to the title of the San Francisco show – 'The Battle of the Film Bands'. Moreover, it comments on the US business scene during the Reagan years characterized by cut-throat competition, which is represented metonymically by the Houston skyline. Ennio Morricone's music suggests that the heroes from Sergio Leone's Spaghetti Western *Once Upon A Time in The West* had been replaced by corporate institutions, which battle like gunslingers at high noon.

The fact that the soundtrack was appropriated (without permission) and added afterwards, without the filmmaker's instigation, does not weaken the argument that *44/85 Foot'-age shoot'-out* is a radical statement. On the contrary, the utilization of a soundtrack neither made nor chosen by the filmmaker himself should be understood as a response to the consumerist logic of capitalist culture and its fetish of ownership and property. In order to turn appropriation into a political act, however, the hijacked element must, according to Craig Dworkin, maintain a reference to its original context and the manipulation must remain evident (2003: 13). Both of these apply in the case of *44/85 Foot'-age shoot'-out*: firstly, because the theme from *Once Upon a Time in the West* is an extremely popular tune; and secondly, because Kren openly announced that the music was added not by himself but by his colleagues from the filmmakers' group No Nothing Cinema. By ascribing multiple authors, Kren's strategy of productive embezzlement unsettles hierarchies and pursues a logic parallel to that of the Situationist concept of *détournement*, which provided a model of creative plagiarism to politically charged ends.

Unlike *détournement*, which interferes with and 'improves' upon its found objects (for instance, by overpainting canvases picked up at the flea market), *44/85 Foot'-age shoot'-out* is in the spirit of non-intervention and hence invites comparison to the Dadaist ready-made, with its 'spectacular ratio of effort to effect' (Elsaesser 1996: 22). At this point it is worth recalling that Kren himself made a film entitled *29/73 Ready-made*, which is, as already mentioned, entirely composed of unedited outtakes gathered from his reading of Groucho Marx's letters in a television studio for a documentary film directed by Hans-Christoph Blumenberg (*Die lange Nacht von Casablanca*, 1973). This material, intended for disposal, was re-appropriated by Kren, who 'treats the scenes as an *objet trouvé* consisting of puzzling documents from an aborted mission' (Grissemann 2012: 95). The film form of *29/73 Ready-made* contrasts with the normally labour-intensive process of filmmaking and thus represents, like *44/85 Foot'-age shoot'-out* a reversal of bourgeois value-creation.

In 1995, official Austria celebrated cinema's centennial with a project called *hundertjahrekino*, curated by Hans Hurch. Kren was invited to contribute the trailer. Its title – *49/95 tausendjahrekino* – mirrors the project's title, with one slight, but important difference. The glorious 100 years of the moving image are connected to a quite inglorious period of history: the 'Thousand Year Reich' – Adolf Hitler's term for National Socialist Germany that was to last for a thousand years, but in reality was ousted after a mere twelve years. The element by which Kren links the 100th anniversary of cinema and the product of Hitler's diseased imagination is the dialogue from the soundtrack, appropriated from Peter Lorre's only film as director, *Der Verlorene* (*The Lost One*, 1951).

The making of *49/95 tausendjahrekino* was scheduled for the period of one month, during which Kren positioned himself – day after day, between 4 and 6 pm – on Vienna's Stock-im-Eisen-Platz, pointing his camera at tourists photographing St. Stephen's cathedral. The aim was to capture them from a close distance at the very moment when they pressed the button on their film or video cameras. Though Kren's point of departure

was not a score, as with many of his earlier films, *49/95 tausendjahrekino* nevertheless was made according to a plan, which involved producing exactly one metre of film per day, shot frame by frame, exposing the filmstrip at a rate of only two frames per second. As Thomas Korschil points out, this extremely short exposure time makes the individual shots themselves appear nearly static – which brings Kren's filmmaking close to the activity of the photographers – whereas the rapid succession of camera-obscured faces, flashing up for a split-second, is a result of the shakiness of the hand-held camera as well as the quick in-camera editing (1996: 47). Part of the plan was also to determine the length of the film by an external rationale, namely the two-minute, 45-second (or 30-metre) standard length of a 16mm film reel. Employing pre-established rules, and a prefabricated industrial standard, Kren was furnished with the means of removing certain subjective and personal elements from the film's construction.

A comparable anti-subjective impulse governs the practice of appropriation. While *44/85 Foot'-age shoot'-out*, with its recycled Morricone tune, testifies to a spirit of non-intervention, the soundtrack for *49/95 tausendjahrekino*, while appropriated, was also edited. Originally Kren intended to use ambient sounds from the filmed location, but they did not yield a satisfactory result. The idea to use snatches of dialogue taken from *Der Verlorene* instead was born when a passer-by approached Kren, while he was recording, saying that he had known him earlier, which Kren denied. In Lorre's film, shot in Hamburg during the winter of 1950–51, the main character – played by Lorre himself – is reminded of his murderous wartime past and forced to confront his previous identity. The dialogue appropriated by Kren comes from a scene on a train, where an importunate drunkard exposes the Lorre character: 'I know you. I don't know where I know you from, but I know you … I've seen those eyes somewhere before … Mistake? Impossible. I know those eyes.' In the apocalyptic end of *49/95 tausendjahrekino* a siren triggers an air-raid warning, a voice shouts 'All men to the hero's cellar' and the sound of a slamming door occurs precisely at the moment when the screen turns black.

The Apparatus of Production

Johanna Drucker's distinction between two opposing models of artistic authorship, quoted in the first part of this essay, also helps to identify two different moments in Kren's career as a 'soundmaker'. Experiments with handmade sound, inscribed methodologically in the tradition of handwriting and expressive art, can be found exclusively in his very early films, whereas appropriated sound, which lacks the trace of the artist's hand, and could be thought of as conceptual, appears much later in his work. Kren's development – in terms of Drucker's theory of the producing subject – can be described as a trajectory from 'self-expression' to 'self-erasure.'

By circumventing the use of a recording device, both handmade and appropriated sound testify to an economy of means that correspond to the filmmaker's limited

financial resources. However, these strategies should also be understood in the context of concurrent art movements of the time, such as Informal Painting and Concept Art, of which Kren was well aware. Kren's hand-scratched and hand-drawn sound clearly references informal art, with its impulsive traces, whereas his appropriated sound suggests a relationship to conceptual art practices.

Drucker's concern with the role of the artist as a 'producing subject' dismantles the notion of the artist as a transcendent genius, questioning the artist's subject position in relation to the apparatus of production. *1/57 Versuch mit synthetischem Ton* and *3/60 Bäume im Herbst,* on the one hand, and *44/85 Foot'-age shoot'-out* and *49/95 tausendjahrekino,* on the other, articulate opposing models of artistic subjectivity. Scratching and drawing are dependent on certain intensities, since the merest alteration of the pressure of the fingers, the tension of the hand, or the use of the tool can affect the result. This is even truer for handmade film sound, if one considers the tiny size of the area devoted to the soundtrack. Normal filmmaking practices depend on a series of optical, chemical and mechanical processes, whereas handmade – i.e. cameraless – film, where only a pointed object or some other instrument intervenes between the filmmaker and the filmstrip, is intimately connected to notions of presence and corporeality.

In contrast to handmade film sound, which could be regarded as the direct expression of a bodily gesture, appropriated sound avoids the body's trace, eclipses the artist's signature and transforms him or her 'into a subject repeating endlessly the already available already made' (Drucker 1994: 138). The act of appropriation replaces artistic activity, conceptualized as an act of inscription, by mere 'gestures of artistic authorship', such as selecting, naming, pointing and signing.

Though starting from opposite premises, both strategies represent a radical critique of traditional art practices. The pointedness of handmade sound resides in the fact that, within the very framework of a technical medium, the artist returns to pre-apparative techniques (such as scratching or drawing), whereas appropriated sound banishes the evidence of the physical trace and hence offers a critique of art production in terms of an association with an identifying mark. Drucker's concept, based on the question of how the producing subject interacts with the medium in material terms, helps to theorize these two opposed, even conflicting, strains of Kren's sound-making activities. Analysing Kren's oeuvre in audio-visual terms provides the opportunity to take into account one of its aspects that is overlooked; it also provides fresh way of looking at his films.

References

Drucker, J., 1994. *Theorizing Modernism. Visual Art and the Critical Tradition.* New York: Columbia University Press.
Dworkin, C., 2003. *Reading the Illegible.* Evanston, IL: Northwestern University Press.

Elsaesser, T., 1996. Dada/Cinema? In: R.E. Kuenzli, ed. *Dada and Surrealist Film.* Cambridge, MA: The MIT Press.

Grissemann, S., 2012. Fundamental Punk. On Kurt Kren's Universal Cinema. In: P. Tscherkassky, ed. *Film Unframed. A History of Austrian Avant-Garde Cinema.* Wien: Synema.

James, R.S., 1986. Avant-Garde Sound-on-Film Techniques and Their Relationship to Electro-Acoustic Music. *The Musical Quarterly*, 22, p. 83.

Korschil, T., 1996. Die ersten, die letzten, soweit. In: H. Scheugl, ed. *Ex Underground. Kurt Kren. Seine Filme.* Wien: PVS Verleger.

Levin, T.Y., 2003. 'Tones from out of Nowhere': Rudolf Pfenninger and the Archaeology of Synthetic Sound. *Grey Room*, 12, pp. 32–79.

McKay, R., 2000. Alive and Well Yet. In: M. Magee, ed. Austin, Texas: *Cinematexas International Short Film and Video Festival* (festival catalogue).

McLaren, N., 1953. Notes on Animated Sound. Reprinted in Manvell, R., and Huntley, J., 1975. *The Technique of Film Music.* London, New York: Focal Press.

Moholy-Nagy, L., 1972. *ein Totalexperiment.* Mainz, Berlin: Florian Kupferberg.

Russett, R., 1988. Experimenters in Animated Sound. In: R. Russett and C. Starr, eds. *Experimental Animation. Origins of a New Art.* New York: Da Capo Press.

Tscherkassky, P., 1995. Kren. Peter Tscherkassky im Gespräch mit Kurt Kren (1988). In: A. Horwath, L. Ponger, and G. Schlemmer, eds. *Avantgardefilm. Österreich. 1950 bis heute.* Wien: Wespennest.

Notes

1. The song can be heard at: http://www.kbdrecords.com/wp-content/uploads/2008/07/05-really-red-ode-to-kurt-kren-1982-usa.mp3 (last accessed on 21 December 2014).
2. Besides Levin's article, an account of the history and the methods employed in the creation of optically synthesized sound can be found in McLaren (1953; reprinted in Manvell and Huntley 1975: 185–193) and in Russett (1988: 163–165).
3. Sibyl Moholy-Nagy: "'I can play your profile,' he would say to a friend, sketching the outline of the face in his notebook. "I wonder how your nose will sound?"' (Moholy-Nagy 1972: 67).

2/60 48 Köpfe aus dem Szondi-Test

2/60 48 Heads from the Szondi-Test (1960, 4:19 min, b/w, silent)

Abbe Fletcher

2/60 48 Köpfe aus dem Szondi-Test is Kren's second film. In it he pursues his preoccupation with numbers, established in his first film, and augments it into a structure directly derived from the subject matter of the film. This subject matter is the 48 pictures that comprise Leopold Szondi's somewhat problematic perception test, intended to identify psychiatric patients' leanings towards a particular diagnosis, through their identification – or lack of it – with a set of eight psychiatric patient 'types'.[1] The test is made up of six sets of eight photographs of different types (sadist, epileptic, hysteric, catatonic schizophrenic, paranoid schizophrenic, manic-depressive manic, manic-depressive depressive and homosexual – indicating the dated and contentious nature of the test), from which the patient selects two he likes best and two he dislikes. The patient's identification with the facial characteristics represented in the pictures is intended to assist in the diagnosis of the patient's own condition.[2] The seriality in Kren's film builds and diminishes in cycles, transforming the subject matter and reconfiguring it as a test of perception for the viewer.

For Kren's purposes, the test offers a structured subject/object matter, which would lend itself to his experiments with serial frame montage: a form of quasi-found footage, arranged in sets that could be re-ordered in the process of filming. Kren has talked about the importance of the linking of images rather than individual images themselves.[3] In this he echoes Vertov, who stressed the significance of the intervals between frames in drawing the action to a kinetic resolution.

This film is concerned with the linking, interchanging, comparing, structuring, morphing, abstracting effect of connecting elements in different faces, and their cumulative effect. Here the evidential and aesthetic aspects of cinematography are subverted to present a reconstituted visual experience. The effect of the short frame lengths is one of animation and recombination that deconstructs the act of watching and emphasizes the active process of seeing what is on the screen. Watching the film constitutes an act of apprehending the images we are seeing; the viewer is able to examine details of the faces, according to Kren's plan; the intensive examination reveals details, similarities and contrasts that are not visible in the individual test cards themselves. As Peter Weibel suggests: 'Kren's art is thus the language of seeing, the opseography; the study of the glance, of visual processes; the optical study of the processes of perception' (Weibel 2005: 146).

Kren's visually kinetic approach diverts the original intentions of the Szondi test. It is no longer a contentious act of identification, demonstrating that identification on the

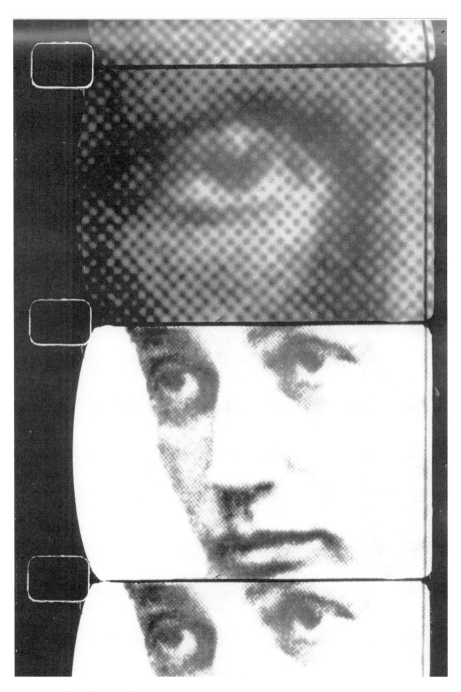

2/60 48 Köpfe aus dem Szondi-Test

basis of physical appearance is only superficial. The multiple reframing of the individual cards reveals numerous aspects of each head, not least the graphic nature of the repeatedly reproduced photographs, which becomes a dominant factor.

Kren takes the 48 cards and films them for one to eight frames, according to a structured frame plan. This strategy is common to some of Kren's other films, including *3/60 Bäume im Herbst* and *4/61 Mauern Pos.-Neg. & Weg*. The heads on the Szondi test cards are cropped and their features filmed and juxtaposed in a series of different sequences that develop and move the locus of concentration across the features. The different graphic textures of the photographs, given their varying manner of reproduction and their age – some date from as early as 1892 – add an abstract quality to the facial features, so that some are reduced to a grouping of black dots on white, the underlying pattern of half-tone images.

According to the psychologist P. Henry David, the age of the photographs, and thereby the appearance and dress of the figures in them, was not perceived as an issue in performing the test,[4] and yet this becomes the very focus of Kren's film. The historical appearance of the photographs, combined with their degradation through reproduction is magnified by Kren's close framing that abstracts and thereby alienates the images from the possibility of identification. The test is rendered a historical artefact and thereby stripped of its contentious and ambiguous validity and clinical relevance and reconstructed as a filmic investigation. The viewer is challenged to keep up with the rapid framing and structuring of the test cards, but eventually surrenders their ability to track the images and is carried along in a flow of features, details, graphic patterns and photographic grain.

The frame plan for *2/60 48 Köpfe aus dem Szondi-Test* is a series of handwritten columns of numbers and numerals followed by a tick. This differs from Kren's frame plans for subsequent films, which are marked out on graph paper with crosses (*3/60 Bäume im Herbst*), vectors (*16/67 20ᵗʰ September*) or blocks (*31/75 Aysl*). Under close inspection, the handwritten frame plan reveals an intricately patterned structure. Kren numbered each of the six sets of eight cards with roman numerals. He then gave each of the eight cards within that set a number. The frame plan is a handwritten list in vertical columns identifying the set number, followed by a smaller number to the right to denote the card within that set, and next to that the number of frames that will be shot (e.g. I1 4, II2 3, III3 2, IV4 1). Cards are selected from consecutive sets (I, II, III, IV, III, II, I) and the heads within those sets also remain consecutive (I1, II2, III3, IV4). Next to each entry there is a small tick, which Kren presumably made as he was taking each shot. Kren's handwriting is tiny, neat and meticulous and there are no visible mistakes or corrections in the plan. The methodical and strictly consecutive selection across the sets and cards within the sets, presents a consistent approach to the selection of faces, which, to look at the finished film and the effect of the similarities across the faces, seems surprising as they appear to be chosen for their similarities, not by consecutive patterning. In shooting the film, successive faces were selected from separate sets; no two faces from the same set appear consecutively. The frame lengths remain between one and eight frames.

The frame lengths appear in consecutive patterns, starting off at four frames in duration, diminishing to a single frame and then building back up to four frames: 4, 3, 2, 1, 2, 3, 4. These opening shots are close-ups of different mouths. This pattern is repeated three times with different sets of pictures. Then the pattern is reversed: 1, 2, 3, 4, 3, 2, 1. This shape is repeated three times with shots of mouths from different sets, after which there is a sequence of longer frame lengths – 8, 7, 6, 5, 4, 3, 2, 1, 2, 3, 4, 5, 6, 7, 8 – repeated twice with different shots. Here the framing widens to focus on noses and mouths. Then there is a sequence of eyes and noses (6, 5, 4, 3, 2, 1, 2, 3, 4, 5, 6) repeated three times with different shots. This is followed by a sustained sequence (5, 4, 3, 2, 1, 2, 3, 4, 5) repeated seven times, forming the body of the montage of eyes and noses. Then follows three-and-a-half cycles of the pattern 4, 3, 2, 1, 2, 3, 4, showing full faces, cropped shots of eyes, noses and then mouths; one sequence (1, 2, 3, 4, 3, 2, 1) showing mouths; three sequences of full faces (7, 6, 5, 4, 3, 2, 1, 2, 3, 4, 5, 6, 7); three-and-a-half sequences in the pattern 1, 2, 3, 4, 5, 6, 7, 6, 5, 4, 3, 2, 1, which starts with full faces, then eyes, then noses, then eyes again followed by a single eye; four-and-a-half sequences comprising close-ups of individual eyes (5, 4, 3, 2, 1, 2, 3, 4, 5); followed by four sequences of both eyes (1, 2, 3, 4, 3, 2, 1). This constitutes the first 40 seconds of the film.

There are 38 discrete sequences in the complete film. A sequence here is identified as a series of shots of similar shot size and subject. The film starts with a sequence of close-ups of mouths (1), and then the frame widens to include nostrils (2), after several of which the shot changes to a sequence of close-ups of eyes (3), left eyes (4), both eyes (5), then widens to include eyes and noses (6). From here, the framing widens to show the left side of the face, not including eyes (7). After this sequence, the frame narrows again to focus on the left-hand side of the faces (8), extreme close-ups of noses and moustaches (9), then cuts to close-ups of the white space to the right of the faces (10). This withholding of establishing shots of full faces leaves the viewer little space for orientation and the possibility of organizing the faces. The following sequence focuses on full faces, using the eyes as the pivot point (11). After this there is a sequence focusing on the corner of heads (12) then one on noses, moustaches and mouths (13), then back to the top of the head (14), foreheads (15), eyebrows to eyes (16), followed by a sequence of faces in medium-shot (17), faces in profile and front on (18), noses and mouths in close-up (19), right-hand eyes (20) and then back to noses and mouths (21). The next sequences focus on the right-hand side of faces (22), both eyes (23), the left-hand side of faces (24), shots of full faces, front on, cropping to left eyes (25), noses (26), left-hand eyes (27), eyes horizontal and rotated (28), extreme close-ups of mouths (29), left-hand sides of faces (30), right-hand side of faces (31), extreme close-ups of frown lines, between the eyes (32), faces that have been rotated to horizontal (33), the left eye, both eyes, including the nose, and full faces (34). Finally, there are medium-shots of faces (35), shots of noses as the focal point, central in the frame (36), followed by close-ups of noses and mouths (37), until the film finishes, as it began, on extreme close-ups of mouths (38).

The Szondi test comes with a structure: the 48 cards split into six sets of eight heads or 'types'. Kren could have cut between 'types' within a given set, but instead he chose to cut between the sets, retaining consecutive set numbers and card numbers in ascending and

BOX 3

2/60 48 Köpfe aus dem Szondi-Test

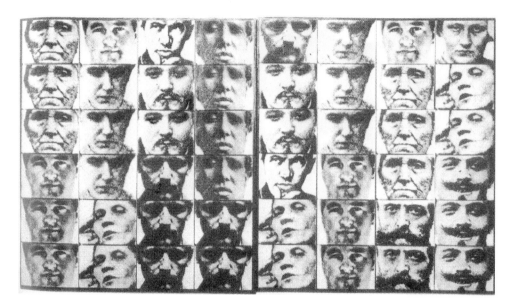

2/60 48 Köpfe aus dem Szondi-Test

descending patterns. Significantly, this is something the original performance of the test on patients would not allow as it would contradict the purpose of the test itself, where the key aim is identification with a specific 'type' within a restricted range of options (one of each within a given set). Could Kren's rejection and replacement of the formal integrity of the test, with his own formal structure that integrates the sets, perhaps demonstrate his scepticism towards such a test?

The editing of this film was completed in camera and it was presumably shot from a rostrum. Each card was placed before the camera and the desired number of frames taken, then the next card, and so on. The short shot lengths create the illusion of animation of the still faces: eyes close and open, brows shift, mouths smile or grimace, moustaches appear and disappear, faces tilt, turn and fill the frame. The variation of frame lengths between one and eight frames, in ascending and descending patterns of varying frequency, gives the illusion of gesture, creating a circular pattern of movement rather than a regimented, uniform or constant metre. The sequences form areas of concentration across the faces: mouths, noses, eyes and so on, that, rather than offering the opportunity for comparison, produce a synthesizing effect: the noses move, shift, squash, lift, fall, nostrils widen, shrink, and disappear in shadow. The expressions of the faces, when split into their constituent parts, are deconstructed (through the cropped close framing) but also homogenized: individuals become a mass of features. At one point in the film, the faces drift to the left-hand side of the frame, and the white spaces to the right of the faces

are examined, receding and expanding as the size and shape of the juxtaposed heads shift. At another point, the axis of the heads is rotated so they fleetingly appear horizontally, disrupting the (vertical) continuity of the film, and prompting the viewer to remember that they are watching flat, printed images that have been deliberately positioned, filmed and structured by the filmmaker. There is even one shot where the edge of the test card is visible and the white painted table on which it was shot fills half the frame. This single 'mistake', admittedly only visible when examining the film frame by frame, serves as a reminder of the shift that filming, editing and reconstituting the test poses, in contrast to the test as comprising a group of images and a prescribed set of instructions. It also shows Kren's fallibility, a reminder that this film is made by frame by frame, and by hand, just as his frame plan shows his workings.

48 Köpfe aus dem Szondi-Test demonstrates Kren's ingenuity in devising a comprehensive plan prior to shooting. The effect that is created through this rigorous approach constitutes a visual-kinetic investigation, which stimulates static fragments into rapid movement through editing: the definition of the illusion of film movement itself.

References

Borstelmann, L.J., and Klopfer, W.G., 1953. The Szondi Test: A Review and Critical Evaluation. *Psychological Bulletin*, 50(2), p. 113.

David, P.H., 1950. An Inquiry into the Szondi Pictures. *Journal of Abnormal and Social Psychology*, no. 88, p.735.

Weibel, P., 2005. Kurt Kren: Opseography Instead of Cinematography. In: *Beyond Art: A Third Culture*. Vienna: Springer-Verlag.

Notes

1. The photographs of the Szondi test are drawn from several sources. Thirty-eight are from German textbooks, out of which 30 are from a 1901 introduction to psychiatry text and 8 stem from texts published in 1892, 1904, 1928 and 1922. Six of the remaining photographs are Swedish and were sent directly to Szondi from the Swedish Institute for Criminal Psychiatry. The four remaining pictures are from Szondi's own practice in Hungary (David 1950).
2. Szondi's test appeared in 1947, with the English translation, by his student Susan Deri, following in 1949. The test was rightly met with suspicion by American and European psychologists and was discredited due to its 'assumption that the psychopathological dynamics of the various diagnostic syndromes are somehow communicated to the subjects through the medium of the test pictures' (Borstelmann and Klopfer 1953).

3. In the documentary *Keine Donau – Kurt Kren und Seine Filme* directed by Hans Scheugl (1988).

4. Susan Deri, Szondi's translator, 'postulates that subjects do not consciously recognize the stimulus in the individual pictures, but rather that everyone has certain characteristics corresponding to latent tendencies to mental disease, and that in responding to the test, the person unconsciously identifies with or rejects those latent characteristics in himself. Since both writers [Szondi and Deri] consider a subject's actual selections based primarily upon unconscious reactions, the physical aspects of the pictures themselves, nationality, poor photographic conditions, etc., should be of very limited importance' (David 1950).

3/60 Bäume im Herbst

3/60 Trees in Autumn (1960, 5:03 min, b/w)

Simon Payne

B*äume im Herbst* is Kurt Kren's second film (after *48 Köpfe aus dem Szondi-Test, 2/60*) to use a predetermined and highly systematic in-camera editing strategy. It was made following a score, notated in black pen on graph paper, which is marked out as a series of dots creating a row of lines that zigzag across the page. Each dot refers to a frame, or series of frames, that I will temporarily refer to as a 'shot'. Starting in the top left-hand corner of the graph paper, which marks the start of the film, the first dot above the base line refers to a one-frame shot of a tree. The second dot, which is two points up from the base line refers to a shot of another tree that comprises two frames. The third dot, three points up from the base line, refers to a three-frame shot of a different tree again. The fourth dot, signifying a four-frame shot, marks the apex in this first sequence of the film, with the fifth dot returning to the third point above the base line signalling a contracted shot length of three frames. The sixth and seventh dots denote a two-frame and one-frame shot respectively. This saw-tooth pattern provides the basic shape around which the film is structured, but there are also several variations. In extended rows the longest shot is eight frames, for example, and in other passages the sequence progresses from one-frame shots through to eight-frame shots and then begins again with a one-frame shot. Each of the variations in the film's rows is also mirrored.

Despite using the term 'shot' to help describe the structure of the film, none of the series of frames in *Bäume im Herbst* really constitute a shot. As the whole film was made by shooting single frames, with a handheld camera, no two frames of the film represent an interval that matches continuous shooting; and slight shifts in framing from one frame to the next mean that no two images in the film represent exactly the same perspective. The structure of *Bäume im Herbst* is a highly formal one, but like many of Kren's films it also problematizes the language, pertaining to film form, that one draws on to describe it.

Occasionally the film shows close-ups of tree trunks and branches with the odd crow or pigeon perching amongst them. Largely, the imagery in the film consists of crowning treetops, shot from a camera pointing upwards from far below. All of the trees in the film are deciduous, and were shot in and around Vienna. Some trees are still fairly full of leaves; some cling on to dispersed leaves; others have a few lugubrious hangers-on; but most are bereft of leaves, leaving a spidery scrawl splayed out against the sky. In a few instances a low sun can be glimpsed through branches, and there are passages in which the trees against the sky, in silhouette, make for a high contrast image. For the most part, the muted and supressed tonal range reflects a sky that is grey and overcast. The fact that the

film is in black and white, or rather shades of grey, makes for a tenor that is more wintry than autumnal. *Bäume im Herbst* has a heavy air that resonates with some of Kren's other films, including *20/68 Schatzi* and *5/62 Fenstergucker, Abfall etc.*, which engage more or less explicitly with recriminations in post-war Austrian culture. In *Schatzi* an indistinct grey image is slowly resolved to reveal a photograph of a Nazi officer surveying a mass open grave. In *Fenstergucker, Abfall etc.* the mostly elderly people, peering from their windows onto the street, are cast as unsympathetic onlookers.

In contrast to the tone of the film, which could be described as sombre, its graphic impact is startling. The combination of the handheld camera and shooting pattern, which is unsettled by definition, makes for a charged and chaotic dynamism, and gives the impression that the film was shot in stormy weather conditions. Treetops shake, branches dip and tremble, limp leaves flutter and the fronds of willow trees wave as if buffeted by the wind. The movement is illusory however, conjured by the method of handheld single-frame shooting. Similar to the animation technique of pixilation, the effect is a form of filmic movement – a peculiarity of the method of shooting rather than a continuous record of natural motion. The movement of the leaves is especially animated, and poetic: still images of inert matter are brought to life, or rather back to life. The blustery winds that the impression of movement suggests are also evoked by the timbre of the film's soundtrack, which sounds like wind battering a microphone. In fact, the sound was produced by drawing in ink along the length of the filmstrip in the soundtrack area. (The inverse method, of scratching into the filmstock, was used to produce the soundtrack for *Versuch mit synthetischem (Ton)*). Formally, there is an intriguing counterpoint here, in that the soundtrack is the product of a continuous stripe that runs along the filmstrip, whereas the film frames are modular cells.

The systematic, modular nature of Kren's work is often aligned with other Austrian formal filmmakers, notably Peter Kubelka, whose approach to filmmaking in turn evokes the methods of the Viennese serialist composers of the early twentieth century. In different ways, the compositions of Hauer, Schoenberg, Webern and Berg were based on the distribution of the 12 semi-tones of the chromatic scale in distinct patterns based on specified rows and their variations. Kren's approach to filmmaking could be seen as akin to these abstract principles of musical composition, given the rows of frames that the score of his film describes. (Eisenstein's account of 'metric montage' as a method that involves counting frames also chimes with Kren's approach.) But *Bäume im Herbst* is fundamentally a documentary film, rather than an abstract film, that aspires to visual music. The form of the film is not an end in itself, but a means of delimiting the representation of its subject. In contrast, the films of Peter Kubelka – especially *Arnulf Rainer* (1960), which only comprises black-and-white frames and white noise or silence – are far closer to the form and nature of serial music in its near-total internal consistency.

The element of improvisation in *Bäume im Herbst* is another factor that distinguishes it from Kubelka's films and the lineage of serial composition. Viewing the separate images in the film, frame-by-frame, the trees often look as if they were framed quickly and

3/60 Bäume im Herbst

informally: sometimes they are off-kilter and only more or less in focus. In this respect, the imagery of *Bäume im Herbst*, which looks as if it was shot in an improvised manner, operates in counterpoint to the film's mathematical score. Distinct from a tradition of abstract graphic cinema, epitomized by Kubelka's concrete films, Kren's handheld camera represents a mode of looking that is intuitive and highly subjective. In many ways *Bäume im Herbst* has a highly structured lyric form. The central tension of this film's form turns on the relationship between its systematic strategy and an immanent contingency.

One way of considering this tension is via another set of strategies from the field of avant-garde music, specifically in relation to John Cage's distinction between chance and indeterminacy. For Cage, chance procedures, involving the roll of a dice say, offered a

means by which a new form of music might be notated. In *Music of Changes* (1951), for example, Cage used chance procedures to produce very precise notations corresponding to pitch, duration, dynamics, density and tempi. In other works Cage was equally devoted to compositional strategies that would provide a greater capacity for interpretation, allowing for a music that would be 'indeterminate with regard to its performance'. In contrast to the performance of a piece of music, there is nothing indeterminate about how a film is projected. Certain examples of expanded cinema where performance is involved are exceptions that prove the rule; for the most part the apparatus of film projection is a fixed affair. At the same time, no two screenings of any film ever reproduce the same experience. And this is especially the case with *Bäume im Herbst*, which could perhaps be characterized as indeterminate with regard to its perception. The viewer can't possibly hope to take the whole film in, and the complex pattern of the film can't be unravelled without consulting the score. As in the composition of music, chance procedures can also be used to structure film. *Bäume im Herbst* isn't strictly the product of chance procedures – so much of the action of filming, such as when to press the shutter release, and how to frame, was seemingly left to improvisation in the moment – but the score for the film proposes the application of a predetermined and arbitrary structure.

The arbitrary nature of the film's structure might best be appreciated if one considers the strategies involved in Chris Welsby's landscape films, in which there is usually a direct correspondence between the method of shooting and the meteorological conditions that influence the landscape features that the films depict. In works such as *Wind Vane* (1972) and *Tree* (1974), the direction and velocity of the wind affects the motion of the camera and the nature of what it records. In this regard Welsby's films actually evoke Cage's oft-cited intention of 'imitating nature in her manner of operation'. In contrast, the ostensible subject of *Bäume im Herbst* and the film's structure are alien and unrelated to one another.

The comparison of strategies employed in the composition of music and film is illuminating, in pointing to ideas and aesthetics that cut across practices and mediums. However, analogies also serve to highlight differences. The notation of music is geared towards its experience in future performances and something analogous could be said of film – i.e. the structure of a film is geared towards its reception on projection – but filmmaking, *Bäume im Herbst* included, usually also points in another direction. Graphic cinema apart, filmmaking in general, points to the past and the world at which the camera was directed at the moment of shooting.

In Malcolm Le Grice's essay on Kurt Kren, originally published in 1975 and reprinted in this volume, *Bäume im Herbst* is classified, in very specific terms, as the first 'structural' or 'structuralist' film. Drawing on an essay by Roland Barthes, Le Grice suggests that 'structuralist art can be thought of as the material formation of experience through the explicit incursion into the thing (event) observed by the mode of observation'. And from Claude Lévi-Strauss, Le Grice borrows the term 'homology' to explain the relationship between the act of filming *Bäume im Herbst*, frame by frame, and the experience of the separate shots of the film in projection. In sharing the same relation, or relative structure,

he sees the events of filming and projection as 'homologous'. Given that the film was edited in-camera, the film constitutes, to coin a phrase, a 'record of its own making'. Following from Le Grice's account of Kren's films, *Bäume im Herbst* became one of a number of key works around which the theoretical aims of 'structural/materialist film' were developed.

In Peter Gidal's defining essays, structure and materiality are touchstones, but the viewer's capacity for identification is also an issue. On one hand the structural/materialist film (or 'film-as-film') aspired to exist as a new object of perception, on par with the modernist artwork, but the ideological imperative that sought to counter meaning, and keep identification at bay, necessitated structures that would be difficult to decipher. Kren's *Bäume im Herbst* involves several aspects that resist identification. One aspect is the impossibility of keeping up with or comprehending the complex variations, extensions, contractions and inversions in the structure of the film. One's conceptual grasp of the film, even one's impression of the film, lags behind the direct experience. Another aspect that resists identification is the relationship between the structure of the film and its filmed subject. Though there is an equivalence, or a 'homology', between aspects of the film's shooting and projection, the structure of the film makes no appeal to the pro-filmic, by way of analogy to systems in nature say, as in the films of Chris Welsby. Hence the qualification of *Bäume im Herbst* as a structural/materialist film avant la lettre. But *Bäume im Herbst* can also be read against the grain of materialist film theory. In its presentation of a series of fleeting images, each of which offers only a momentary grasp of nature, and in so far as the form of the film hinges on a relationship between an arbitrary structure and intuition, *Bäume im Herbst* invokes a way of thinking about the world as indeterminable and contingent. Despite resisting identification and interpretation, the film manifests a philosophical position regarding our knowledge of the external world.

3/60 Bäume im Herbst

3/60 Trees in Autumn (1960, 5:03 min, b/w)

Gareth Polmeer

Trees in Autumn is remarkable for its subtle complexity. Over the course of the film a series of shots of trees are juxtaposed in a rapid succession of movements. Drawn against the sky, there is melancholy in the branches. Made bare by the autumn winds, they produce a latticework that constantly shifts within the frame. In the movements of the image of a tree, the 'here' and 'now' are displaced in the variability of natural phenomena. This essay is an interpretation of the film in relation to select ideas of motion and place in G.W.F. Hegel's writing, mainly in the preliminary considerations given to 'sense-certainty' and immediacy in the *Phenomenology of Spirit*. The quasi-Hegelian themes in Kren's films are interesting not because they are illustrative, but because they illuminate the role of nature and the role of the senses – the sensuous – in relation to questions of knowledge.

The recurrence and focus of *Trees in Autumn* echoes Hegel's description of consciousness, towards 'the immanent content of the thing … immersed in the material, and advancing with its movement' (1977: 32). Kren's film is not a representation of consciousness, but the images and processes in it are a catalyst to self-reflection, in the Hegelian sense that 'consciousness is, on the one hand, consciousness of the object, and on the other, consciousness of itself' (1977: 54). This corresponds in the film to the relationships between material nature, recording, representation, projection and experience. The systems of images draw nature into the forms and rhythms of film, bringing about a dialectical movement between seeing and thinking the image-in-time.

The film brings attention to the relation between image and referent: of what is seen 'now' in 'this' image 'here'. These ideas are brought into the connections of nature, space and time, and the means of defining the particularity of 'a' tree, despite the film's intense focus. Such problems do not refute the existence of trees (or general claims to meaning) but show particularity in difference, moving between the perceptual ambiguities of 'this' tree 'here' and 'now'. This seems particularly evident in a film that moves indistinguishably through rapid juxtapositions of the same and/or different trees. Hegel writes of 'sense-certainty' that:

The 'Now', and pointing out the 'Now', are thus so constituted that neither the one nor the other is something immediate and simple, but a movement which contains various moments … The *Here pointed out*, to which I hold fast, is similarly a *this* Here which, in fact, is *not* this Here, but a Before and Behind, an Above and Below, a Right

and Left. The Above is itself similarly this manifold otherness of above, below, etc. The Here, which was supposed to have been pointed out, vanishes in other Heres, but these likewise vanish. What is pointed out, held fast, and abides, is a *negative* This, which *is* negative only when the Heres are taken as they should be, but, in being so taken, they supersede themselves; what abides is a simple complex of many Heres. The Here that is *meant* would be the point; but it *is* not: on the contrary, when it is pointed out as something that *is,* the pointing-out shows itself to be not an immediate knowing [of the point], but a movement from the Here that is *meant* through many Heres into the universal Here which is a simple plurality of Heres, just as the day is a simple plurality of Nows.

(1977: 63–64, original emphasis)

These words call to mind the displacements and shifts in *Trees in Autumn*, reflecting how objects relate with what is excluded in representing them: in this case how a single tree relates to multiple others; of how 'here' and 'now' become a moment past. This dynamic is mirrored rhythmically in the impression of moving trees that are also static, as single frames flittering through the shutter – foregrounding the dichotomy in all film projection. The trees dance in the frame through a rapid montage. The motion exists between photograms, between shots and between the branch edges stencilled by the frame's 1.37:1 ratio as the camera moves. At moments the film is fluid, with the hand-held camera movements and the objective rectangle of the frame/screen in constant interplay. It is unclear whether the rapid sequence of shots is made of repetitions or variations, and this remains largely indeterminate in the serializations that carry the work forwards. The film's shots are isomorphic with the mechanical rhythm of the projector gate, but it is as if frames occasionally jam and judder. This adds to something like a slippage between shots, at times appearing systematic, at others arbitrary. Sometimes the effect is a smooth transition, as the free forms of branches complement each other figuratively, at other times there are jolts as the juxtapositions clash.

In working through questions of nature and structure, Kren's film echoes concerns in the work of Viking Eggeling, who stated that 'what should be grasped and given form are things in flux' (Richter 1971: 113). Correspondingly, a title at the beginning of Eggeling's *Diagonal Symphony* (1924) announces that the film is 'an experiment to discover the basic principles of the organization of time intervals in the film medium'. The reference to intervals also appears in the writing of Dziga Vertov, whose approach to montage might be compared with Kren's. Vertov wrote of his films in 1922 that '*Intervals* (the transitions from one movement to another) are the material, the elements of the art of movement, and by no means the movements themselves' (1985: 8). Hegel writes in his *Science of Logic* that:

External sensuous motion itself is contradiction's immediate existence. Something moves, not because at one moment it is here and at another there, but because at one and the same moment it is here and not here, because in this 'here', it at once is and is not … motion is *existent* contradiction itself.

(1969: 440, original emphasis)

What filmmakers such as Eggeling, Vertov and Kren have all variously explored seems to echo in this 'at once is and is not': the contradictions of motion referenced both by the interval and simultaneity, of both stasis and flow. In this way Kren's film also develops around intervals such as the shifts between stuttered images, the similarities/dissimilarities between trees and shape, and the spatial and temporal breaks.

There is music to the movements of branches. Working in Vienna, Kren's films and system-based approach, as well as that of his contemporary Peter Kubelka – with the film *Arnulf Rainer* (1960) – have drawn various comparisons to the serial systems of the Second Viennese School of composers Arnold Schoenberg, Alban Berg and Anton Webern. Although Kren had a diagrammatic plan for *Trees in Autumn*, which has something of a metric structure, the movement of branches seems irregular and causes counter-rhythms. The graphic scores for some of Kren's films resemble musical notation, and the numbered composition, like Kubelka's, resemble elements of serialism. This seemingly rigid and measured process embraces the technical logic of the apparatus, but what emerges is far from definite or calculated. The formal composition is exceeded in its visualization, and the contingencies create variable experiences in multiple viewings. In Hegel's terms of 'measure' and 'alteration' – with musical notes given as an example in the *Logic* – such an event in *Trees in Autumn* might be termed the movement of quantity into quality, and vice versa (1975: 160).

The framing ranges from wide shot to close-up, and the movements along branches by the camera wander towards the frame's edge, towards off-screen space, with the shadows and light extended beyond the edges of the projection in the room. These images have a musicality that could be said to shift pictorially in harmonies and disharmonies. The sequence of shots and frames moves in a binding flow, but the quick movements continually appear to break. The film moves across these fissures, shifting the tree from the image. This is a continuation of the graphic planning, of the musicality and fluidity that moves between the numbers and grids, of the dialectic of stillness and movement in cinema.

As film progresses through the projector mechanism, an optical track, a few millimetres wide and running alongside the images, has a variable area of transparency that would ordinarily change in width according to the frequency and volume of the sound. Light from an exciter lamp, shining through this transparent area, is picked up by a sensor and sent as a variable voltage to an amplifier. In *Trees in Autumn* a drawn line, rather than an audio waveform, creates the soundtrack. Pops, crackles and other sounds become

associated with the occasional flickering film grain and the movements of trees, creating tangible relations between the pro-filmic and projection events.

The film's hand-held footage is also like an inscription, but with light: at times a scribbling, jittering motion. The single-frame patterns of recording sometimes imply a continuous short burst of recording with a juddered hand/arm movement. In this way, and with those aspects discussed above, Kren sets into play a subtle layer of material connections in this film; the apparent repetitions become something more. No one place, no one tree or landscape seems to be defined, but is instead left open; thus, in the initial considerations of sense and space, as Hegel wrote, 'we see that the Now is just this: to be no more just when it is' (1977: 63). In Kren's film, this is not an endless relativity, but a way to the particularity of things through their juxtapositions and contexts.

References

Hegel, G.W.F., 1969. *Hegel's Science of Logic* (trans. A.V. Miller). Amherst, NY: Humanity Books.

Hegel, G.W.F., 1975. *Hegel's Logic* (trans. W. Wallace). Oxford: Oxford University Press.

Hegel, G.W.F., 1977. *Hegel's Phenomenology of Spirit* (trans. A.V. Miller). Oxford: Oxford University Press.

Richter, H., 1971. *Hans Richter*. New York: Holt, Rinehart & Winston.

Vertov, D., 1985. *Kino Eye: The Writings of Dziga Vertov.* ed. A. Michelson (trans. K. O'Brien). London: Pluto Press.

Time Splits: *4/61 Mauern pos.-neg. & Weg* and *31/75 Asyl*

4/61 Walls pos.-neg. and Way (1961, 6:09 min, b/w, silent)

31/75 Asylum (1975, 8:26 min, colour, silent)

Aline Helmke

movie in a traditional sense creates an illusion of temporal space. The viewer is usually unaware of the film's materiality and the mechanisms of the apparatus behind it. However, the illusion is sustained only as long as the audience is not distracted from diving into the world of action and movement. Kren's films, on the contrary, force the spectator into a radically different viewing experience. They deconstruct and thus destroy the illusion of continuous time and space. Individual film frames refrain from building up as continuous movement, and neither does filmic space suggest a narrative.

I will discuss two of Kren's films, separated by 14 years, but in my view related to each other: *4/61 Mauern pos.-neg. & Weg* and *31/75 Asyl*. Like most of his films, *Mauern* and *Asyl* are based on a score written prior to shooting. These will be reviewed along with the films in order to fully reveal his 'formal' approach to filmmaking. It will show that over the years, Kren developed a complex spectrum of conceptions of, and approaches to, the same issue: how to treat the photographic film frame with respect to constellations of filmic time and space that uncover the specific qualities of the medium.

4/61 Mauern pos.-neg. & Weg is the last in a series of three early films shot frame by frame. (The first being *2/60 48 Köpfe aus dem Szondi-Test* and the second *3/61 Bäume im Herbst*.) Usually, this method is applied to make inanimate material appear to move on its own, as in animation. Rather than creating the illusion of natural movement, Kren treats the film stock as a string of photographs, thus establishing a tension between the still and moving image: on the one hand, each frame is an individual photographic image, with a certain duration; however, once projected, the photographic frames behave like film frames in the sense that 24 frames per second pass before the spectator.

The whole film is based on what Kren referred to as a *Kaderplan* (Kader = single frame), a precise score drawn on graph paper prior to shooting. It depicts a figuration of a staggered rising and falling graph in eight rows. This suggests a metric, rhythmical pulsation. Comparing the score with the actual film, it becomes clear that the whole film consists of black-and-white still images with a duration ranging from one to eight frames. Each still or theme is defined by numbers or the word *Weg* (path) and indicates its place and duration in the composition (see Colour Plate 12).

There are two types of shots. Predominant are close-ups derived from positive and negative slides. They show a range of 60 details of decaying walls, presumably filmed frame by frame in a studio on a stand or a rostrum. The second type is a panorama view,

the one named *Weg* in the notation. It is a park-like environment with paths leading through it. Following the score, Kren effectively edited 'in-camera', though 'editing' in this context describes a process of combining frames rather than a method that aims at creating an illusory flow of action.

The close-ups are taken in short intervals ranging from one up to eight frames as stated above. In a metric rhythm, they constantly switch from a positive motif to its negative and vice versa, then to the next positive-negative pair and so forth with increasing and then declining frame duration. The first positive-negative pair, for example, is built up on the following system (where '+' indicates a positive image, '-' indicates a negative image, and the numeral refers to the number of frames):

+1/-1; +2/-1; +3/-1; +4/-1; +5/-1; +6/-1; +7/-1;
+8/-1;
+7/-1; +6/-1; +5/-1; +4/-1; +3/-1; +2/-1; +1/-1.

As the projected image decreases in duration, it becomes increasingly invisible. The rapid alternation of light and dark creates a strobe effect, which has a strong and perhaps even irritating impact on the viewer. This turns out to be a rather unsatisfying experience even for an audience that is familiar with watching experimental films. Not only is the film at variance with the usual habit of watching a continuous stream of moving imagery, it also impedes any attempt to contemplate the subject. Nor does it enable the viewer to comprehend the underlying metric structure. The pace of the alternations is too fast to analyse, and there is no underlining or supporting soundtrack to make its rhythmical arrangement appear more distinct. The fierce staccato of images leaves the viewer with nothing to hold on to. Without the possibility of reading the structure of the film, to make it more comprehensible, and without being able to read meaning 'into' the film, the viewer is left with the pure visual impact. The eye is attacked by the flickering stills of unequal duration, so that irregularity becomes the dominating visual impression. This puts the viewer in a state of disorientation.

The close-up shots are infrequently interrupted by the panorama view. Akin to the close-ups, this shot is also photographed frame by frame. Unlike the photographs of the wall, these frames are taken from a single point of view. In addition, the passing of time is perceivable: the sequence is a time-lapse. The camera captures people moving along the paths, the change of light and the trees' moving shadows, all of which are sped up.

Compared to the ongoing flicker of the close-ups, the time-lapse sequences are more relaxing to watch. Eventually, the eye is able to connect the individual images and fuse them into a moving image sequence. Although movements still do not appear natural, it feels like a relief for the eye and mind when the 'phi phenomenon' produces the illusion of a coherent course of motion. This way of watching a film sequence is more familiar and closer to the common experience of watching a movie.

The positive-negative shots of the wall, however, refuse to merge into one another. No matter how hard the spectator consciously tries to see similarity in the form, to smooth out the difference, the separate images retain their distinctiveness. Watching the close-ups means dealing with a paradox: the respective positive and negative images can be indicated as a pair by the similar shapes depicted, which means they are identified as belonging together but those shapes simultaneously act as antagonists regarding the distribution of light and dark planes within the frame.

There is no way to read progression or succession into the image. A rapid change of light and dark planes is perceivable, so indeed there is something going on, but can it be described as movement? Movement implies an object's change of position within a space. To create the filmic illusion of movement on a screen, an object has to carry out a gradual change of position within a number of frames, or vice versa, a constant flow of motion has to be cut down into a number of frames. Once projected, such frames will blur into a moving image sequence. The images in *Mauern*, however, are static shapes that flicker. The phenomena of duration, pulsation, contrast and alternation are perceivable, but not locomotion or progression. Surprisingly, as soon as the eye is drawn into the flicker, one's attention begins to be directed towards aspects regarding the formal qualities of the motif. The opposing pairs of positive and negative forms start to melt into one another at their intersections – exactly in-between the positive and the negative. The impression generated on the retina is a relief-like, three-dimensional structure.

A further antagonistic relation in the film is that between the close-ups and the wide shot. The details of the wall appear as abstract forms, yet they remain legible and reveal the material qualities of old bricks and plaster. In contrast, the wide shot, which appears five times throughout the film, shows scenery such as hills, paths and trees. Particularly at the beginning of the film, it offers a viewing experience that is opposed to watching the close-up shots, enforced by the contrasting method of filming as stated above. The way the wide shot is perceived gradually changes whilst it is repeatedly shown. This is a surprising effect that can only be seen in relation to the irritation and disorientation of the eye that is affected by the close-ups. The first time the wide shot of the park appears, it is clearly distinguishable from the close-up shots and thus acts as an antagonist. However, every time we see the wide shot again, it gradually appears to converge with the close-ups. With every repetition of the wide shot, the park tends to be interpreted in favour of the abstract formation of lines and planes; and vice versa: the close-up shots of the decaying walls develop a potential to be associated with surfaces of a wide shot, or an extreme wide shot even, because the surface of the wall comes to look like the surface of the moon. This may be an effect that is caused and amplified by the repetition of the wide shot, but is also due to the fact that the wide shots decrease in length throughout the film and that the trees' shadows increasingly darken the whole scene, making it appear less distinct.

In the projection event, the sequential arrangement of images creates an awareness of film-time by the fact that the eye is disabled from generating an illusion of natural motion. The failing attempt to perceive motion coupled with the impossibility of

diving into an action, or scene, forces the spectators into a radically different manner of watching a film, to make them become self-aware in regard to the cognitive process of motion perception. In this sense, the film is self-referential and purely 'filmic'. With his recording method, Kren releases the frames into their being as single-frame entities. They do not blur into a moving image but remain self-contained. However, rather than being perceived as a projection of stills in a row, the film's contrasts, structures and motifs continuously build connections and create perceptual effects. This leads to an uncommon, challenging viewing experience, bringing to mind the formal qualities of the medium and revealing the antagonism between the still and moving image, the close-up and wide shot, representational and abstract form.

According to the numerical classification that Kurt Kren used for his films, *31/75 Asyl* was shot 14 years and 27 films after *4/61 Mauern pos.-neg. & Weg*. Meanwhile, Kren developed a wide range of approaches and strategies in how to capture and structure film-time, which included exploring and inventing various ways of running the film stock through a 16mm camera in order to expose it to light.

The films *4/61 Mauern pos.-neg. & Weg* and *31/75 Asyl* both deal with natural environments. Both films are silent, based on a graphic score and edited in-camera. These aspects aside, *Asyl* demonstrates a very different approach to treating the film stock in the camera in order to make film-time visible, with Kren modifying his practice of in-camera editing. Here, the montage does not combine various shots or frames in a row. In fact, the 'editing' is done *within* the frame. The film was shot over 21 days, but each frame contains a reference to each of these days simultaneously, whether visibly or not.

The scene that appears in *Asyl* is a view onto fields, a fence and a path shot from a higher position (perhaps a window on the second floor or from a tall farmhouse). The film starts with a black frame and a quick fade-in of two dots – little peep holes in the upper part of the frame showing tree branches and the sky behind. After a few seconds, two more holes pop up at the bottom of the image, then more start to appear, distributed all over the frame so that soon the black parts of the frame fill with visible objects. Later on, the holes partly overlap so that depicted details appear as part-superimpositions. Several times, the screen is entirely exposed, revealing the whole scene, only then to be erased by black holes or replaced, or superimposed, by another cut-out. The whole scene constantly shifts while details appear and disappear. The visible sections have a blurry outline, and together with their quick fade-in, over three frames, the points of time tend to pop into the frame like raindrops, together building a mosaic of time shifts.

Asyl was shot during a change in season, presumably spring. This is detectable in the film, as nature and weather conditions are in constant flux. Kren's decision to shoot on colour film underlines this aspect, as it emphasizes the changes of light and colour. The details of the scene first appear while covered with snow, during sunshine or cloudiness. The ground and the trees are either bald or covered with snow or grass. These indications of a change in season are distinct and happen concurrently with the time shifts within the

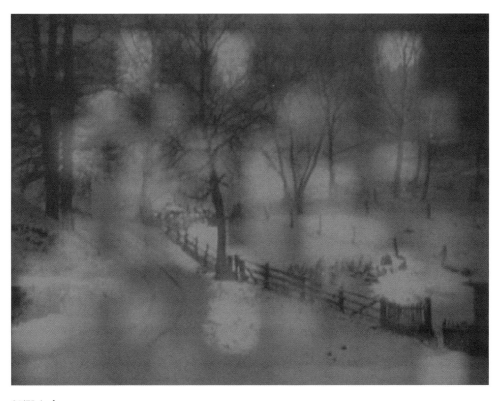

31/75 Asyl

frame. Thus, an inherently unspectacular view from a window turns into a sight where the spectator becomes consciously aware of the depicted time span.

The entire film is shot from a single point of view; hence, it is tempting to say that it consists of one shot. This is true regarding the depiction of the scene, but the shot itself consists of more than one take, and is made up of several layers of time. According to his own description, Kren shot the film within a period of 21 days, by exposing and rewinding the film inside the camera over and over.

> The film was shot over 21 days. Every day it went through the camera once. In front of the camera, a black mask with five holes was positioned, through which the light went through and would expose the film. The arrangement of the holes was changed every day. Within 21 days, the holes would all together release an entire image.[1]

(Scheugl 1996: 180f)

Kren's strategy of shooting is determined by repetition and the use of a matte technique: as described above, on each day of filming, a different matte with a certain arrangement of holes was fixed in front of the camera lens. This allowed only a part of the film to be exposed to light. Kren didn't shoot the film frame by frame but at the usual speed of 24 frames per second. After shooting, the film was wound back through the camera, then on the next day of shooting exposed and rewound again and so forth.

The arrangement of the holes follows an exact plan outlined in two variations and drawn onto graph paper. In the second and presumably final version of the score, the 21 days of filming are represented in 21 layered bars distinguished by different colours, which together build the superimpositions on the filmstrip (see Colour Plate 15). The first version is composed of only seven layers (see Colour Plate 14). This might indicate that Kren initially aimed at filming over seven days or weeks. The 21 layers in the second version consist of seven differently coloured sections – each colour section building a separate block of layers – which suggests that there is a link between the seven layers in the first version of the score and the seven equal-coloured bars in the second version. It is hard to determine the exact time span during which the film was shot. Gabriele Jutz and Sigrid Sprund state that Kren shot *31/75 Asyl* in 21 *consecutive* days (Jutz 1996: 102–109; Sprund 2006: 158–168). This might be the case, but it is not necessarily so. The score is open to different interpretations. Kren himself simply mentions that he shot *Asyl* in 21 days. Taking the first with the second versions of the score together, if the bars of the same colour are read as consecutive days of filming, and the blocks themselves as shooting days within a week, *31/75 Asyl* might well have been shot over the course of seven weeks (plus one day, as the violet-coloured bars consist of eight rows), with an increasing amount of shooting days per week. The dramatic change in weather might also suggest that the film was shot over a period longer than 21 consecutive days.

In both versions of the score, the timeline, on the y axis, is split into 90 units, each unit representing one metre of film stock. Kren shot the film at the speed of 24fps and referred to the footage counter of his 16mm Pathé camera in order to translate his score into a film.

The scheme of running the film through the camera while exposing it to light (or holding it from being exposed) follows a repetitive structure in shifts: each section of layers has an individual starting point, signifying the days on which filming took place. The first three sections consist of one layer each, the first one starting at the very beginning of the film. The second section begins after the first unit (the first metre of film), the third after the second metre. The fourth section consists of two layers and is shifted two units along from the beginning of its predecessor, so that it begins after four units in total. The fifth section consisting of three layers is shifted three units from the beginning of its predecessor and so forth. The fact that the layers are shifted signals the starting point of the film's exposure in metres. In addition, the gaps between the differently coloured sections could indicate the number of days that were left between a day of filming and the next.

A proportional structure that arises between the layers is also detectable within the different lengths of exposure throughout a day of filming. The first layer begins with

21 units of exposure, corresponding to the total number of days on which filming took place. This is followed by a gap of seven units, where the film is run through the camera without being exposed to light. The second length consists of 13 units of exposed film. The sum of the second length and the gap before it adds up to 20, which is one unit less than the previous unit of exposed film. This pattern is repeated down to one unit of exposed film, which marks the end of the day's filming. There are parts in the timeline where all layers are lying upon each other without gaps, indicating the moments when all masks are superimposed on the same part of the film and the multiple exposures add up to reveal the whole shot. Remarkably, the relations of the time spans altogether build a system of balance and harmony in a traditional sense: units of filming and the gaps are built on the Fibonacci sequence 1, 2, 3, 5, 8, 13 and 21. The same applies to the coloured blocks consisting of 1, 2, 3, 5 and 8 layers.

The score illustrates Kren's distinct method of working with the film stock and the camera, in view of their particular functions and potentials, held together by a system relating to a certain mathematical logic and harmony, which is translated from the visual level of the score to the film's temporal level. Kren takes advantage of the film stock's characteristic that it can be exposed to light repeatedly, supported by a feature of the camera that enables the film to be rewound. Traces of different moments can be captured in succession, but appear simultaneously when projected.

Usually, a film takes place in the here and now when it is screened, and suggests a continuity of time and space. However in *Asyl*, through the technique of multiple exposures, the continuity of time within a frame is replaced by a frame that contains several moments at once. This results in a dichotomy. In contrast to the duration of the film, which can be imagined as a point (the 'here and now' projected image) shifting along a timeline, it becomes evident that different moments in time are visible through the multiplicity of assembled time-fragments. Thus, the point shifting along the timeline itself is made up of several other points on different timelines. The correlation of different points in time is confused, producing a unique viewing experience, which calls attention to both film-time and the time span filmed.

Remarkably, both scores and the film itself anticipate the way digital surfaces and interfaces are designed: the scores for *Asyl* visualize the layered bars arranged in a timeline in the same way that editing or image-processing software depicts the digital electronic stream of film data as a visual entity. In addition, the fact that the film is built up on multiple segments that together reveal the entire scene brings to mind a correlation with the pixels of a digital image (even though the filmed fragments contain much more visual information than pixels do, which only comprehend a single piece of information).

In *Asyl*, Kren's approach to capturing time depends on a fundamentally different concept to that of *Mauern*. The overall pace of the film is much slower than in Kren's earlier film. Here, the score's basic unit is a metre of film footage, instead of a frame, which means about five seconds of projected 16mm film, whereas the longest duration of a projected motif in *Mauern* never exceeds eight frames, equating one-third of a second.

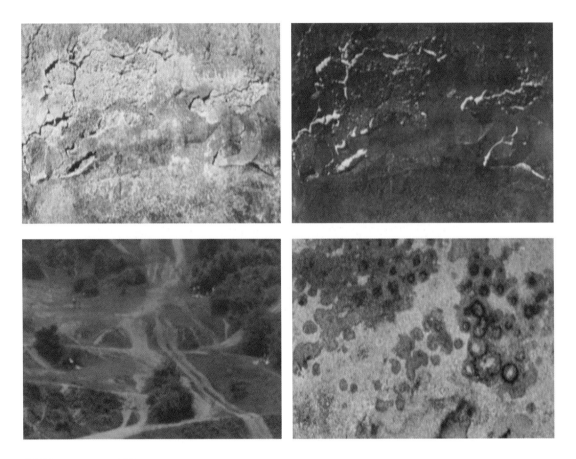

4/61 Mauern pos.-neg. & Weg

Asyl is shot at 24fps, so that the occurrences on the screen happen in 'real-time' when projected. Although the film is built up of fragments, which consist of gaps both within the frame and along the timeline, it gives the impression of an incomplete jigsaw puzzle, in the sense that one can always imagine the context of the entire scene. With *Asyl*, rather than creating a moving image, Kren sets the view itself in motion. Within the frame of a static scene, the eye shifts in and out of, and between, the appearing and disappearing zones of visible entities.

The underlying structure upon which the film is based cannot be deduced without the reference of the corresponding diagram. Even with the aid of a digital source, which allows a frame-by-frame analysis at any point in the timeline, it is impossible to figure out the score. The explanation is simple. The score of the film is inevitably translated

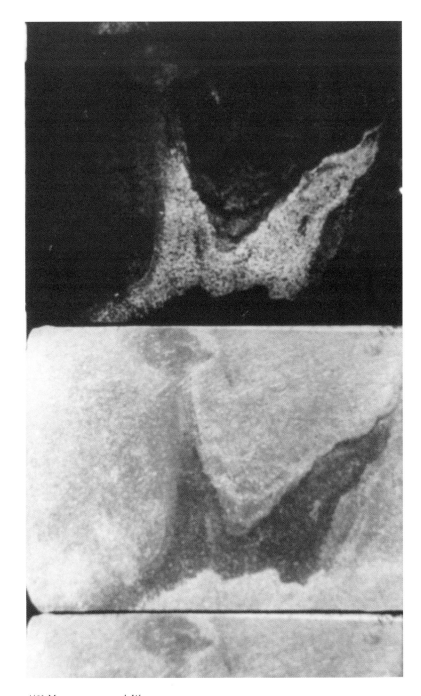

4/61 Mauern pos.-neg. & Weg

more loosely when shooting with reference to the footage counter than by using a frame-by-frame method of shooting. The handling here doesn't solely depend on the technical mechanisms of the camera but additionally on the filmmaker's response time to what he sees on the footage counter. Therefore, it is no surprise that there are inaccuracies when comparing the layers of the score with the actual superimpositions in the film. Counting the actual frames shows that the film units are not equal in length, causing shifts to the superimpositions that, following the score, should appear in synch.

Compared to the black-and-white imagery of *Mauern*, the visible segments that occur in 'real-time' within one frame, together with the fact that the film is shot in colour, give *Asyl* a more natural appearance. Moreover, the loose translation of the score makes the rhythm of the emerging and vanishing visible fragments appear more organic. The subtle differences of the colours in *Asyl* enable the viewer to distinguish the alterations caused by the different weather conditions. Counteracting this, but also revealing an aspect of Kren's working method, the end of each 30m roll of film is indicated by a characteristic strong red colour cast, bringing into mind the medium's material as such. *Mauern*, however, gains a distinct quality from the abstraction caused by the lack of colour: presumably the close-ups and wide shots wouldn't combine as much – to a state of structural visual unity – if Kren had used colour film.

The films discussed here embody only two of the various approaches in Kren's oeuvre. Nevertheless, through their different approaches to filming, they give an idea of the span that Kren's work comprises. It is especially the potential of the film frame that he scrutinizes, be it a single unit, a positive or a negative image, black-and-white footage or colour, a string of photographs or a stream of images composed of multi-temporal fragments. *Mauern* and *Asyl* can be seen as events that, rather than functioning as moving images, envision (filmic) time and bring to mind the premises of perceiving motion. Kren replaces the method of creating 'moving pictures' by formal strategies that are concerned with investigating and challenging components that are fundamental to the medium of film, notably the film stock and the camera. With every film, Kren presents a new and self-contained strategy of filmmaking, by way of an entirely coherent system, which is often developed with the aid of a score. From my perspective as a filmmaker, it is particularly interesting to see Kren's films in conjunction with his *Kaderplans*. A tension persists between the two aesthetic forms, the abstract diagram's two-dimensional entity and the respective film. As could be shown with *Mauern*, the intervals of the score suggest a measured, regular structure but lead to an outcome that has an unsettling effect. The fact that the content of each frame is predetermined doesn't necessarily lead to the predictability of the film's appearance and impression, and vice versa: in the projection event the underlying formula can be sensed, rather than viewed; and by no means can it be instantly deduced.

It is not surprising that the translation from one medium to another, namely from a two-dimensional drawing to the time-based media of film, involves a shift of emphasis. Where a conventional storyboard is designed to evoke the film's visual nature as clearly

as possible through depicting the type of shot (including any camera movement) as well as the filmed subject, Kren's *Kaderplans* are abstract graphs, which solely concentrate on the film's structure. The filmed subject generally isn't depicted, despite the fact that the subjects that Kren shoots are key to the films' effects. In contrast to Peter Kubelka's metric film *Arnulf Rainer* (1960), Kren's films are never purely abstract but always refer to things, individuals, nature or the space that surrounded him. Content is an important element through which the visible is established.

The gap between a formal concept and its – to an extent – unforeseen outcome distinguishes and characterizes Kren's approach to filmmaking. The tension between the two operates as a creative stimulus, challenge and motivation. Even when he could estimate the outcome of certain filmic structures, he retained this approach through inventing new strategies of filming. In Kren's own words: 'With all films I make – the adventure is that I never know what the outcome will be' (Scheugl 1996: 159–189).[2]

References

Jutz. G, 1996. *Eine Poetik der Zeit.* In: H. Scheugl, ed. *Ex Underground Kren: Seine Filme.* Vienna: PVS Verleger.

Scheugl, H., 1996. Seine Filme, eine kommentierte Filmographie. In: H. Scheugl, ed. *Ex Underground Kren: Seine Filme.* Vienna: PVS Verleger.

Sprund, S., 2006. *Kurt Kren: Ein Leben in Kadern, Kurt Kren: Das Unbehagen am Film,* ed. Thomas *Trummer,* Vienna: Atelier Augarten.

Notes

1. Original translation: *Der Film wurde an 21 Tagen gedreht. Er ging jeden Tag einmal durch die Kamera. Es war eine schwarze Maske vor der Kamera mit fünf Löchern darin, wo das Licht durchkam und den Film belichtete. Die Löcher änderten sich mit jedem Tag. Alle Löcher zusammen würden an 21 Tagen das ganze Bild freigeben.*

2. Original translation: *Das ist bei allen Filmen so, die ich gemacht habe – das Abenteuer, dass ich nie genau weiß, was kommt dabei heraus.*

Strategies in Black and White: *4/61 Mauern pos.-neg. & Weg* and *11/65 Bild Helga Philipp*

4/61 Walls pos.-neg. and Way (1961, 6:09 min, b/w, silent)

11/65 Helga Philipp Painting (1965, 2:29 min, b/w, silent)

Nicky Hamlyn

4/61 *Mauern pos.-neg. & Weg* is mainly composed of black-and-white negative transparencies, shot in close-up, of areas of a crumbling, distressed wall riddled with staining and efflorescence. These are intercut with their corresponding positives according to a strict plan in which every frame is accounted for (see Aline Helmke's essay above). The images are punctuated briefly by high angle time-lapsed views of a park, which is laced with paths along which people scurry. These five near-identical shots are interspersed, in decreasing duration, through the film.

The pixilated wall section contrasts in numerous ways with the framing and movement of people and tree shadows in *Mauern*. Both images are planar, the former perpendicular to the camera, the other undulating and rising away from it. Thus, although the outdoor scene is viewed from an angle, there's the implication that, if it were viewed perpendicularly, the result would be an image as similarly abstract as that of the wall. However, in its existing framing the indistinct, ant-like movements of people, and the enveloping flow of tree shadows, signal two kinds of abstract movement in the scene, even as it remains representational: abstraction is both implied and actual in the viewing experience. In counterbalance to the park scenes, the patterns in the surface of the walls can be read anthropomorphically, such as winking eyes, foetuses and faces etc. Here, then, an abstraction gives rise to representations, as a result of the spectator's imaginative projections. This tendency may then return us to the animated tree shadows that creep across the park, enveloping the walkers like a malign giant. There is thus a kind of circular movement, whereby anthropomorphism brings representation back from even the most abstract image.

While the viewer may consciously flip between two perceptual modes in watching the park shots – in a similar manner to the duck/rabbit illusion – in the wall sequences, this flipping is engineered by the cuts from negative to positive. (It is a time-based process structured into the film, in contrast to the park scenes where flipping takes place during shots, as opposed to between them.) The a-rhythmic switching between negative and positive prevents the development of a regular kinetic flow or flicker effect. Every flip into positive posits and re-posits representation, only to negate it in the moment of the cut to negative. It is the cuts that do all the work here, as a special form of the Vertovian interval. Whereas Vertov's interval theory proposes an animating moment in the split-second jump from one image to a different, contrasting one, here the shift is from one image to the same, except that the contrast is absolute, because the tonal values are reversed. The cuts do not so much animate as disrupt, and the effects of them last as

long, or almost as long, as a given image is on the screen, depending on the duration of that image. Thus shot and cut are in a relationship of mutual efficacy that is explicitly more or less equal.

The cuts from negative to positive, and vice versa, have different effects, depending on the distribution of light and dark in the image, and depending on the relative duration of a shot and its counterpart. In some cases an image floods its counterpart with white, obliterating it, especially when the white image is only a frame or so in length. In others, pinpoints of light appear to blink out of a field of darkness, creating a 3D effect. The degree of flicker is also affected by the tonality of the images: a mid-grey negative produces a similar positive, whereas a light negative gives a dark positive and vice versa. However, a mid-grey solarization effect is also frequently produced by the rapid flips from negative to positive and back. Towards the end of the film, Kren returns repeatedly to a strange frog-shaped stain on the wall: an image in the image, in contrast to the bas-relief of most of the shots. For once there is relative calm in a sequence dominated by disruptions that also turn on the small but pervasive shifts of shadow generated by the bas-relief, as well as on the reversal of tonality.

For *11/65 Bild Helga Philipp*, Kren filmed a black-and-white geometric abstract print, part of one of a number of 'Kinetic Objects' – multi-image wall works and sculptures – made around the same time by the Austrian artist Helga Philipp (see Draxl, 2009: 12, with partial English translation on page 233). The camera appears, most of the time, to be at an acute angle to the picture plane, and frequent cutting generates a-rhythmic patterns that shift between stasis and quasi-movement in a similar manner to those in *Mauern*. The painting is flat, and arguably is about flatness in terms of its composition, yet it does invite the viewer to look at it from an angle, insofar as one cannot but be aware of the way the diamond shapes, of which it is composed, alter in shape and proportion as one glances across the canvas. This is different from the work of Bridget Riley, whose pictures occupy broadly the same territory, but where a frontal point of view seems to be more strongly required.[1] After a few viewings of *Bild* it becomes apparent that there are sections that appear to be mirror-like, left-right framings of the same area of painting. It's tempting to think that the whole film has a palindromic structure, but closer examination shows that it does not. However, the effect of the way the film works is to invite a structural analysis that turns out to be all but impossible, unless one were to put the print on a bench and study it. This is because it is so difficult to register, let alone describe, the differences between one shot and the next, since it is mostly a question of small degrees of difference between near-identical formal patterns. But even if one could analyse the film in this way, then one would not be studying the 'film', but rather the filmstrip (and even this is no easy task as the illustration makes plain).

One might evoke here Peter Gidal's objection to what he called 'Steenbeck analysis', in which, by repeatedly watching cuts in feature films on an editing table, one was not thereby attending to the ideological effects the film produced when seen at normal speed. However, one could equally argue that such scrutiny is appropriate to this and

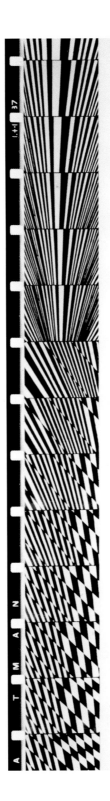
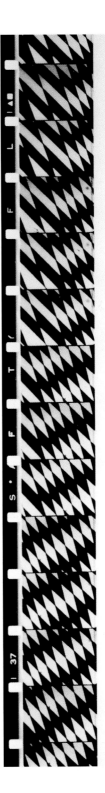

11/65 Bild Helga Philipp

other metrically structured films: there are not the ideological effects generated from 24fps illusionism in the way that there are in narrative movies; and it seems reasonable to analyse how they are composed, given that their compound structure is explicitly inscribed in the oscillation between stasis and apparent motion.

Bild is replete with effects generated by a number of factors including framing, scale, rhythm and repetition. The scale of the shots changes the way one sees the surface of the image and the degree of abstractness. This sounds absurd, because the painting is wholly abstract, but when the camera is close enough to it so that one can see surface marks and imperfections, there is a strong sense of seeing a film of something – a representation – whereas in the wider shots one has an experience of more or less surfaceless, or at least textureless, abstraction. The varied tonal range of *Mauern* is absent from *Bild*. Instead one experiences a play of relatively homogeneous-patterned surfaces, with a more or less regular distribution, and even balance, of black-and-white shapes. As in *Mauern*, though, the film is also composed of an a-rhythmic stream of individual short shots that refuse to coalesce into movement. At the same time, there are also moments where Kren moves the (handheld) camera across the painting line by line – using it as a script, in effect – which generates hesitant, quasi-continuous movement.

However, the similarities in editing structure between the two films are more than cancelled by the way the heterogeneity of the material in *Mauern* creates constant interruptions and disruptions, in contrast with the homogeneity in *Bild*, which facilitates a more even and continuous flow. Thus, we see how a similar editing pattern in two films can produce dramatically different senses of kinesis, flow and continuity, depending on the disposition of tonalities both within the frame and between shots. The negative-positive interplay of *Mauern* has a correspondence in *Bild* where, for example, a composition, or array, of black and white in one shot is followed by a white-and-black counter-shot with a similar disposition of forms. Thus, the film invokes the idea of alternations of negative and positive counterparts through the act of framing. In this respect, we come to understand that 'negative' and 'positive' are not essential categories; they are only tonal arrays, the definition of which depends on their relationship to each other in time and space, and other contextualizing factors.

Bild Helga Philipp recalls, inevitably, Peter Kubelka's film *Arnulf Rainer*, in which equal quantities of black and white are systematically apportioned. Kren's strategy however is arguably more interesting for the way it confronts representation with abstraction. Within this so-called abstract film, there is frequently a sense, which is almost impossible to account for, that we are sometimes looking at the painting square on, and sometimes at an acute angle, even in the absence of clues such as drifting focus across the frame, which would indicate shallow depth of field across an object that was close, and at an angle, to the camera. Thus, representation and the knowledge it supposedly affirms is a central problematic of *Bild Helga Philipp*.

Aline Helmcke argues that *Arnulf Rainer*, composed as it is of black-and-white frames, is more radical, because purer, than *Mauern*. But pure abstraction can be seen as a retreat

from the problems of dealing with representation. Kren's film clearly comprises filmed surfaces, yet he defies us not to see these images as abstracting: There is a process going on, neither the presentation of a representational image as graphic abstraction, nor pure abstraction, the latter of which deviates from a filmic problematic into the area of pure light play and kinesis. The constant oscillation between representation and its negation, coupled with their shared a-rhythmia, prevents these films from nestling in a domain of pure flickering light play. Rather, they insist on their being as films: they could not be otherwise, unlike flicker, which in itself could equally be generated by other means, such as a strobe lamp.

Reference

Draxl, K., 2009. The Square in Motion. In: *Helga Philipp: Poesie der Logik.* Vienna and New York: Springer.

Note

1. I am grateful to Angela Allen for suggesting that Riley's black-and-white paintings invite a different approach from the viewer to her colour ones, because the colour interactions require a more or less frontal view to be experienced effectively, and in which a single event often unites the entire canvas, which similarly requires a frontal point of view.

5/62 Fenstergucker, Abfall, etc.

5/62 People Looking Out of the Window, Trash, etc.
(1962, 4:48 min, colour, silent)

Yvonne Spielmann

Kurt Kren's film *Fenstergucker, Abfall, etc.* mixes shots of people gazing out of the windows of their Vienna homes with shots of household trash that has been carelessly dumped in public. Kren contrasts seemingly non-related fragments of reality with cuts at the level of the interval that evoke the aesthetics of collision in the counterpoint montage of the revolutionary Soviet cinema. The viewing experience of audiences, over many decades, has led us to understand such combinatory poetics of associative montage as a uniquely filmic means of depiction.

Kren's montage in this silent film is an associative array of sensual terms that stand in stark contrast to each other. These terms are connected through a series of close-ups – of people walking, running or standing together in groups – portraying day-to-day street life. Shots of passers-by, of outdoor trash and, later in the film, alternating positive and negative images of the natural phenomenon of the eclipse of the sun, all stress the presence of the camera as the unintentional observer of unplanned events. In contrast, Kren's subjective viewpoint is affirmed when he returns the looks of the peering gazers by using the camera 'to shoot the people with the camera for looking out of the window' (Kren in Scheugl 1996: 166).

A sense of inescapability is inscribed in the rapidly edited shots of mostly elderly individuals, or couples, who have made themselves comfortable at open windows looking onto the street. From this position they may have waited for hours, watching out for an event or incident that would interrupt the collective ennui of post-war daily life. As Kren's shots capture the onlookers in the window frame from street level, the distance between the safe position of the gazers who are uninvolved in the activity below them, and the artist who mingles with that street life, is put under critique. The mood of Viennese 'gemütlichkeit' (coziness) depicted in Kren's film was soon to be aggressively attacked by political and artistic provocations, including happenings, actions, independent and underground films, and by the exploits of the Vienna Aktionists with whom Kren himself was associated from 1964 to 1966. Here, in *Fenstergucker*, made slightly earlier, the response of the filmmaker is one of discomfort rather than provocation; Kren's handling of his camera is subjective and personalized. Nevertheless, he uses it like an aggressive instrument to target those who were, perhaps, passive onlookers to the atrocities during the Nazi regime some 20 years before, after the German Third Reich annexed Austria in March 1938.

In this respect, one possible reading of the film conflates the activity of gazing from the window, or wasting time, with ending up in the trash. The associative montage describes

a timeline of decay. Furthermore, the thrown-away objects, such as bottles, papers, broken glass, sundry materials and the repeated image of a dead dove, all dumped and decaying in the open air, are disturbing reminders that something could have been done to combat or even prevent Austria's annexation and subsequent atrocities. In the montage of associations, we are sharply reminded of the casual and disengaged curiosity of people, trapped in inactivity, bypassing responsibility. A chain of events that goes unchallenged is further evoked by intermixed close-ups of random passers-by whom the filmmaker shows in short shots and fragments. In contrast to the window gazers, the passers-by are unidentifiable, but they express a stream of movement in the motion of their hands, arms and legs as they walk. We also see groups of people loosely standing together, which indicates the possibility of communication. Under the Nazi regime, the gathering and standing together of even small groups of people was forbidden, given the suspicion that critical ideas would spread beyond their control in face-to-face communication. In Kren's film, direct communication indicates the potential in activity, which may lead to societal change. This stands in stark contrast to the immobile onlookers at their windows who express inactivity and non-intervention.

Above all, Kren is interested in the abstract quality of film images, in patterns corresponding to the formal composition of light, shadow and movement. The poetics of abstraction in Kren's films lies in the depiction of fragments of reality. He creates a reality effect out of the material, as in documentary filmmaking, but eschews temporal continuity through experimental methods of editing. In an anti-illusionistic manner, Kren prefers to cut up the human figure through framing, and to alter the apparent duration of actions by shooting sequences in patterns that seem to affect their speed. The unfolding of time in a cinematic sequence of images becomes a matter of variation.

Aesthetic principles, abstract forms and recordings of reality are merged when, in the first third of the film, Kren juxtaposes positive and negative shots of an eclipse of the sun. When the material is reversed, it is as if a series of dancing boomerang-shapes unfolds before our eyes. We are not invited to recognize or even enjoy the sight of a rare natural phenomenon. Instead, we are challenged by a schema of serial single images that tend to evade representation. The film viewer is made constantly aware of the processes of filming and editing. The uneven rhythm of forms and inner-frame movements contribute to the abstract tonality of the film.

Another way of reading the montage of associative images, fragmentation, reversibility and variation is to see them as referring to activity as a motor of change. We might understand these dynamic sequences of movement and mobility as a visual counterpoint to the stasis and standstill that we perceive in the images of people looking out of the window and of the trash. Similarly, the montage sequences of *Fenstergucker, Abfall, etc.* reveal tensions that arise from the confrontation between the immobility and mobility of people and things when they are captured as film images. Further to the formal-technical level of montage, Kren contrasts the more or less static camera with a dynamic sequencing of shots. Kren shot the film at the 'normal' speed of 24fps, but then edited the

length of shots by using a serial technique that determined the progression of the number of frames for each shot according to the mathematical sequence of Fibonacci numbers.

In mathematics the first two numbers in the Fibonacci sequence are 0 and 1, and each subsequent number is the sum of the previous two. The Fibonacci sequence thus begins with the following numbers: 0, 1, 1, 2, 3, 5, 8, 13, 21, 34, 55, 89, 144 etc. In Kren's film, the sequence from 1 to 34 is used to define the number of single frames that make up the length of shots. The serial montage of these shots – following the Fibonacci sequence from 1 to 34, and then the same sequence reversed – produces the apparent changing tempo of the film, which either accelerates or decelerates. As others have pointed out, Kren often applied such number sequences in order to exploit the golden ratio in the rhythm of his images. (The Fibonacci sequence is intimately connected with the golden ratio.)

Kren's rapid cutting and sequencing of shots with variable frame lengths develops a formal system that critiques inactivity, immobility and gazing. The approach is rooted in formal film aesthetics, and aims to disclose conditions of the medium that are usually invisible, but the strategy also addresses the recent past in terms of the intolerable suppression of collaboration with the Nazi regime in Austria. The critique surfaces metaphorically at two points in the film. One is the reference to the allegedly detached onlookers, an image that we know very well from historical photographs of Nazi parades; the other relates to the uncared for trash, which – like the undigested remains of the recent past – does not simply disappear, but would need to be properly dealt with and processed.

Kren's vision is distinct from the early revolutionary use of the 'camera-eye' to penetrate visible reality. The difference between Kren's strategies and the concepts of counterpoint, collision and contrast that were developed in the associative montage of Eisenstein, or the intervallic theories of Vertov, is that the systems in Kren's films appear to produce random snapshots. However, the formal composition of shots that are timed in the frame-by-frame shooting plan of the complete film does not leave the development of events in the film to chance. (The same principle can be found in Kren's other films where he shoots single frames and edits in camera, and when he inserts black frames, as in *TV*, which are similarly carefully counted.)

A fundamental dialectic emerges from the film form in Kren's work. Nothing appears to be permanent or lasting in *Fenstergucker, Abfall, etc.*, simply because the line of development – 'etcetera', as the film title implies – must inevitably end in decay. The elapse of time that is suggested by the subject matter of the window gazers, and the repetition of shots in the film, might be seen as signifying a wasted opportunity. This rather pessimistic view is first expressed in the order of words in the film title, and mirrored by the order of events in the course of the film, which associates watching with inactivity. At the same time, Kren roughs up the footage that he shoots, and he understands the activity of shooting a film as a violent encounter with the real. In this respect, the aggressive montage resonates with growing discontent in the aftermath of the destruction of World War II. More or less consciously, Kren's filmic response to the continuation of patterns of

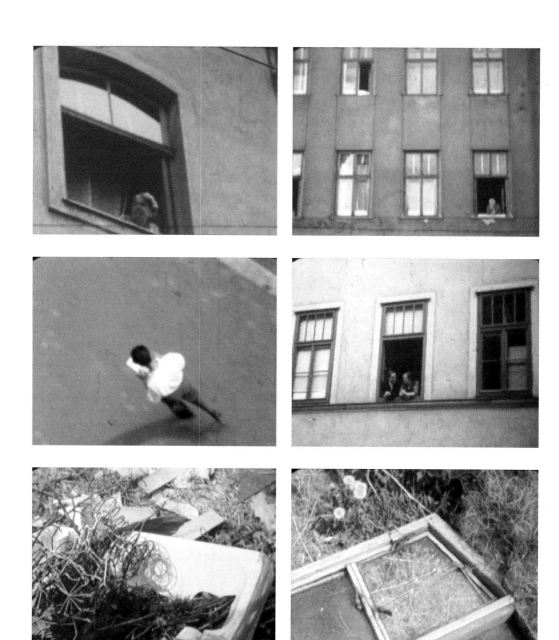

5/62 Fenstergucker, Abfall, etc.

behaviour from the past was aligned with the wider opposition of artistic movements – culminating in the 'Art and Revolution' event in 1968 – that dealt with depression, doubts, uneasiness, and instability; the sense of the (then) present moment between an undigested past and an unknown future. Kren's film systems act to restructure the real in fragments, a method that he systematically developed in his previous films, *48 Köpfe aus dem Szondi-Test*, *Bäume im Herbst* and *Mauern pos.-neg. & Weg*, and perfected in *Fenstergucker, Abfall, etc.* These works coincided with the dawn of Vienna Aktionism. In the following years Kren was to make films of the actions of Otto Mühl and Günter Brus (emphasizing that they were not simply documentaries).

Kren's work belongs to a category of system films that have been discussed widely in the debates around structural film. In particular, the filmmaker and theorist Malcolm Le Grice, in his article on Kurt Kren of 1975, highlighted the mathematical system for 'ordering experience'.

> Kren has counteracted both the narrative and expressive concepts of montage through mathematically organised montage configurations. Consequently, many of his films make use of a limited number of repeated shots in various combinations and lengths.
>
> (Le Grice [1975] 2001: 59)

The film demonstrates how montage is a system that exposes abstract qualities and restructures material to form a poetic composition of variations on numerical schema. Kren's counting system can be appreciated for its disruption of the normative, expected flow of images, but his montage technique also makes evident societal problems, which are the result of historical events that have been left unprocessed. The overt aggression towards the people looking out of windows also needs to be located at the time of the film's shooting. In the early 1960s, when television was new and rare, it was quite common, at least in Austria and Germany, for elderly people and those who mainly stayed at home, to spend long hours looking out of the window to kill time. Only with the advent of television, as the leading entertainment medium, would people give up this habit, since they could now spend their time watching the world on the television set. In view of the emerging media of television and video, it is noticeable that at least two of Kren's films, *TV* and *Fenstergucker, Abfall etc.*, show a scepticism towards people's participation in the real world.

References

Le Grice, M., 1975. Kurt Kren reprinted. in: *Experimental Cinema in the Digital Age*, 2001. London: BFI.

Scheugl, H. ed., 1996. *Ex Underground. Kurt Kren seine Filme*. Vienna: PVS.

15/67 TV

(1967, 4:08 min, b/w, silent)

Yvonne Spielmann

'TV' is a programmatic title that combines reference to the embryonic age of electronic media broadcasting with the material, language and form of film. The connection that it makes between media is timely and well-balanced, resonating with the then growing competition between experimental film, television and video art. It also refers to the gap between watching films in the cinema and on television.

In his own comments about the film, Kren explains the title of 'TV' as to do with the kind of images that he shot from inside a quay-side café in Venice. The camera looks out of the window onto the quay, where we see girls coming, going, waiting, sitting on a bollard, talking, passing by on roller skates. A man with a child walks close by the window, while further away a crane ship crosses the field of vision as if it were closing the horizon of sight at its furthermost distance. The colloquial German word for television (*fernsehen*) literally means to see or even to gaze into the distance. Just as film images bring views of the outer world from distance to closeness, so television brings them right into the living rooms of our homes. In 1967 relatively few people had television sets at home, television programmes did not run 24 hours a day, and they were only in black and white (as Kren's film consequently reflects). Before the age of packaged travel, Italy and perhaps especially Venice were, as they had been for Proust, imagined and desirable but very distant locations. In this era, television held the promise of a window that opened onto the world and transmitted multiple perspectives within the fixed frame of windowed views.

This effectively inscribes the metaphor of the window in the relationship between film and television. The window is the central visual feature and permeable border in Kren's film. Just as Leon Battista Alberti's 1435 treatise 'De pictura' had described the painterly window, so here the frame of the screen is seen as a window in which three-dimensional space is translated into the two-dimensional picture plane, whether on the movie screen or the canvas of a painting. Differently from painting, and by way of the moving camera and duration, film has rendered mobile the frame itself, and developed an aesthetics of 'mobile framing' that belongs to the canon of film language. As a result, and unlike the fixed perspectival frame, the filmic metaphor of the window encompasses not only frame-within-frame division but also sequential movement inside it. Anne Friedberg's comparative study of 'The Virtual Window' stresses the difference. She writes:

> The complex relation between perspective and the moving image necessitates a more refined account of the viewer's position in space in relation to a fixed frame with either static, moving, multiply layered, obliquely angled, abstract, sequential, or multiple-

frame images. As moving images follow each other, the shifts of editing offer the viewer multiple perspectives but sequentially and within a fixed frame.

(Friedberg 2006: 2)

In fact the camera is immobile in *TV*. The fixed frame that holds the film image is in counterpoint with its presented, visible content. This consists of five different scenes, each 1½ seconds long, that depict sequential movements of people and objects. Throughout the film, the five short scenes (i.e. shots) are varied in 21 different sequential combinations. The five different scenes are not always all used to build one sequence, since some sequences only alternate between two or three different shots. Kren's idea of film, which usually builds upon the frame as the smallest unit, here rather takes the shot as its basic unit and reinforces this entity by repetition. He deliberately uses a variable number of frames to compose a scene, and combines variations of different or repeated scenes in a series of five, which creates one sequence. In total, the film has 21 variations, which each time include five differently repeated scenes, and these sequences are grouped together in blocks of eight. Each of the sequence blocks is segmented by the insertion of black frames. Furthermore, and in accordance with the focus on individual frames, the number of black frames inserted between the series of scenes is equally variable. Black frames indicate a break, but also merge into the movement of the shadowy figures in the foreground who are sitting at the café table. These figures appear as black shapes, and sometimes obscure the viewer's sight of the events outside the window.

Supported by the punctuating black frames, the film's shifting rhythm determines its sequential movement, which on the one hand is based on a mathematical system and on the other hand is not symmetrical or entirely predictable. This is to underline the dynamic, and furthermore poetic, aspect of film as a medium of moving images. In contrast, the static component of the windowed perspective, which refers to the screen (film) and monitor (TV image), is maintained in the steady selection of shots. The static point of view is reinforced by the visual frame-within-frame setup. Because the café's window is situated in the middle ground of the image field, it metaphorically recalls the cleavage of the unchanged camera shot, which actually 'frames' the whole picture. The stability of the built frame of the café's window in this respect mirrors the static use of the film camera. Thus, the reinforced pattern of framing, together with the literal articulation of the window as the central visual metaphor that relates to the boundaries of the film image, is set apart from the dynamic mobility of short scenes that seem to have been captured at random. The camera acts like an accidentally present observer; it neither affects nor does it investigate the scene that is unfolding in front of the apparatus. In this respect, the camera position of the film may be seen as similar to the distanced viewpoint of a television news reporter. It also resembles the passivity of a television viewer who receives glimpses of information from all over the world in a collage-like programme structure that from the early days of television has been characterized by two

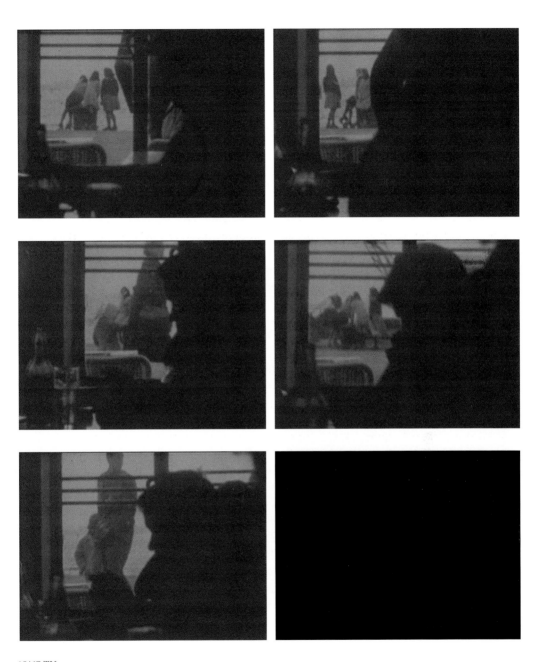

15/67 TV

mechanisms: a potpourri of temporally and spatially unrelated events, and the structural repetition of sameness. These televisual parameters are the core structuring principles of Kren's film on and about television.

The point of departure in Kren's film is the diverse set of unrelated and random events that inhabit the field of vision and which are focused by the fixed point of view. The immobile camera constantly registers the events in the café (and outside it) and does not stop recording when, for example, someone gets up from the table and blocks the view with his body. Here, we are not only made aware of the apparatus but of the presence of the filmmaker. He is participating in the scene at the table in the café at the time of the shooting. This confirms Kren's documentary approach, since he did not stage the events but depicted incidents as they occurred in front of him via the camera eye. This involves a self-reflexivity on the part of the filmmaker, which is not unusual in an experimental film, and has been historically identified as one of the characteristics of 'structural' film. From a more contemporary point of view, we can see that the positioning of the self also refers to the level of the two media involved, which still had novelty value at that time. Film and television/video artists around 1967 were still grappling to accept each other. From a self-reflexive position in film, Kren expands into the structural principles of television. In effect, he is forcing the televisual way of presenting kaleidoscopic views of the world into a rigid 'frame-by-frame shooting plan'. In a critical reading of the film's reference to television, the arbitrary, almost mechanical form of the film, which follows Kren's personal shooting plan, provokes a distanced mode of perception. The gap brings up the question of how broadcast events in television news and related formats are chosen, and how they are temporally and spatially combined in an abridged context to finally converge in the window frame of the monitor.

The fixed frame of the café window also serves as an indissoluble interface between media. It tells us that, in film as in television, the apparent discrepancy between viewing and the viewed lies in the function of the window. Initially, it seems to open freely onto the world, but then we realize that it depends on conventions that determine the conceptual framework of its system of representation. Furthermore, the repetition of sameness, which is another structural component in Kren's experimental work, reveals another layer of media critique, or at least media awareness. Here, as in other films, Kren used a mathematical system that he carefully prepared as a hand-drawn diagram of a detailed frame-by-frame shooting plan before making the film. This plan determines the repetition of each shot and gives the film a firm construction. The diagram notes the order of the five numbered shots, which changes in each of the 21 variations. At the same time, the impression on viewing the completed film is that it is, above all, a poetic composition. The mathematical order in the combination of shots creates the syntax of a poetic language; despite the film's formalism, it allows for inconsistent and non-predictable progression. However, once we relate the viewing of the film to its conceptual grounding in television, the film's shooting plan can also be seen as a matrix that discloses those dealings with fragments (or bits) of information that characterize the cultural

Plan for *15/67 TV*

institution of television. Over decades, the repetition and variation of the same schema in television has established its unique programme structure. In view of the two media that are combined in *TV*, it is perhaps the filmmaker's intention to make us aware of the constructedness of film and television, without obscuring the poetics of composition that achieves a visual rhythm.

Finally, Kurt Kren's primary interest in visual composition is also manifest in the film's depth of field that conceptually refers to the composition of foreground, middle-ground and background in painterly images that employ perspective and the window as a frame. It is at the same time a metaphor and an instrument to create spatiality for perspectival viewing. The window in Kren's *TV* plays with the borders of vision and extended views, and aesthetically asserts the potential of the film image to represent spatiality. Here, film's visual capacity to produce depth of field is superior and preferable to the televisual image, which in its early phase appeared in low resolution and was unsuitable for long shots. In an ironic way, Kren's choice of title for the film reveals a media contradiction.

Television, as its prefix 'tele' suggests, wishes to capture views from far away and at a long-distance, but in its emerging years it could not technically compete with film and could not deliver the deep space or long shots that were part of the established vocabulary of the film medium. Technically then, *TV* could not have been shot on video. In addition, the blackness of the black frames wouldn't have worked on a monitor, their effect needing film projection, whereby black frames merge with the blackness of the off-screen space. More interestingly, perhaps, is the reflection on the difference between viewing the world through film and television. As Kren explains, the film bears the title *TV* because he regarded the distant image that we view outside the window frame as like staring into the distance (Scheugl 1996: 174). This is how Kren understood television.

References

Friedberg, A., 2006. *The Virtual Window. From Alberti to Microsoft*. Cambridge, MA: MIT Press.

Scheugl, H. ed., 1996. *Ex Underground. Kurt Kren seine Filme*. Vienna: PVS.

17/68 Grün-Rot

17/68 Green-Red (1968, 2:56 min, colour, silent)

Simon Payne

The close-up camerawork of *Grün-Rot* hovers and revolves around a number of green glass beer bottles, some of which have sharp, jagged edges where they have been broken at the base. The bottles each stand upright, usually against a red background, and it's this combination, of green on red, that marks the focus of the film's investigation. The frame seldom shows the full width of a bottle, providing an intensity that is further concentrated by the fact that the whole film was shot one frame at a time. The lack of any visible splice marks also suggest that it was edited entirely in-camera, which effectively makes the film a record of its own making. In more conventional modes of editing, the temporal structure of film is only finally determined after shooting, in 'post-production', but as with other films by Kren – including *3/60 Bäume im Herbst*, *31/75 Asyl* and *37/78 Tree Again*, which employ pre-determined structures and processes – *Grün-Rot* seems to have arrived at its final form directly.

The green beer bottles make for a still-life composition, and in its fragmentary, rapid-fire construction, which synthesizes various perspectives to produce near-simultaneous imagery, the form of the film might initially suggest a quasi-cubist endeavour. In this respect it calls to mind Malcolm Le Grice's later *Academic Still Life* (1976), especially given Kren's influence on Le Grice, but the composition and structure of *Academic Still Life* is quite different. In the first instance, the set of Le Grice's film is more generic, comprising wine bottles and apples arranged on a crumpled white tablecloth. The structure is also more studied: the gaps between objects and discontinuous planes having been transcribed as the interval between frames. In contrast, *Grün-Rot* is a more intuitive film. And rather than operating via formulaic analogies or equivalences between painting and film, it reflects and produces ways of thinking about representation that are exclusively filmic and concern the particularities of the camera-eye. The surface, thickness and curvature of the glass bottles, which refract and filter rays of incidental light, reproducing a range of hues, is a metaphor for the lens. Looking through a transparent medium is likewise something of a metaphor for film (-making and viewing) in general. The following discussion of *Grün-Rot* concerns thoughts on film that it prompts, dealing especially with questions around colour and transparency.

In filmmaking, in contrast to observational painting or drawing, the constellation of marks and shapes in the surfaces and objects of the surveyed field is not described or invented, but found, through the lens of the camera. Besides finding and framing, the essence of film form – the capacity for true invention in film – lies in the ways in which what's observed and exposed is organized and structured. In *Grün-Rot*, a number

17/68 Grün-Rot

of passages are structured in terms of clusters of frames that hover around a particular feature of the bottle. At the start of the film, the beer bottle's embossed logo is one such feature, another is the ellipse defined by the rings around the top of the bottle. In these passages of the film, where single frames repeat slightly reframed images of recognizable parts and details, the result is a frenzied motion.

Other passages of the film suggest direction and velocity: several sections of the film, for example, involve single frames shot in sequence to reproduce a tracking movement up or down the height of a bottle; other sequences involve the camera circling the base of a broken bottle, making it look as if it's rotating. In these instances, the shape and characteristics of the glass bottles direct the camera towards certain features that it will light upon, as well as leading and propelling its movement. At the same time, the energetic and animated nature of the film reveals the degree to which the content, or

subject, of the film is brought into being by the agency of the camera. The subject of any film is beholden to the interaction, and to a reciprocal relationship, between the camera and what it shoots. In *Grün-Rot*, shot in single frames and close-up, which make it a very intense film, the tether between filmic and pro-filmic is an exceptionally short one.

In a brief comment on *Grün-Rot*, Kren has said that it was shot over the course of several days, in different lighting conditions, including daylight and artificial light. This is quite apparent in the film itself; the change in lighting conditions makes the colour of the bottles and background a fugitive and varied phenomenon. In a section halfway through the film, the broken base of a bottle, presumably shot in daylight, shines an emerald green against a bright white background. In other darker sections of the film, presumably shot under artificial light, the greens are far more yellow, or even golden, often tilting to brown and orange. Greens still feature in some of the darker sequences, particularly in

17/68 Grün-Rot

the first half of the film, in glimpses of the neck of a bottle, or in spittle-like globules and tiny bubbles of froth, but details such as these are increasingly interspersed with flashes and flecks of brilliant yellow and orange, marking the rim of the bottle top or catching a nicked or scratched surface.

For large sections of the film colour is consigned to highlights, while the body of the bottle verges on pure black. In these passages the majority of the frame is often consumed by darkness – more on which follows below – with light only interjecting at the edges of the image, in shifting amber streaks and stripes that line the sides of a bottle. The curvature of the bottle yields these stripes, outlining its shape in the refracted light. Besides defining the form of the bottle, which is otherwise invisible in its darkness, these striped highlights also describe the relationship between the bottle and its surroundings, particularly the angle of incidence of the light source on its surface. In contrast to the transparent emerald green of the bottle that was shot in daylight, which was produced by lighting conditions that surrounded the bottle with equal luminance, the stripes that line the edge of the bottle in the darker sequences of the film are evidence of a much more directional and focused light source. In this respect, what one sees in the film concerns the relationship between lighting, darkness and colour, as much as the bottles themselves.

Green and red makes for a potent, sometimes jazzy, combination. If one puts a swatch of green and red side-by-side, for example, the clashing combination produces a zinging ripple along the line where they meet. Another optical effect occurs when one stares at something red for long enough, which on turning away results in a greenish afterimage. Red and green were also significant colours in the context of early experiments in additive film colour. In G. A. Smith's Kinemacolor system of the early 1900s, for example, the reproduction of a near natural colour spectrum was attempted by exposing black-and-white film stock through alternating filters and subsequently staining every other frame red or green. But in the realm of subtractive colour mixing, green and red are considered mutually exclusive, complementary colours, sitting on opposite sides of the colour wheel. When mixed as pigments, green and red produce a dark colour approaching black. Similarly when red is filtered through green all that is left is darkness. At various points in *Grün-Rot* one sees glimpses of red behind the green glass bottles, and it is the light of the red background, filtered by the green glass bottle, that produces the dark mass which is such a prominent feature of the film, often consuming the image.

The combination of the green glass bottle against a red background has the curious effect of making a transparent object opaque. As Wittgenstein suggests in his *Remarks on Colour*, 'the impression that the transparent medium makes is that something lies *behind* the medium'. In this instance, however, the red background effectively renders the green glass bottles black and hence opaque. In the passages of the film that are most opaque it is as if we 'see through a glass darkly'. Given that the bottles are filmed in close-up throughout, usually filling the frame, they practically become invisible, and in the darkest passages where light and colour are only fleeting, the film verges on pure abstraction. On one hand the darkened glass is simply the effect of the subtractive mixture of complementary

colours, but it is also a powerful example of an image in which what is ostensibly there is inferred, rather than visible. On a more prosaic note it also confirms the point, which the film makes throughout, that colour is not an inherent property of objects, but a function of the light that they reflect.

References

Wittgenstein, L., 1977. *Remarks on Colour*. Edited by G.E.M. Anscombe (trans. L. McAlister and M. Schättle). Oxford: Blackwell

Negation and Contradiction in Kurt Kren's Films:
32/76 An W + B, 18/68 Venecia Kaputt and *42/83 No Film*

32/76 To W + B (1976, 7:42 min, colour, silent)

18/68 Venecia Kaputt (1968, 20 secs, colour, silent)

42/83 No Film (1983, 3 secs, b/w, silent)

Nicky Hamlyn

A number of Kurt Kren's films turn on strategies of negation and contradiction. These strategies are often realized through the use of layering or partial obliteration as a way of cancelling the image, denying it the fixity, or positivity that it depends on for its representational power. Self-cancelling montage, as in *42/83 No Film*, and negative titling, as in *33/77 Keine Donau* (*No Danube*) are also deployed.

In *32/76 An W + B* Kren took a photograph of a window overlooking a Munich street and the park beyond it. He attached a large negative of this image to the lens hood of the camera through which the film was then shot. Over the period of a month he pulled focus so that different aspects of the scene become sharp. The focus pulling alters the relationship between the scene being filmed and the negative, which it is tempting to think of as a kind of reference image, but whose reference points are reversed, and which is itself subject to shifts in focus. The filmed layer – the landscape – changes constantly, both in terms of focus and density, as well as in the way things appear, such as pedestrians and cars, which are not in the photograph. However, our ability to measure these differences, to distinguish them from the photograph, is confounded, because the differences between the filmed scene and the photo, which is never visible in itself, generate only compound images that are negative, in the sense that they partially obscure the differences between the photographed and filmed scene: a ghostly third image results from their interaction.

These interactions are different for different parts of the image. Where a static object is superimposed on itself, there tends to be a persistent dark bluish area, most notably in the trees that dominate the foreground, whereas in the busier parts of the scene the patterning fluctuates. As they come into focus, bright edges and patches of sunlight punch through the negative and seem to emerge relatively unaltered. This is partly because as the background is brought into focus the negative dissolves, thereby spreading and losing density, though still tinting the scene overall. When the objects in the scene defocus they lose their distinctiveness, outlines dissolve, and as their colour and density come to dominate, they blur into the negative, which is itself always relatively soft: light is more evenly dispersed, so contrast diminishes. Thus from a more or less uniform process, complex unpredictable phenomena emerge. This is a characteristic of most of Kren's best films, including everything from *15/67 TV*, a straightforwardly shot film with permutative montage, to the anti-montage *18/68 Venecia Kaputt*, discussed below, in which painted material is superimposed on tiny fragments of film.

In Malcolm Le Grice's *Yes No, Maybe Maybe Not* (1967), a 16mm black-and-white negative and its positive copy are overlaid. This should produce an entirely self-cancelling

32/76 An W + B

image, but in fact produces a mid-grey texture that retains at least the outlines of a representation. While it may be possible to explain the existence of this vestigial image as the product of an imprecise superimposition of negative and positive, it could also point to the way characteristics in the negative film stock, its positive counterpart, and differences in the tonal values between negative and print generate anomalies in relative densities, to say nothing of the way the eye-brain deals with information, often by exaggerating the boundaries between contrasting tonal areas, for example.

Kren's film incorporates other variables, such as the way focus pulling also affects the size of the image, and hence its constituent elements. These elements correspond to objects: trees, people etc., but one might additionally ask if the definition of an object can mean anything in this context: since the focus shifts continuously across different layers of depth in the scene, there are only momentary conjunctions of patches of light

and dark, which may or may not be spatially contiguous, and may or may not sharpen into edges or points of light. In effect, focus shifts are really changes in the film's surface-movements, and in this respect the negative is a kind of moving image. This is one of the ways in which Kren breaks down the distinction between photographs and film: insisting on the fact that film is made up of still photographs, while photographs themselves might become movie images when subjected to changes in focus and density.[1]

The negative hanging in front of the scene is a reminder of photographic inadequacy and so, by extension, are films shown to be. *An W + B* expresses a resistance to the temptation to think of film as more adequate to its subject than a photograph, because of the added element of time and apparent motion. However, no quantity of photographs, presented singly or in sequences – here about 11,000 frames – can add up to a complete record of anything, and we grasp this from the constantly shifting, never repeating, array of tonalities in the work.

18/68 Venecia Kaputt is an entirely different kind of film. *An W + B*, though very complex, runs at a pace that is slow enough for the viewer to register the shifting view on the park. Although all the complexities are impossible to grasp, the film is on screen for nearly eight minutes, so there is a sense of having time to take in the work, to accumulate a sense of what is there, at the same time as becoming aware that there is always more than can be absorbed. *Venecia Kaputt* is very short at only 20 seconds and the division of the work into four sections enhances the sense of brevity. Furthermore, as in a number of Kren's films, the titles, at 11 seconds, last longer than the film itself, followed by the film, which consists of four brief fragments of less than two seconds each, separated by three or four frames of blue-on-black scribbles in the same colours as the titles and the end credit, the latter of which takes up the remaining three seconds.[2]

Not only do the opening titles dominate the work in a temporal sense, they do so visually too, since the same blobby blue ink that is used to create the titles and end credit is also superimposed over three of the four shots in the film, and to create the scribbles on the frames separating them. (The fourth shot has white scribbles.) The blue graffito appears not to have been applied directly to the film, but to be a superimposed layer: its lack of focus separates it from the focused imagery, which appears intact beneath the scribbles, not partially erased as one would expect from a scratched film. (The film looks as though it could even have been shot through the blue layer.) Thus the titles, or at least the materials out of which they were made, negate, as it were, the film itself. The film is also dominated by words in the image proper. The camera points into a narrow gap between two buildings, beyond which can be seen a large ship with a chequered flag flying. On the left-hand side of the frame is a large sign: 'Hotel Teson', in bold capital letters, while a similar sign: 'Trattoria alla Bronsa' occupies a position slightly further away on the right. The framing shifts from shot to shot and the ship moves slightly through the frame. It takes several viewings to gauge these changes, which are partially concealed by the pauses between shots. This reminds us of how much is missed, or simply concealed, in most of the films we watch, especially if they are only seen once, as will often be the case. Here,

Kren seems to be saying: if you can't take in a bare eight seconds of material, consisting of a repeating, static shot, what hope is there for most other films?

Even without the blue layer, the film would be difficult, and in this sense the layer is superfluous. If so, why is it there? It is partly a paradoxical act of cancellation, since one has to be able to see what has been cancelled to realize that it has been cancelled. Perhaps then the film is a negation of a negation, but one that does not lead to affirmation, unless what is being affirmed is negation again. If we can't take in what is in front of us, we might as well not be able even to see it properly, since if we could we wouldn't be able to absorb it anyway. Therefore it is better to experience the work in the only way possible, in the self-conscious sense that 'taking in' is impossible, seeing is impossible, or if not that, hopelessly – dangerously in some contexts – inadequate. And this is what cinema

18/68 Venecia Kaputt

wants us not to notice. Here is the politics of *Venecia Kaputt*. Perhaps this is connected to the decision not to scratch the film, a removal process that usually results in another kind of image untroubled by the issue of legibility, since the result is a new synthesis that may be understood in wholly aesthetic terms, often romantic-nostalgic, as in Bill Morrison's work, for example. Kren's added layer retains the integrity of the filmed layer, while making it harder to read: a wholly opposite strategy.

42/83 No Film is one of the shortest films ever made. Although listed as being three seconds long, the two shots that constitute the film total only 33 frames, less than one and a half seconds at 24fps. Like *Venecia Kaputt*, text also dominates the work in various ways and, again, the title shot is the longest in the film, at 48 frames (two seconds). For all its absurd brevity, however, it is a fully formed film. It has a title cum front credit and two shots, one positive, one negative. The shots consist simply of the words 'NO FILM', in large block capitals, first in negative then in positive with the addition of a question mark. It's tempting to think of this work as a cryptic rejoinder to Peter Kubelka's films *Adebar* (1958) and *Arnulf Rainer* (1960), both of which have equal amounts of black and white in them. However, when the film is examined more closely this idea loses some of its plausibility. Firstly, the first shot, at 24 frames, is nearly three times longer than the second (nine frames), making the film asymmetrical overall, in contrast to Kubelka's. Secondly, the second shot, the positive version of the first, has the added question mark.

No Film's economy extends to its manner of production. All three cards from which the film is made; title, first and second shot, are almost certainly the same card. Although the title shot is framed slightly differently to the two succeeding ones, the framing for these latter shots is identical, as is the point size and font for all three. Presumably Kren made shot one, then two, by adding the question mark, then the title by removing the question mark and adding the credit and title information – '42/83' above and '© Kren' below the title word. This raises the question how the question mark was removed from shot two. Given it appears slightly lighter and slightly skew, it's possible it was stuck onto clear acetate, overlaid for exposure, and then removed for the title shot.

No Film is full of puns and contradictions. The meaning of the title shifts according to which word is stressed. The second shot partially cancels the first, insofar as it is exactly derived from it in both a technical and semantic sense. In this sense it is parasitic of the first shot, even as it denies it. The denial is made imagistically – symbolically – as opposed to lexically, by putting the image (the same word) into negative. However, the addition of the question mark also answers the first shot by challenging it, as if to say: 'what do you mean, "no film"?' But it is also a question about what kind of film it is, and there's a broader question about what film is. Does it need images? When, and in what sense, are words images, and does it need celluloid to be a film? It's necessary to bear in mind that the last question at least is being asked in an era prior to the ubiquity of video, let alone digital media; Kren is exploring a deeper issue, here, than simply whether a film can be made in video, or whether video might be classified as film. The video era permits us to scrutinize these films in a way previously all but impossible. Yet the possibility of counting

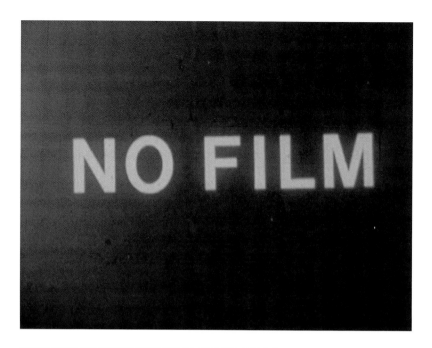

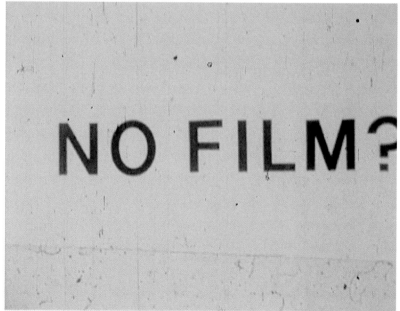

42/83 No Film

frames and computing measurements increases, rather than closes, the unfathomable gap between the object of film as a sequence of frames and its effects, even as, at the same time, the film foregrounds, in viewing, its construction from those very frames. While at a material level it is explicit in its forms of construction, the causal relationship between those frames and the effects generated remains elusive.

Notes

1. Wilhelm and Birgit Hein, the dedicatees of *An W + B*, explored change of focus as movement and other related phenomena in systematic fashion in their film *Structural Studies* (1974).
2. Three seconds is devoted to each of the opening title words: '18/68', 'Venecia' and 'Kaputt' are longer than the individual shots of the film itself.

20/68 Schatzi

(1968, 2:29 min, b/w, silent)

A. L. Rees

Even more than with most of Kren's films, it is best to watch *Schatzi* before reading about it. This is not only because of its intense and disturbing subject matter, which is initially hard to recognize and name, becoming decipherable as the film unfolds. The viewer is plunged into a unique process of seeing and interpretation that also bears out Malcolm Le Grice's insight about the existential aspect of Kren's films, in which the 'chief protagonist … is the person behind the camera'. Since that person is also partly identified with the viewer, *Schatzi* is a phenomenological film as well as a kind of record, and should first be experienced 'raw'.

Preceded by Kren's characteristic handwritten titles, the first abstracted, mottled and grey images in close-up are intercut with black spacing. These black frames, interspersed at regular and then shorter intervals throughout the film, analogize the intermittent filmstrip, and even montage editing, while problematizing recognition, since the viewer has to work hard to see the content of the 'visible' frames, i.e. the oblique shots between the interrupting hard-cuts into blackness. Another aspect is added when we see that the obscure shapes on screen, which at first might be innocently taken for natural forms, are in fact piles of corpses. The death-drive of the film, its negative vision, hinges on the black frames that both disrupt as well as propel the compulsion to see, and in this case question our own viewing of the grim scene that is gradually revealed.

The jittery handheld camera in *Schatzi* at first suggests the film was shot live – that it is archival footage perhaps – since it imparts a sense of ghostly motion to the figures on the ground and especially to the uniformed Nazi officer, who prominently and alone surveys the corpses, standing to the right of the frame. But it soon becomes clear that we are not watching a documentary film, and that Kren's camera is in fact hovering over the surface of a single photograph that shows the site of a massacre. While the camera continuously moves over this image – but broken by the black-frame interruptions – sight is further disrupted by the variance in tone and density. Some are also solarized by stacking a positive and a negative slide of the photograph with another overexposed slide and attaching them to a window.

These crude but direct and powerful devices further hold the image from imaginary completeness, except for one brief shot in full tone, which occurs at about a minute and a half into the film; the only point at which the image is momentarily 'clarified': the officer, the bodies, a distant wall (and possibly some buildings), some wooden country carts. The solarization returns, with longer black spacing between the shots, whose pace

now quickens. Whitening out, the image begins to dissolve into its framed space, over-exposure making the images less readable again.

At first, the content of the shot had to be imagined or assembled by the viewer from the sparse evidence of the close-up abstractions that open the film; now the scene has to be remembered or recalled from its previous apparitions. The camera seems to move closer into the source photograph, reversing the initial procedure while paradoxically keeping much the same distance from its surface by pulling back to a wider frame that includes the officer in near-close-up. It ends in the visual debris and ambiguity with which it began; as noted by Nicky Hamlyn in another context, Kren fragments the image 'to the point of obliteration'.

The source image chosen by Kren for this direct but also elusive memorial/memory film is unknown. According to Hans Scheugl's notes, made from interviews with Kren, it was 'found in an attic'. The place and date of the event depicted are not stated. The viewer is inevitably driven to make guesses and assumptions, but in the absence of historical information about it, the scene is both rigidly specific – these bodies, this open ground, this officer – and rigorously anonymous. The gruesome mass death on view cannot be finally known in this sense; the bodies cannot be named or even counted. Some reviewers claim that it shows a town square, but it might equally be a camp. The people depicted may have been shot, or victims of some other terrible death. There is no warrant to decide who they are, although the dominating figure of the officer is enough of a hint even as it offers no certainty. No clue is given to the nature of the massacre, if that is what it is, but the scene is brutally frank about its own evidence and about the status of its sole live participant, the officer frozen in the photograph like everything else and then reanimated by the camera. The purpose of the photograph, who shot it and why, are unknown.

Little more is also known about how Kren himself came upon this photograph; one wonders in what circumstances. He perhaps gambled that no more was needed to know, and his own treatment of it underlines this by the distancing devices he adopts – the shaky camera, the printing, the black frames, the movement from close up to full shot and back again – to refute any idea that a photograph is self-revelatory. Brute factuality is enforced, but the film does not dwell voyeuristically on the anonymous bodies, many of whom are only inferred as such by occasional fragments of limbs, or twisted shapes, that briefly come into view but are never lingered over. The officer's profile is likewise turned to one side, making his image both indecipherable and definite.

Perhaps not surprisingly, in view of its content and its sardonic title, *Schatzi* has had less critical attention than others of Kren's films. An exception is Anne Schober, in her essay 'Cinema as Political Movement in Democratic and Totalitarian Societies since the 1960s' (2009). Placing the film in the context of other contemporaneous provocations, Schober firmly does not go beyond the film's visible clues, describing it as 'a single photograph showing a tall man in uniform from behind watching over the field in front of him which is covered by dense piles of corpses'. She correctly reports that this figure 'is usually identified as an SS officer'. Just as objectively, she notes that the film opens with 'a

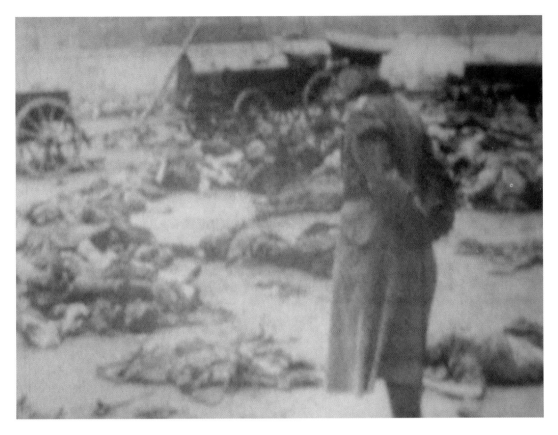

20/68 Schatzi

montage of almost abstract, flickering, darker and lighter … grey planes', which are slowly revealed to be part of a single 'treated' photo that contains everything the film shows, bar the black frames.

While not guessing at the locale and exact circumstances depicted in the photograph, speculation that the film almost necessarily invites and also rejects, Schober interprets the film through the wider optic of her essay on political and psycho-sexual film performances of the 1960s, in which Kren took part. She understands the officer gazing at the dead to be a surrogate or implied viewer, through whom we identify – and identify with? – the scene. This is allowed precisely because it is taboo to look at corpses. But it seems to me dubious that the SS man plays this role of intermediary between photo and viewer. He is a major component of the scene, but an unlikely conduit for the spectator, even if his act of masterful looking both evokes, and distances itself, from our own. If anything is a vehicle for the viewer it is surely Kren's panning and jerky camera, which directly enacts both our

ability and reluctance to see the photograph as revealed – the officer, by contrast, even from his twisted angle, implicitly sees everything at once in his field of vision.

Perhaps because Schober thinks that the title *Schatzi* (sweetie, darling, honey) is 'irritating', she detects a semi-pornographic or obscene parallel here, in line with her wider theme of transgression and resistance. This would be canalized through the officer again, via Nazi sadism, though she is perhaps not quite sure if this aspect of the film is a violent displacement of that fetish trait or on the contrary an allusion to 'lust and desire', reclaiming those ambiguous leitmotifs of post-1950s provocative art in Austria and Central Europe. Taking the title rather literally, Schober connects the officer ('Sweetie') to the cultural association of sex with fascism, though it is left open as to whether this evokes sexual *repression* in fascist ideology (the flipside of its fetishism) or its antithesis in libertarian sexual *expression* – as in the performance art of the Vienna Aktionists, for example. Both invoke perversion as a category. Schober leaves this question open, but adds that the taboo on gazing at the dead is linked to pornography, since in both 'a knowledge is staged' (in a rather curious translation from German). In looking at death and sex enacted, Schober argues, we see what the repressed looks like.

These of course are not the only examples of such dual drives, and their cultural linkage is only asserted and not further explained. If the film invokes one definitive fascist trait, however, rather than sex-and-death fetishism it must be mastery and power, which here does indeed have sadistic overtones almost by default through the Nazi officer and the heaped dead around him. The SS man could not be a clearer if inadvertent emblem of Paul Celan's famous line from his 'Death Fugue' – 'Death is a master in Germany' – written 20 years before Kren's film was made. But solemnity, earned or gratuitous, was not Kren's style or intent. He pulls monuments down by subjecting them to his cutting and abrasive tactics – as in the destruction through cinematic means of this testing and chilling photograph – in order to open it to new meaning, or to the limits of meaning.

Schober is perhaps right to call the title irritating, since it deliberately mocks its subject by being addressed presumably to the SS man. To gauge its force, however, I do not think the invocation of psycho-sexual myth is required, but perhaps one should attend to its irony. It is sardonic rather than sadistic, in order to ward off the least hint of sentimentality and false identification. The title is twisted, and perhaps uniquely perverse, but not to erotic ends. It will always keep the viewer at bay, as much as the busy visual devices, editing, camerawork and printing that make up and break up the re-photographed scene.

But Schober's attention to the title might possibly help to re-evaluate how 'knowledge is staged' in this film – one of only two in which Kren re-shot a found atrocity photo as a political statement (the other is *24/70 Western*, an anti-Vietnam War film). More precisely, it reflects at a distance on how such knowledge is staged in our own time. When Kren made this film, far fewer people had seen images of mass death and wartime murder than today. Many who stumbled on them by accident, in books and newspapers or newsreels, especially after World War II, never forgot them. Schober is right in this regard – they were semi-hidden, taboo, excoriating, looked at with dread. This reluctance

to look, and a mirrored compulsion to do so, is given a literal and metaphorical shape by Kren, interrupted vision being just one of his strategies.

But how does this stand now, when streamed images of mass killing are instantly available to all online users, in vast and manic detail? How many can be authenticated? Who filmed them? How many invite scopophilia and sadism rather than repel them? Kren was a pioneer of the not-yet-seen, and *Schatzi* was made long before the Internet, but this antithetical death-fugue is also an anti-spectacle that runs counter to universalized and exploitative images of desensitized death. As if to underline the limit to visual truth, itself interrogated in the film, the title maintains a sardonic and perhaps bitter ('Sweetie') distance from false sentiment – historically as well as subjectively. Raymond Durgnat, in another context, described Kren's 'concentrationary universe' in which 'no one's his own self, everyone's everyone and nothing. Ruthlessly executed, the formal idea becomes a gruesome philosophical jest' (1966: 10). This was written about *48 Heads from the Szondi Test* two years before *Schatzi* was made, but it incisively predicts the later film's tone, strategy and effect.

References

Durgnat, R., 1966. *International Times*, 14 Oct. [online]. Review of films at the Destruction in Art Symposium (DIAS).

Schober, A., 2009. Cinema as Political Movement in Democratic and Totalitarian Societies since the 1960s. In: A. Harutyanyan, K. Hörschelmann, and M. Miles, eds. *Public Spheres After Socialism*. UK: Intellect.

31/75 Asyl

31/75 Asylum (1975, 8:26 min, colour, silent)

Gareth Polmeer

The frame's wholeness is unstable; some light will always pass into darkness, missing the expectant latent photosensitivity of the silver halide crystals. When each frame is pulled through the camera mechanism, the shutter also draws another void – the frameline – between each photogram. It is with respect to the intervals in these processes that I will discuss Kurt Kren's *31/75 Asyl*, a film that reflects on the ephemeral transformation of landscape and the material surface of the filmstrip. *Asyl* comprises three rolls of film, each of which were rewound and re-used, but with different areas of the frame exposed each time. This was achieved by placing interchangeable pieces of cardboard in front of the lens, each with different apertures cut out as image-masks, so as to allow light through only to selected parts of the film surface. The film was recorded from a fixed camera through a window with a view onto a rural landscape. Kren describes the process of making the work thus:

> The film was shot in 21 days. The film stock went through the camera once each day. There was a black mask with five holes in front of the camera, and the light shone through them and exposed the film. The holes changed every day. All the holes together would release the entire image after 21 days.

> (Burger-Utzer and Schwärzler 2004: 14)

The different arrangements of openings in the range of masks create areas of multiple exposure with blur and overlap. The different times of filming, and the adjustment of exposure levels, create a collage of landscape scenes with differences in light, moving tree branches, and green fields that become snow-covered. The changing space of the landscape is itself re-presented constantly throughout the film. Different combinations of masks mean that at times only a couple of areas appear. At some moments as many as a dozen are visible, whilst at others the entire frame is revealed, with several areas overlapping to create a seemingly total image.

On one level, the selections and contingencies that Kren introduces – framing, masking, the time of day – are echoes of the micro-operations in the filmstrip. A detailed close-up of film's surface recalls a constructivist painting or early abstract film: the substrata of intervals suggested in an electron micrograph image of the silver halide crystals, which cluster in geometric forms, in film emulsion. Compositions of polygons – cluttered, neighbouring, sometimes overlapping – appear as hovering forms in space,

darkness enveloping their edges. Zoom out and the darkness vanishes. In this sense, the appearance of the image in this film is a void made present. Just as the light entering the many apertures of the cardboard mask hits only selected areas of the frame, the density and dispersion of crystals in film emulsion makes for a selective response to the photons contacting the filmstrip. A latent image is formed on film as photons are absorbed by silver halide crystals. Colour sensitivity is registered at different layers of the emulsion, each of which might be further layered for latitude.

Asyl can also be considered in light of the relationship between silver halide crystals and the pixels of digital media. The film's depiction of a moving grid places it at a key historical juncture, in terms of its relation to windows, multiple frames and spaces, and the historical ascendancy of the pixel and raster grid. In 1975, the year Kren made the film, engineers Gareth Lloyd and Steven Sasson at the Eastman Kodak Company developed the first digital camera using a charge-coupled device (CCD) sensor. The first image recorded by the new camera was 10,000 pixels in resolution. Like the selectivity of film emulsion, the pixel and compression algorithms approximate too, reducing visual phenomena to an averaged value, leaving intervals in the neighbouring blocks of colour.

Asyl evokes grids on several levels, including the window through which it was shot, the film frame and the graphic score used to compose the montage of shots. As with other 'structural' films, Kren devised diagrams to realize the work in correspondence with sequences worked out on paper. The processes of making the work shift between the ordered space of the grid and a fluidity of movements and natural forms. The film has a kind of matrix structure, with the framing giving orderliness, but this is continually blurred and reshaped by the different exposures and the changing patterns of light that passed through the masks. In this sense, the film is something of a 'virtual window', suggesting links between various frames, spanning the perspectival image of historical landscape painting to the multiple spaces of the Graphic User Interface (Friedberg 2006).

Comparison with the interface of a contemporary computer-based video-editing programme, such as Final Cut Pro or Adobe Premiere Pro, shows a similarity between Kren's plans and the layering and compositing of digital video files on a 'timeline'. In this type of software, the user/editor works within the 'non-linear' structure: adjoining, overlapping, cutting, layering. Like the 'database imagination' (Manovich 2001: 239) of Dziga Vertov's *Man with a Movie Camera* (1929), Kren's diagram and process, in which the layered, coloured bars appear to represent the ordering of shot sequences, also have a sense of approaching and working through database possibilities. Here again the contingencies of the filming are contrasted with the rigidity of the rectangular blocks: the relationship between order and disorder played out into the mutability of the image. Other diagrams also show Kren's detailed method; the symbols like a form of code that write the complex structure, involving a fixity and fluidity that permeates the films.

Asyl is a work in which the idea of landscape develops both through nature, and the nature of representation in the film medium. In this sense, the film is not only about technology per se, but also about the idea of film as an apparatus; the way in which

31/75 Asyl

image technologies shape their relation to nature, and in turn are shaped by those conditions. Whilst Kren invents a procedure specific to film, the work directly anticipates the quite different procedures of digital media. Embracing structure and system, which also encompass the photographic capabilities of film, *Asyl* presents nature as an image developing in time.

The motion of photograms or the progression of pixels is always holding on to the present (a present also in a paradoxical relationship with its claim to something past). *Asyl* problematizes the perception of time frame and space: days and times overflow into one another. *Asyl* is about the material of light as much as the filmstrip. By making visible the selective operations of framing and exposure, the conditions of the image are examined in detail, but with an indeterminateness that also reveals the instability of time and motion. The location in *Asyl*, the landscape *there* in the image, is questioned as its wholeness,

constituted from parts of light corresponding to multiple time frames, is synthesized and reshaped. The underlying structures of crystal or pixel that constitute the film or video image emphasize its condition and appearance. Flickering to the surface, the layering of silver halide crystals call to mind the pixels of the raster display, the territory of the screen, a space to be traversed, where the containment of the grid might break open.

The grid has a diverse history. As one of the defining structures of industrialization, it is embedded in modernity. It structures, frames, reduces, maps and shapes the matrices of screens and digital camera technologies. It has been claimed variously both for and against nature. The multi-levelled constructions of *Asyl*, the temporal and spatial possibilities engaged through its production and planning, and the relations of the database, pixels, grids and windows in the emulsion place the work within the nascent computer-age and contemporary systems. Both the database and the grid spatialize time, with new computer interfaces and software opening multiple spaces and windows within the frame. Compositing and editing operations brought about by computers enable modes of 'spatial' montage, beyond the largely temporal concerns of cinema hitherto. Here space and time in montage both have crucial importance, as Manovich (2001), who first developed many of these ideas, suggests. Like Zbigniew Rybczynski's *Tango* (1982), an example Manovich cites, *Asyl* might be seen as another kind of proto-compositing experimental film in which spatial montage operations are explored in relation to layers, pixels and windows alongside the multiple temporalities comprised in the filmed sequences. As Birgit Hein comments on the film, 'The exchange of the masks does create movement, but not as a course of time towards a goal' (1977). Thus, the film can be regarded as having a progression – in that the darkness 'moves' to more complex areas of multiple exposure – whilst lacking a definite momentum. The sequences are time-based, but in the manner of their layering and non-linearity are directed away from a definite temporal structure or direction.

Asyl brings into relation a number of planar levels: apertures within apertures, windows within windows, frames within frames. Filming with a camera mounted on a tripod facing out of a window, Kren first of all frames the landscape outside, the fenestration of the architecture providing an opening into the room, like the dark chamber of the *camera obscura*. Passing through this glass plane, the apertures cut into the cardboard masks filter the incoming rays further, allowing shards of light to proceed to the third aperture of the camera itself – opened accordingly to an f-stop – and then through to the filmstrip and its layers. *Asyl* invites a sensuous re-examination of what it means to frame landscape, to reflect on the imaginative possibilities and spaces opened up by cinema as the art of light. But just as light both moves towards and spills out of the screen – is projective and reflective – so the territories delimited in the image have shifted in digital media (via networks, databases, pixels) and in the emissions of the monitor display (electrons flowing from the cathode-ray tube, charged ionized gases in plasma or electroluminescence in light emitting diodes). *Asyl* intersects these histories with its myriad levels – frames, windows, apertures, crystals and pixels.

In another intriguing relation between the grid and its breakdown in *Asyl*, light enters through several rectilinear openings – the window, the small rectangular holes in the mask – but in its path between mask, glass lens, the cylindrical lens chamber and the film plane, the final shape embedded within the emulsion takes on a more fluid form. The light's focus through the rectangular mask shape has expanded and lost its shape. Towards the end of the film, as the edges fluctuate between the different pinhole exposures, there is the completion of a total image. The entire landscape is seen as 'whole'. But as a reminder of the instability of this image, darkness envelopes again. At the very end of the film, one final burst of orange light flares out across the frame. This draws the image back to the light. The photons emerging from the screen meet the beam that shines towards it from the projector in momentary equilibrium.

References

Burger-Utzer, B., and Schwärzler, D., 2004. *Kurt Kren Structural Films*. DVD booklet. Vienna: sixpackfilm.

Friedberg, A., 2006. *The Virtual Window: From Alberti to Microsoft*. Cambridge, MA: MIT Press.

Gidal, P. ed., 1976. *Structural Film Anthology*. London: BFI.

Hein, B., 1977. Synopsis of *Asyl*. Available at: http://www.sixpackfilmdata.com/filmdb_pdf.php?id=248&len=en [Accessed 26 November 2014].

Manovich, L., 2001. *The Language of New Media*. Cambridge, MA: MIT Press.

Sitney, P.A., 2002. *Visionary Film: The American Avant-Garde 1943–2000*. Oxford: Oxford University Press.

37/78 Tree Again

(1978, 3:46 min, colour, silent)

Gareth Polmeer

Tree Again was the first film that Kurt Kren made in the United States – filmed in Vermont. It was produced with out-of-date infrared film and features a series of shots of a tree and the surrounding fields, at different times, over a period of 50 days. I will discuss the film in relation to the representation of trees in contemporaneous experimental films and videos as well as some other subsequent works. Alongside Kren's *Tree Again*, the films of Rose Lowder and Chris Welsby, and the videos of Steina Vasulka all engage a critical dialogue between intention and contingency; planned decisions in framing or structure, alongside unpredictable natural phenomena; and means by which landscape, technology, artist and nature interconnect to form a unique investigation of place.

What unfolds on screen in *Tree Again* is a palimpsest of colour and forms. Filmed in a field, a lone tree stands the height of the frame nearly, off-centre left. Behind it a clump of trees disappears in a curve, left of frame. To the right there is an open expanse of field and further right there are more trees in the background. Whilst the film is shot over 50 days, Kren assumes roughly the same filming position for each sequence. In this way, the single-frame recordings create a stuttering, flickering time-lapse, with constant misalignments and re-framings shifting the position of the tree and, most noticeably, the horizon line. The result is a sensuous and impressionistic dance involving the changing density of leaves, light on the trees and shifting bursts of colour (gold, red, blue, green, flashes of white).

Cinematographic technologies are mostly manufactured for particular consistencies in factors such as colour value and contrast ratio, for the purposes of 'accurate' visual reproduction. A conventional filmstrip is layered with different emulsions with sensitivity to different wavelengths of light (blue, green, red), which, when developed and printed from, approximate a realistic colour image. (Infrared film, discussed below, is more or less monochromatic, i.e. sensitive to only a narrow part of the colour spectrum.) The slippages and inaccuracies of colour and motion in *Tree Again* emphasize the contingency of its appearance, which concerns the material quality of the film stock and the camera technology. There is a painterly quality to the tree in the film, as if daubs of colour have been blotted into the foliage. The film sometimes seems like a painting in motion, as if paths suggested by brushstrokes move a distance beyond the frame. The changing weather causes contrasting patterns of shadows on the ground and rolling clouds in the sky. Alongside the differing illumination of the tree and the sometimes bleached-out sky, the tonal variation and inversion often offsets the depth between foreground and

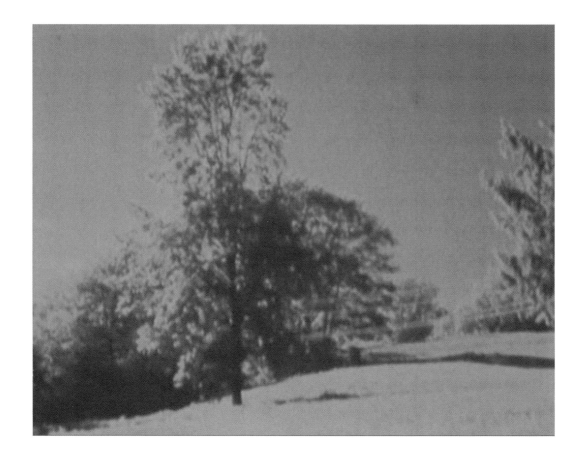

background. Towards the last ten seconds of the film, the time-lapse shifts into a 'real-time' recording. Whilst the film image is only a semblance of the world, it reflects reality, and retains a trace of its referent in its indexicality. *Tree Again* explores the idea of trace, as the complex collage of the tree comes together through natural phenomena.

Kren's other films in which landscape and trees feature prominently include: *3/60 Bäume im Herbst* in which the branches of trees are juxtaposed through a rapid montage; *31/75 Asyl* where holes cut into cardboard masks and rewinding/re-filming create a collaged landscape; and *32/76 An W + B* where a negative image, printed as a large slide, is suspended in front of the camera, aligning and misaligning with the same 'positive' view shot through a window. In all of these films, as with others, such as *5/62 Fenstergucker, Abfall, etc.*, *15/67 TV* (1967) or *49/95 tausendjahrekino*, Kren's mode of observation takes two main forms, either peripatetic (walking in fields or streets) or a fixed viewpoint (often from a window). Unlike *Trees in Autumn* where the branches of

the trees are seemingly in proximity to the frame, frequently breaking from its constraint, there is a sense of distance in *Tree Again*. The subject is an occurrence 'in frame'. Things are further away, at a distance; grazing animals moving around seem small as they scatter about in fragmented animation; the clouds roll across the sky in deep perspectival depth.

In *Tree Again* Kren makes distance a form of immersion however. Whilst taken from a fixed point-of-view, the landscape is not beheld from outside; distance does not objectify; the image is constantly fluctuating on the film surface. The surface becomes a question of the different registration of depth in the image, that is, of the complexities such investigations imply; that times and spaces are distant – indeed never there as such – and are brought to reflection. What appears as a whole image is constituted through its parts – multiple layers and colours in time – and it constantly seems to disintegrate as light shifts rapidly. Kren appears not to have had a predetermined vision for the film, no specified outcome that would accord with an intention, not least of all because of the uncertainty surrounding the use of the out-of-date infrared film stock and its technical characteristics. This emphasizes the contradictory nature of the image and what one sees in it: infrared light, with a wavelength of 800 nanometres to 1 millimetre, extends beyond the visible electromagnetic spectrum of human visual perception, which spans 400 to 700 nanometres. The spectral landscape in *Tree Again* brings forward something from below the surface, in the form of a trace that is ordinarily invisible. Conversely, many forms of representation rely on invisibility, in terms of the discontinuity that is masked by conventions such as the 180 degree rule or, more contemporarily, the momentum of fast-moving action sequences. In contrast, *Tree Again* is at once turbulent in the successions and changes of the tree and landscape, and yet also calm, flowing and ethereal. Absence is always present in cinema, but its presence is mostly obscured. *Tree Again* seems to embrace this however, in its appeal both to continuity and discontinuity, fragmentation and flow.

Film and video can be seen as part of an evolutionary/manufacturing process, whereby plant-based cellulose is transformed into the celluloid filmstrip; sedimented organisms (oil) are turned into plastics; aluminium is used in camera bodies; silica in lenses; silicon in microchips; and likewise the use of organic light-emitting diodes (OLED) in videographic technologies. The image of nature becomes familiar (naturalized as such), and further mediated within technological reproduction, sedimented into the apparatus and its histories. Natural resources are divided into discrete parts, as is the 'idea' of nature, re-animated into a new conglomerate. *Tree Again* explores this as figure and ground, engaging the technology, and the questions of compatibility and difference between the two-dimensional semblance of reality on-screen and its referent. In *Tree Again* the image often nearly bursts into abstraction; the flurries of colour and flitters of light present a landscape always on the brink of vanishing. What is perceived on one hand as a whole image is constantly restructuring. This fluctuation of the image means nature appears as becoming something other in the film.

In 1978, with *Tree Again*, Kren was not alone in his approach to the filmic investigation of natural phenomena and the landscape. A number of other European and North

American filmmakers were also using structural and systematic approaches around this time. The filmmaker Rose Lowder developed what Scott MacDonald calls an 'Ecological Cinema' (2001: 82–87). Films such as *Retour d'un Repère* (*Recurrence*, 1979) or *Champ Provençal* (*Provençal Field*, 1979) feature meticulous investigations of landscapes, including trees, with sequences that involve varying focal lengths, varied framing and rapid in-camera editing. In *Recurrence*, shots of a tree from the window of Lowder's Paris apartment are used in reflective permutations involving different formations of its foliage. She comments: 'you're filming a tree that's moving around; it's never in the same position when you come back to it. The structure is repetitive, but it reveals a developing reality' (MacDonald 1997). This 'developing reality' parallels Kren's film in which the morphing tree is at once always 'that tree there', but also fluctuating and never there, or at least changing in motion. The systems-based approaches often employed by Kren also correspond with the emerging operations of computers and pixels. At the same time that Kren's investigations explored the bounds of filmic representation, through images of trees, in the United States, Steina Vasulka was looking at natural forms in relation to an investigation of the electronic video image. In *Selected Treecuts* (1980) the 'contrast between the "real" camera images of trees and the frozen, digital computer images forms an essay in motion and stillness, the organic and the synthetic, tracing a trajectory from the photographic to the electronic' (Vasulka 1980).

In the United Kingdom Chris Welsby also developed a systems-based approach to landscape films in the 1970s, drawing on influences from painting and the logic of sampling emergent in computer technology. In 16mm film works such as *Seven Days* (1974), *Cloud Fragments* (1978) and *Sea/Shore* (1979), 'the mechanics of film … interact with the landscape in such a way that elemental processes – such as changes in light, the rise and fall of the tide or changes in wind direction – are given the space and time to participate in the process of representation' (Welsby 2001). More recently Welsby has moved towards other forms of landscape art, as in the installation *Tree Studies* (2006). In this piece, the single-frame recording methods employed in earlier films have evolved into a dialogue with computer code, using live data from weather systems to control the playback of digitized footage of a tree from three perspectives. As *Tree Studies* works through the tensions of a technologically mediated response to nature for the twenty-first century, so *Tree Again* envisaged these questions for its time. Where Welsby's new work engages the loop and non-linearity inherent to computers, Kren's films work in relation to the finitude of the photogram and the chronology of the filmstrip.

Welsby has said that his films are explorations of transient nature, and of the complex interactions of natural phenomena. In this sense too, *Tree Again* traces the seemingly insignificant through the focus on everyday fleeting moments. The combination of systems, images and colour evoke a sensation of nature within the form and content of the film that is experienced as presentation, rather than representation, so to speak. It is ephemeral and on the verge of nothing: the combination of clouds, wind, light and leaves expresses the work's fundamental instability (the fact that when the out-of-date

film came back from the lab it may just have been blank). That may well have been the case of course, given the out-dated stock Kren used. Reflecting on the film himself, Kren said, 'I spent 50 days shooting this film, without any hope of anything at all being on the film. And I thought, I'm totally crazy. That's the way it is with all the films I've made – the adventure that I'm never completely sure what the end result will be' (Burger-Utzer and Schwärzler 2004: 16).

References

Burger-Utzer, B., and Schwärzler, D., 2004. *Kurt Kren Structural Films.* DVD booklet. Vienna: sixpackfilm.

MacDonald, S., 1997. Rose Lowder Interviewed. *Millennium Film Journal,* [online] 30/31. Available at: http://www.mfj-online.org/journalPages/MFJ30,31/SMacDonaldRose. html [Accessed 26 November 2014].

MacDonald, S., 2001. *The Garden in the Machine: A Field Guide to Independent Films about Place.* Berkeley, CA: University of California Press.

Vasulka, S., 1980. *Selected Treecuts.* Available at: http://www.eai.org/title.htm?id=1109 [Accessed 26 November 2014].

Welsby, C., 2001. Artists Statement. Available at: http://www.sfu.ca/~welsby/Intro.htm [Accessed 26 November 2014].

Miscellaneous Works and 'Bad Home Movies'

Nicky Hamlyn

The third DVD of Kurt Kren's films as published by *Index* contains a miscellany of work that fits into neither the structural-themed first disc nor the documentation of Material Aktions by Mühl, Brus and others of the second. Some of the films are discussed by Barnaby Dicker (*Tausendjahrekino* and *Snapspots (for Bruce)*) and myself (*Venecia Kaputt, No Film*) in separate essays in this volume. Of the remainder, closer examination reveals that there are several interesting themes, preoccupations and connections with the films on the other discs, even if the films in themselves are not always as strong.

The aesthetic negativity and terse cultural critique of Kren's oeuvre is evident in much of the work. *22/69 Happy End* consists of fragments of formulaic Hollywood movies – sword and sandal Epics, Biblical dramas, Thrillers and Westerns. These are glimpsed as accelerated, black-and-white fragments, filmed blind off the screen in several different cinemas, turning the most hidebound, generic forms into more or less abstract light play. The speed gives the general impression of blurred imagery, punctuated by sombreros and faces, sometimes just about recognizable as Charlton Heston or John Wayne. *Happy End* seems to offer something like the experience of seeing 24 different images every second so that one has the sensation of experiencing an all but ungraspable flow of diverse images. The speed is much too fast to permit one to follow any dramatic action. Thus, the films are deprived of the continuity that is at the heart of their kinetic economy. These sequences, which form the bulk of the film, are punctuated by four brief sexually explicit shots. The close-up shots of intercourse, presumably supply the film's titular 'happy end': a substitute, firstly for the happy endings that the movies normally supply, and secondly for real sex, whose representation here is perfunctory and banal, rendered in ugly grey tones. The ugliness is a kind of measure of the distance between observing and participating. It also suggests that while it is entirely normal to watch action movies, as opposed to participating in the activities represented therein, the same disposition in relation to represented and actual sex is considered perverse. The final brief image of conjoined genitalia at rest is a blunt metaphor for the anti-climactic banality of most Hollywood conclusions.

Like *Schatzi*, *24/70 Western* is composed from a re-filmed single photographic image, in this case a poster showing the mutilated bodies of victims of the My Lai massacre, shot in extreme close-up. At first sight the images appear to be pornographic, until one recognizes the glimpses of piled up flesh as the naked limbs and torsos of babies and adults. The title is surely ironic, a reference to the Western genre, with its celebration of the rapacious conquest of the American West, here extended and updated to the Vietnam

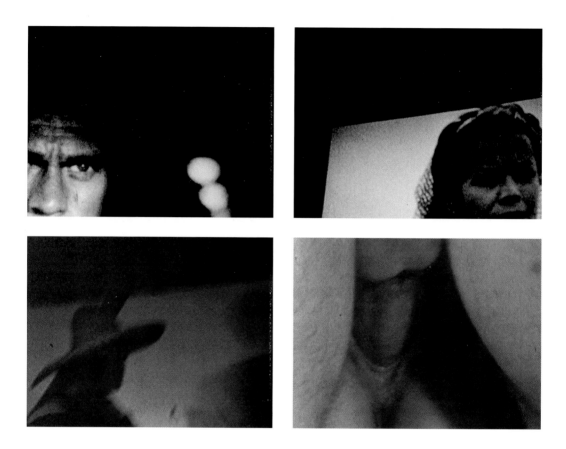

22/69 Happy End

War's westernization of the 'East'. *Western*'s images seem all the more shocking for our only being able to glimpse them.

The film ends with another Kren trope. We see what seems at first to be an apparently unrelated and extremely brief high-angle shot of two figures walking in a suburban location of unpaved road, timber framed houses and back gardens. This invites us to make connections between this mundane, tranquil setting and the evidence of the horrendous violence displayed in the poster, violence whose exposure through the mass media helped to speed the United States' chaotic withdrawal from South East Asia.

27/71 Auf der Pfaueninsel (familien film) significantly extends Kren's practice of making films with titles that are sometimes longer than the images they precede, such as *No Film* and *Venecia Kaputt*, which are also discussed here, in effect blurring the distinction

between the two. The opening credits, consisting of the names of the people who will appear – Günter Brus, family members and friends – plus the regular 'copyright kren' and 'ende' cards, run for just over one minute, while the film itself lasts 23 seconds. There are twice as many title cards as image shots: ten of the former. Of the latter, the first is effectively a reiteration of the 'günter brus' title card, since it shows Brus forming his own name from that of a similar one – Martin Brunshus – printed on the back of a tourist coach, which he achieves by obscuring some letters of the operator's name with his hands. This is followed by two near-identical mid-shots of Brus looking into an animal enclosure, separated by a jump cut. The fourth is a haphazard, handheld, diagonally framed angle on some trees, and the fifth follows the adult group from behind, while in the foreground Brus plays a kind of game with a young girl by walking around her in circles. The camera half-follows his movements, before the film abruptly ends.

21/71 Auf der Pfaueninsel (familien film)

21/71 Auf der Pfaueninsel (familien film)

The extreme brevity of *Auf der Pfaueninsel* and the small number of its shots raise the question why there are two near-identical ones of Brus. From a conventional point of view, one of the two is obsolete, meaningless, and a negation of what shots are supposed to be and do, which is to contribute something to the film as a whole. By inserting an unnecessary shot into what is already a scant and cursory structure, Kren undermines his own logic, since without it the film can be read as a home movie of a day in the park. Kren thus creates something almost abstract with respect to the shot's second appearance, since the information provided by the first is easily absorbed, leaving the second to be read as a configuration of light and shadow that appears as a man in a park. If this is going too far, the repeat at least hints at a putative looping, a device that would similarly put the two shots at odds with the rest of the work. On the other hand, he could have created an entire film of shots of Brus looking into an animal enclosure, in which case each would testify to the inexhaustible variations that produce something slightly different each time, thereby

redeeming the redundancy of the second shot. The repeated shot hints at this possibility without enacting it. Thus, Kren plants a thought-provoking device in what is otherwise an utterly banal sequence.

33/77 Keine Donau is perhaps Kren's most technically ambitious film, ranking with *31/75 Asyl* and *37/78 Tree Again* as a work that tests the medium's technology to its limits. Like those other films it is also a highly risky experiment. Where *Tree Again* was shot on out-of-date infrared film, meaning that there was no guarantee of an image, the demands of making *Keine Donau's* led to the failure of Kren's Pathé camera on account of the multiple rewinding and in-camera superimposition. The film was achieved only at the fourth attempt (with a clockwork Bolex) and comprises 13 exposures on a single strip of 16mm celluloid. Each exposure involved the same framing of a view of the backs of houses and apartment buildings in Vienna, but was made at a different focus setting. This results in varying degrees of mis-registration and hence blurring, since a change of focus also affects the size of the various forms within the shot. Thus focus is everywhere and nowhere. The result is an image that is sometimes translucent and shimmering, while at other moments it has a unique density of colour and matter, as if the layers accumulate to create an impenetrable material depth. This is one of Kren's most beautiful films, punctuated by frequent, stunning jumps in colour and atmosphere, as a result of having been shot in a variety of wintery weathers.

34/77 Tschibo is animated from notebook pages from the years 1970 to 1977. Each year is indicated by a title. The film brings a shooting system of frame numbers, determined as in several of his other works by the Fibonacci series, into conjunction with a variable but homogeneous subject – Kren's handwriting, sketches and diagrams. The short sequences of pages are frequently interspersed by blurred single frames of what looks like a fast tilt down an unidentifiable surface. Thus, lively movement is generated from the variable and fortuitous sequencing of similar pages of writing on the one hand, while on the other hand actual movement is frozen in the single blurred frames. Because they are single frames they cannot generate a movement on their own, but rather they punctuate, or interrupt, the animated pages. The image occasionally jumps into a more continuous and fluid mode when the camera comes across some shooting diagrams for other films, though it is not possible to identify what these are. *Tschibo* is a testament to the unstoppable way in which any conjunction of most kinds of single images (the monochromatic frames of 'flicker films' being the only absolute exception) will coalesce as apparent movement. Similar to *Western*, Kren inserts another unrelated image into *Tschibo* shortly before it ends, this time a much more cryptic view of traffic in a night-time cityscape. One link might be in the limited range of colours of both the notebook pages and the traffic shot; another might be the film's cycle of stop/go motion.

39/81 Which way to CA? traces Kren's journey from the east to the western United States in mostly mid-toned black and white. Although shot with a handheld camera and both humorous and casual in terms of its subject and general approach, the film is nevertheless full of carefully composed shots of Kren's car in a variety of locations. In effect it's a self-

39/81 Which Way to CA?

portrait cum travelogue in which the car replaces the human subject. Kren described this film and others like it, made during his time in the United States, as 'bad home movies'. The shot of Japanese tourists posing for a photograph at the official spot at the southern end of the Golden Gate Bridge anticipates his last film *50/96 Snapshots (for Bruce)*, which is composed entirely of such images, though made in Vienna. As in *Auf der Pfaueninsel*, there are pairs of near-identical shots, but they operate very differently in this film, where they show the front of Kren's car protruding into the left half of the frame. This device is reprised again in *40/81 Breakfast in Grauen*, which begins with documentation of young people making a movie on a rubbish tip, followed by sequences of a group of bearded men eating among piles of salvaged timber. Among these images, Kren puts himself into two almost identical consecutive shots. Although the film is improvisatory and light in its concerns, the shots are again carefully framed, in this case, so that the looming timber in the foreground, filmed from a low angle looking up, dwarfs the human subjects. This is a consistent feature of Kren's films, where people are often represented as machine or ant-like and miniaturized, viewed from a distance as quasi-alien beings, or are displaced into machines, as in the car in *Which Way to CA?*

40/81 Breakfast in Grauen

41/82 Getting Warm, another film of beautiful colour, reprises the green and red theme of *17/68 Grün-Rot*, here through the framing of red-painted roof trusses carried by an identically coloured lifting truck, filmed against blue-green trees and sky, alternating with similarly toned interiors of people watching television. The theme develops through a variety of colour contrasts that increase in saturation before returning to a shot of a glorious red suburban sunset dotted by greenish neon signs in the dark middle ground.

43/84 1984, features Ronald Reagan in an interview, filmed off a television screen and superimposed in up to four layers. This is in keeping with Kren's consistent strategy of mediating his representations of humans one way or another, as in *28/73 Zeitaufnahmen*, a pixilated portrait of film director Hans-Peter Kochenrath in multiple layers, or the extreme close-up re-filming of half-tone portraits in *2/60 48 Heads from the Szondi-Test*. Even in *Auf der Pfaueninsel*, where people are recorded in a relatively straightforward manner, the doubled shot of Brus disturbs the film's putative naturalism, while the rest of the family are filmed from behind.

In *44/85 Foot'-age shoot'-out*, Kren takes us from the inside of his fridge (which contains a variety of German and American products), into his hallway and out into downtown Houston. He makes some loose connections between US-European hybrids by juxtaposing the shots of Houston, a 'Western' city that could be anywhere, with Ennio Morricone's music for *The Good the Bad and the Ugly*: a fitting choice, as an exaggerated take on the strangeness of US culture, for what must have seemed an exotic landscape to a Middle European born between the two World Wars. By his own admission, Kren was unhappy with this film, having been pressurized into making it when he wasn't in the mood.

Kren's ten-year period in the United States was unarguably a low point in terms of his production as a whole, a sense reinforced by the fact that his last few films, made after his return to Vienna, are noticeably stronger and more purposeful. The American films are wistful, reflecting the melancholic passage of a drifter at large in an alien culture. For all their weaknesses though, they are never carelessly or thoughtlessly made. They evidence an eye ever receptive to formal possibilities and conjunctions, and they also express a sense of humour, which is more explicit here than in his major works.

Vernacular Studies: *49/95 tausendjahrekino* and *50/96 Snapspots (for Bruce)*

49/95 thousandyearsofcinema (1995, 35mm/16mm, 2:40 min, colour)

50/96 Snapspots (for Bruce) (1996, 35mm/16mm, 4:12 min, colour and b/w, silent)

Barnaby Dicker

The movies [are] a kind of negative paradise. 'Sightseeing is the art of disappointment,' [Robert Louis] Stevenson noted. The definition applies to films and, with sad frequency, to that continuous and unavoidable exercise called life.

<div style="text-align: right;">(Borges 2001: 263)</div>

Borges' sequence of propositions provides a useful framework with which to approach Kren's last two films. Equally, I hope to show how these films rescue Borges' perspective on life and film from its negative dead-end. In this regard, I am principally interested in the alignment of the films in question with the vernacular 'snapshot' and the public spaces or 'tourist spots' in which they are habitually taken. This alignment occurs at the level of cinematography's frames or photograms, through which Kren foregrounds the photographic 'snapshot' economy of cinema. In doing so, I suggest, Kren harnesses camera-based sightseeing as a means of exploding Borges' 'negative paradise' of the 'movies'.

Before looking at Kren's films, a brief discussion of the 'snapshot' and tourist photography is germane. Richard Chalfen usefully distinguishes between 'chemical-technical' and 'folk art' accounts (Chalfen 1987: 71–74). The former relates to the technological development of sufficiently rapid exposures that radically reduce the chance of producing a blurred photograph. This aspect underpins two further technological developments that are relevant to consider here: photographic cinematography (exposures made at rates upward of around 12 frames per second) and still photography made 'on-the-fly' and 'off-the-cuff', embodied by the handheld camera. Chalfen's latter category, 'folk art' photography, is associated with terms such as 'domestic', 'amateur', 'vernacular' and 'quotidian'. According to Brian Coe and Paul Gates:

It is not the length of the exposure but the intention behind the picture which distinguishes the snapshot: [it is] a photograph taken simply as a record of a person, a place or an event, one made with no artistic pretentions or commercial considerations.

<div style="text-align: right;">(Coe and Gates 1977: 6)</div>

49/95 tausendjahrekino and *50/96 Snapspots (for Bruce)* throw such definitions into question by appropriating the terms of the photographic snapshot (in both 'chemical-technical' and 'folk art' definitions) as a vanguard cinematographic practice.

Susan Sontag notes that 'photography develops in tandem with one of the most characteristic of modern activities: tourism' (2002: 9). Chalfen confirms this by referencing early twentieth-century Kodak adverts aimed at tourists. He also warns against unfounded reductive and negative conceptions of the 'tourist photographer' (1987: 101). Turning to experimental film, it is noteworthy that Stan Brakhage, in his essay 'In Defense of Amateur', speaks of himself as a 'camera-laden "tourist" of [his] own environment as well as in those distant places' he travels to (2001: 150).

When watching many of Kren's films, one is aware of a 'high' intellectual proposition or game housed enigmatically in a 'low', mundane, base, rough-looking body. With *49/95 tausendjahrekino* and *50/96 Snapspots (for Bruce)*, this interplay takes an ethnographic twist, underlining the muddled, worldly interactions between 'high' and 'low'. Kren ensconced himself at two major tourist spots in his native Vienna: Stephensplatz, site of St. Stephen's Cathedral, and the Johann Strauß II Memorial in the Stadtpark, respectively. The films are essentially made up of stop-frame/handheld time-lapse footage of tourists involved in taking or posing for their own group's photographs. The films do not replicate tourist photography, rather *49/95 tausendjahrekino* holds a mirror up to it, while *50/96 Snapspots (for Bruce)*, sits on its shoulder (though these two modes are actually evident in both films).

Kren's studies of a social activity, which Chalfen calls 'camera recreation' (1987: 100), can be seen as critical, humorous and simple, impersonal but also humanistic, and perverse. Voyeurism, however, plays little role in these films, not only because the tourists are unidentifiable as individuals, but also because the films have been generated in public spaces where cameras are a given and – generally speaking – there are no embargoes or suspicions over photography taking place. Furthermore, the films hinge on this circumstance, suggesting the image of Kren reaping a harvest from two fields of photography where all cameras are equal. Kren's camera is thus aligned with the tourists' cameras, all the while seemingly serving different ends (here lies the perversity). Particularly strong in these films – bonding filmmaker, subjects, form and content – is Kren's use of the 'snapshot' mode, that is, a photographic economy, articulated through the cinematographic frame or photogramme; admittedly stretching, or perhaps we should say, translating, the 'snapshot' into tiny clusters of slightly disjunctive frames.

49/95 tausendjahrekino was commissioned as a trailer for *Hundertjahrekino*, an Austrian project celebrating the centenary of cinema. For the most part, innumerable tourist photographers flash past on-screen, 'caught in the act', their cameras aimed slightly aloft. In the last moments of the film, Kren reveals the object of their attention: St. Stephen's Cathedral.

Unlike many of Kren's films, *49/95 tausendjahrekino* has an audiotrack, which is culled from a scene in Peter Lorre's *Der Verlorene* (1951). Kren retained the audio's original chronology, but truncated it, and included 30 seconds of silence midway through his film.

Although Kren apparently saw no 'symbolic relationship' between his film and the audio that he has used, the viewer cannot help but seek connections on account of the selection and editing of the material that emphasizes evocative and repetitive phrases (Scheugl 2004: 16). Kren jettisons the naturalistic, narrative context of the dialogue, causing the material to become at once singular – the specific utterances and sounds – and universal, poetic – the words spoken. Below is a slightly truncated, translated, transcription of the audiotrack:

– Can you give me a light? I know you. I don't know where from – but I know you. Do you know me? Come nearer, into the light.

– Stop bothering the man, he doesn't know you.

– Of course he doesn't know me, I'm only a little man. Nobody knows a little man. But I know YOU. Do you know me? You don't know me. You don't know me. And you don't know me – nobody knows me.

'Do you know me?' is asked in many iterations and garners different responses.

– Young lady, do you know me?

– Well, really! What a vulgar man!

Silence for c.30 seconds.

– What do you want now? Can't you see that I'm talking to this man?

– I could be wrong, but…

– Come on, leave me alone.

– …I have seen these eyes before.

– If you want to make trouble, then go to another seat.

– There can be no mistaking… I definitely know these eyes.

– I've already told you, leave me alone.

– No offence meant.

– Terrible how pushy some people are! Doesn't he realise that you don't know him?

– Of course I don't know him!

– How should somebody like you know a person like that?

Air-raid sirens begin.

– There we have it! Sirens.

– Air-raid sirens! Everybody into the cellar for heroes.[1]

The refrain of 'Do you know me?' stages an ambiguous relationship between the film's visual and auditory/verbal orders. The speech oscillates between appearing to be directed towards the viewer, from the tourist photographers, and vice versa, as if emanating from the audio track on behalf of the viewer. The mention of light, eyes and even seating suggests the medium and environment of cinema. Furthermore, the audiotrack's origin, being a 'classic' film directed by an important actor, strikes up a link with (near native) film history, which looks beyond the avant-garde to narrative film – presumably a gesture on Kren's part to promote the *Hundertjahrekino* project and its aims. There is yet another, darker level at which Kren's use of material from *Der Verlorene* – a film about the guilt of a German war criminal – holds significance to *49/95 tausendjahrekino*. Peter Tscherkassky states concisely:

> Kren associates the anniversary of cinematography with the Third Reich, which was to last a thousand years. 'One Hundred Years of Cinema' also implies images that rule for one hundred years, images which have lost their referentiality and come to dominate reality.

> (2000: 151)

(Recall Borges' 'negative paradise' in which a disappointing cinema has come to colour life itself). The use of material from Lorre's film underlines and fleshes out the politicized wordplay of Kren's title. If Lorre's film sought a degree of mass empathic healing, Kren's involves a degree of estranged black humour. Kren's engagement with the cultural legacy of the Third Reich is not the concern of this essay and has been discussed elsewhere (Büttner et al. 2006). The relevance of this matter here lies in the ways Kren can be seen to identify, and perhaps mock, a certain cultural fascism or imperialism that is present in film history, or perhaps history in general, given the way the film closes on St. Stephen's Cathedral. On this point it is worth noting that the Cathedral site was officially consecrated in 1147 (although, by then, it was already a long-established place of worship). St. Stephen's Cathedral can thus be placed, roughly speaking, at around

one thousand years prior to Kren's film. By extending cinematography's lifespan, Kren rejects its inception date of 1895, in contradistinction to the explicit outlook of the *Hundertjahrekino* project. By directing us towards St. Stephen's Cathedral, Kren invites us to question when cinema began and by what criteria we recognize it. Certainly the tourist photographers constitute some kind of audience for the cathedral both as an object and as an establishment designed to house and group them. Kren shows us that the tourist photographers constitute an active audience.

The tourists' photographs record their pilgrimage to St. Stephen's. This activity charts a movement from the private sphere into the public sphere and back to the private sphere. As a film purposefully intended for the public sphere, *49/95 tausendjahrekino* stands in opposition to this final introspective turn. By photographing the photographers, Kren records a sample number of photographic acts, of which we can imagine many more. Furthermore, his photographing of the photographers also conceptually doubles their activity. This mass of dispersed photographs, Kren implies, if gathered together, would form a thousand years of cinema.

Many of these issues also underpin *50/96 Snapspots (for Bruce)*, the two films clearly using a shared idiom. If, in terms of reflexive strategy, *49/95 tausendjahrekino* points us towards cinema and the middle ages, *50/96 Snapspots (for Bruce)* points us towards snapshot photography and the modern era. Standing in Vienna's Stadtpark, Edmund von Hellmer's 1921 gold-plated, bronze statue immortalizes Johann Strauß II as an icon of popular classical music. The Viennese authorities speculate that this must be the city's most photographed monument (Vienna City Administration, n.d.). Kren pitches up at this site with a viewpoint that may be described as *just beside the tourist photographer*, keeping the famous monument – around which people gather – constantly in view. A visual joke emerges: Strauß performs tirelessly for the ever-changing groups of posing visitors, Kren's rapid shifts in composition causing the statue to appear animated, vigorously bowing his violin. After nearly five minutes of this silent waltz, Kren ends with a title screen reading 'et cetera'.

In these films, tourism as the 'art of disappointment' appears to have been enthusiastically embraced. In their 'negative paradise' the tourist photographers perform what Chalfen calls 'prescriptive behaviours' (1987: 49), showing limited variety in their stances, and consequently, we might assume, their photographs. Here, in line with Borges and Tscherkassky, photography has supplanted lived experience. A quotation from Henri Bergson offers a slightly different perspective:

Though all the photographs of a city taken from all possible points of view indefinitely complete one another, they will never equal in value that dimensional object, the city along whose streets one walks.

(1946: 189)

Bergson reminds us that photography is no world surrogate, rebuffing the description of a disappointing world encountered by Borges. Following Bergson, I am inclined to see Kren as suggesting that no reality exists that can be lost; reality is always what we have; and photographs are simply a part of it. I see Kren as playing on the limited value of any report or document. Despite enduring monuments and repetitive behaviour, and entertaining for a moment the possibility that all space *could* be photographed, temporal change would forever demand a new record. Furthermore, the variability of photography would exorbitantly multiply the ways a given space could be photographed. Additionally, the production time of this continuously updated report would overshadow reception time and disavow its very purpose. Hence Kren's 'et cetera' and a deeply flawed, disjunctive, decentralized 'thousand year old cinema' desperate for landmarks. This is no longer Borges' 'negative paradise', but a positive limbo. The upbeat gesture buried here points to the absurdity of a comprehensive account of film and photography, thanks to the necessary inclusion of unquantifiable vernacular practices.

For Kren, '*linking* the images is more important … than the individual images' (*Keine Donau – Kurt Kren und seine Filme* [Hans Scheugl, 1988]). This is certainly demonstrated in his last two films, where the innumerable tourists, seen frame after frame, reach critical mass. Discussing Kren's work, Peter Weibel writes: 'rapid cutting breaks up not only continuity of movement and light, but also perception [Wahrnehmung] … establishing an abstract time and a filmic reality' (1996: 76–77). In Kren's rapid cut, frame-based films, the form of linkage, operative at the depictive level, is disjunctive, fragmented. Here, depiction of movement and continuity is at a minimum. The faux-Edenic spell of cinema, feared by Borges to be smothering reality, is shattered. In its place, Kren offers what Weibel calls 'filmic reality' and an abstract time formed, in part, by pooled snapshots gathered at source. Kren is less concerned here with the material and technological structure of cinematography than with how that material and technological structure is humanly coded. In these films, Kren's mode of working directly responds to the activities of those around him at the time of filming; we imagine him attempting to catch, with his own snapshots, the activities of his tourist companions. As in other films (for example *15/67 TV* and *38/79 Sentimental Punk*), he presents us with group events and portraits rooted in public space.

Kren shows us that sites thronged with tourist photographers provide valuable spaces for reflexive observation. He provides indications, perhaps oblique, about how we should relate to one another and where we should look, so deeply embedded, as we are, in a camera age.

References

Bergson, H., 1946. Introduction to Metaphysics. In: *The Creative Mind*. New York: Philosophical Library.

Borges, J.L., 2001. On Dubbing. In: *The Total Library: Non-Fiction 1922–1986*. London: Penguin.

Brakhage, S., 2001. In Defense of Amateur. In: B. McPherson, ed. *Essential Brakhage: Selected Writings on Filmmaking by Stan Brakhage*. N.p.: Documentext.

Büttner, E., Dewald, C., et al., 2006. *Filmhimmel* **Österreich**, *Teil IV: Techniken des überlebens/Programm 047*. Wein: Verlag Filmarchiv Austria.

Chalfen, R., 1987. *Snapshot Versions of Life*. Bowling Green: The Popular Press.

Coe, B., and Gates, P., 1977. *The Snapshot Photograph: The Rise of Popular Photography 1888–1939*. London: Ash and Grant.

Scheugl, H., 1988. *Keine Donau – Kurt Kren und seine Filme*, (dir. Hans Scheugl), Interspot Film, Vienna for ORF Austrian Television.

Scheugl, H., 2004. An Annotated Filmography. In booklet accompanying DVD *Kurt Kren: Structural Films*. Wien: Index.

Sontag, S., 2002. *On Photography*. London: Penguin.

Tscherkassky, P., 2000. Lord of the Frames: Kurt Kren. *Millennium Film Journal*, 35/36, pp. 146–152.

Vienna City Administration, n.d. *Stadtpark* [online]. Available at: http://www.wien.gv.at/english/environment/parks/stadtpark.html [Accessed 17 April 2013].

Weibel, P., 1996. Kurt Krens Kunst: Opseographie statt Kinematographie. In: H. Scheugl, ed. *Ex Underground. Kurt Kren, seine Filme*. Wien: PVS Verleger. pp. 51–90.

Note

1. 'Cellar for heroes' is an informal expression for bunker.

Colour Frame Enlargements and Pages from *No Film*

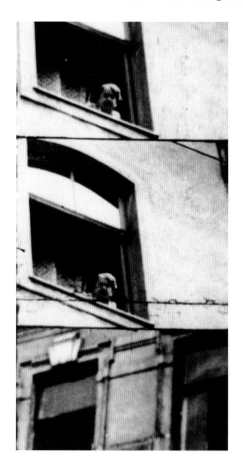

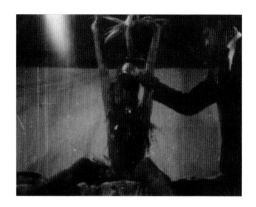

Colour Plate 1
Top left: *5/62 Fenstergucker, Abfall etc.*
Top right: *6/64 Mama und Papa*
Middle right: *7/64 Leda mit dem Schwan*
Bottom left and right: *17/68 Grün-rot*

Colour Plate 2
Top left: *18/68 Venecia Kaputt*
Top right: *23/69 Underground Explosion*
Middle left and middle right: *24/70 Western*
Bottom Left: *26/71 Zeichenfilm – Balzac und das Auge Gottes*
Bottom right: *28/73 Zeitaufnahmen(n)*

Colour Plate 3
31/75 Asyl

Colour Plate 4
Top left and right: *32/76 An W + B*
Middle and bottom: *33/77 Keine Donau*

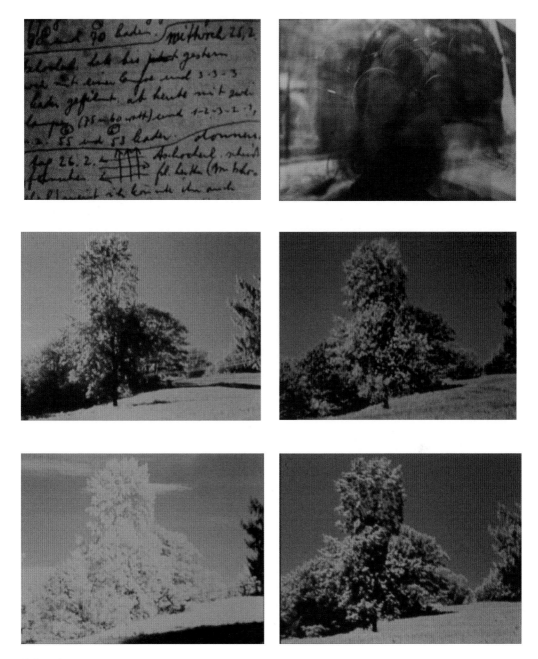

Colour Plate 5
Top left: *34/77 Tschibo*
Top right: *36/78 Rischart*
Middle and bottom: *37/78 Tree Again*

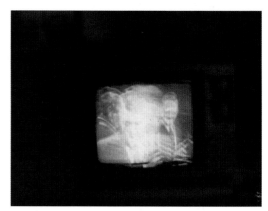

Colour Plate 6
Top: *41/82 Getting warm*
Middle: *43/84 1984*
Bottom: *44/85 Foot'- age shoot'- out*

Colour Frame Enlargements and Pages from *No Film*

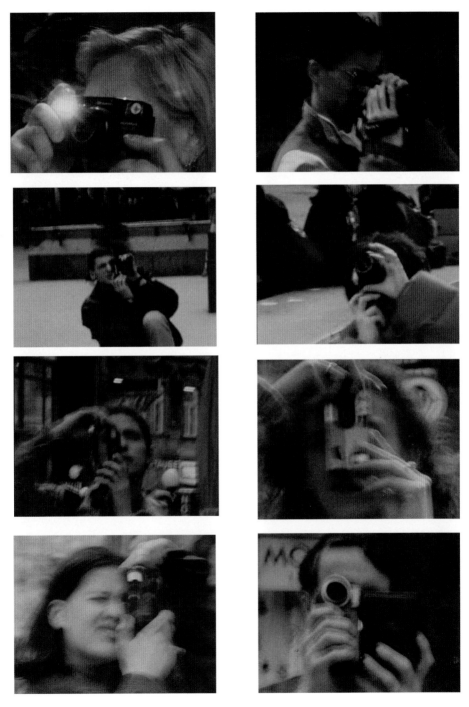

Colour plate 7
49/95 tausendjahrekino

161

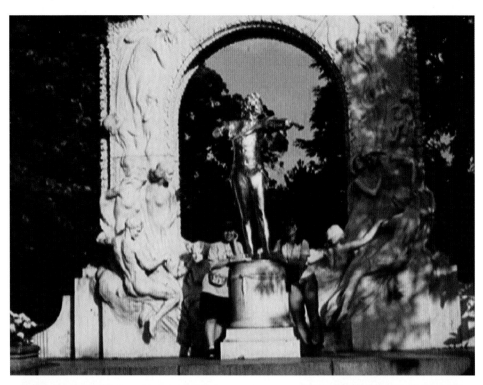

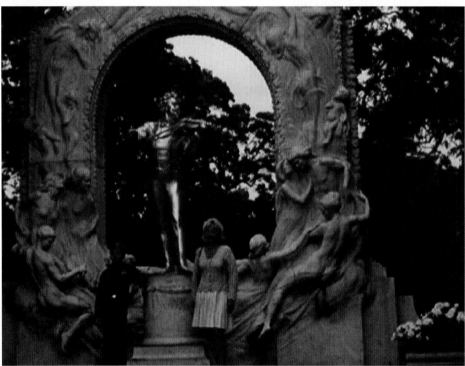

Colour plate 8
50/96 Snapspots (for Bruce)

Kurt KREN
No Film?

Beilage(n): Siebdrucke 2/13 (Hitler - Stalin)

2/13

©1991

Colour Plate 9: Front and inside cover from
Kurt Kren's *No Film* (a limited edition,
self-published book from 1991)

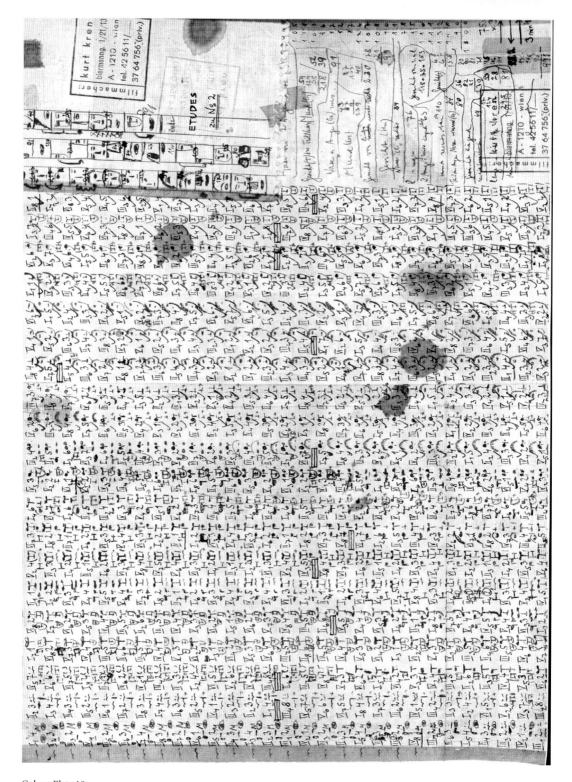

Colour Plate 10
2/60 48 Köpfe aus dem Szondi-Test

164

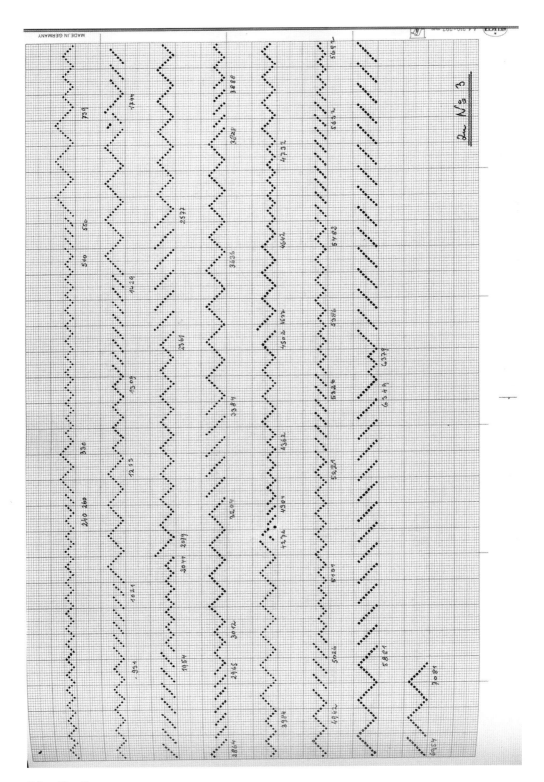

Colour Plate 11
3/60 Bäume im Herbst

165

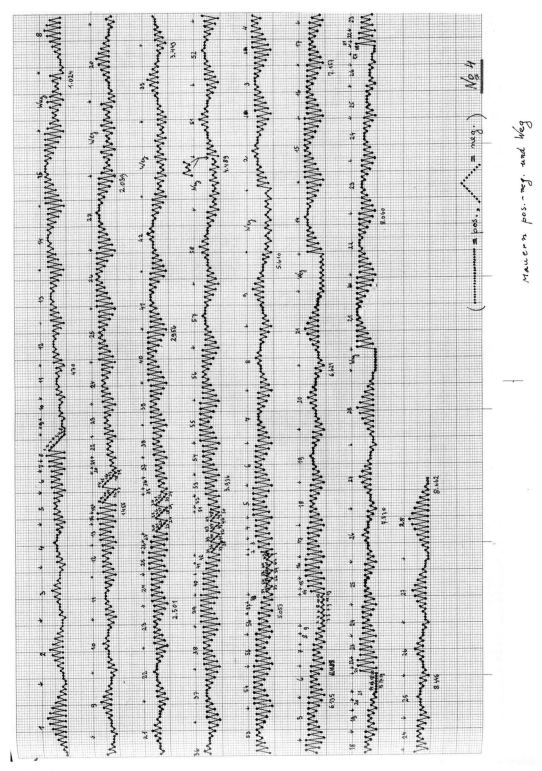

Colour Plate 12
4/61 Mauern pos. –neg. & Weg

166

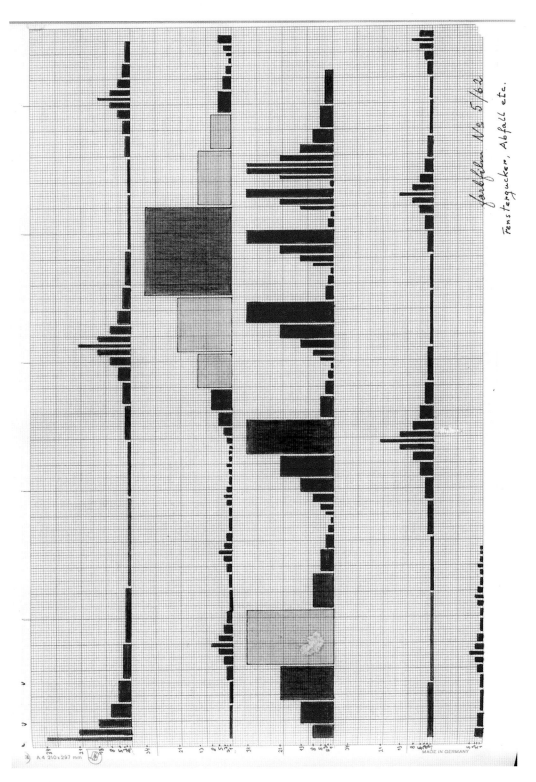

Colour Plate 13
5/62 Fenstergucker, Abfall etc.

167

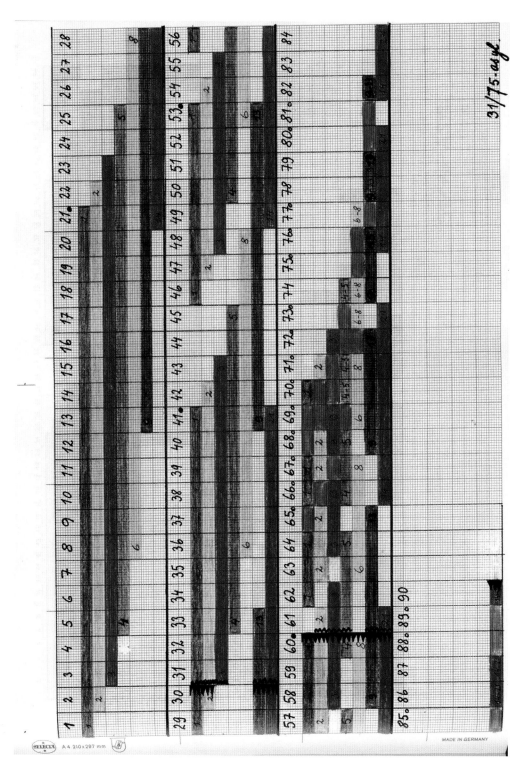

Colour Plate 14
31/75 Asyl

168

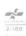

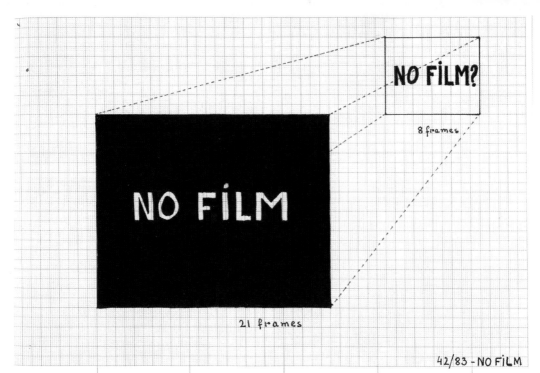

8 frames

21 frames

42/83 - NO FILM

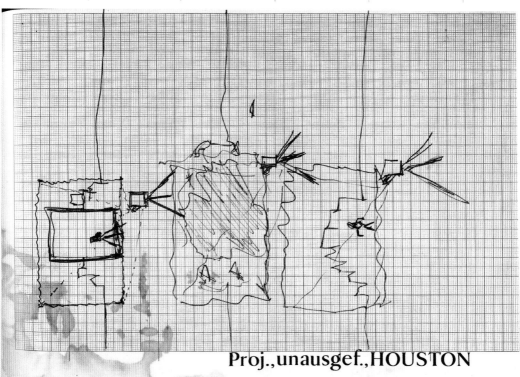

Top: *42/83 No Film*
Bottom: *Projekt, unausgeführt, Houston.*
(Unrealised project, Houston)

Reprints and Facsimiles

Collected Writings on Kurt Kren

Malcolm Le Grice

Some Thoughts in Retrospect on Kurt Kren

I remain a huge admirer of the work of Kurt Kren and am pleased that my writing about him played some small part in having his work seen and appreciated internationally. In my relative isolation as a filmmaker in the late 1960s in the UK, it is clear that my first encounter with his films helped me to understand some of the 'sense' of my own work. At that time I was aware of very few supporting cultural precedents so Kren, together with Peter Gidal and Birgit and Wilhelm Hein, helped reinforce what otherwise seemed a fragile direction.

In *Abstract Film and Beyond*, my stress was quite overtly on the formal qualities of experimental cinema. Under-playing the symbolic direction that had grown from surrealism was, in part, a bias and an oversight, but it was also a positive resistance to a direction which had come to dominate avant-garde film criticism. I am glad that in my *Studio International* essay on Kren I tried to integrate the symbolic and 'imagist' aspect of his work with the 'structural' and formal qualities. In retrospect I have no doubt that one of the features of Kren's films that had attracted me was the 'mystery' constantly implicit in his imagery – a feature I now talk of as 'latency' – the psychological charge when the meaning of an image is unresolved – not held under some dominating idea, concept or narrative but that is none the less motivated.

Now, as when I wrote the book and essay, I strongly resist a form of criticism that focuses on the artist rather than the work. Of course, the psychology and personal history of artists must underpin the content of the work they make, but I want to avoid treating this as 'primary' content – instead seeing a work as a public act where the spectator has an equal role in creating meaning not confined to decoding the vision, or worse, intention, of the artist.

Having said this, Kren's life as a child exiled to Holland during the Second World War, away from his Jewish Austrian family, left its mark in persisting difficulties he had in forming comfortable or confident personal relationships. It is difficult to imagine the formative experience of a child of 11 in Rotterdam at the outbreak of war not returning to his family and Vienna until he was 18 – and then, from my understanding, continuing to experience a deep sense of rejection. From my direct experience I saw in him a personal sense of uncertainty or reticence but this was never a coolness – he showed warmth and affection to other experimental artists and, as far as my minimal Austrian/German would allow me to share, an ironic sense of humour. I see some of these qualities reflected in

his work as, for example, a conflict between the restraint of the extreme mathematical precision of his editing and his frequently highly emotive imagery.

He endured a very long period of his life when his work seemed only to be appreciated by fellow experimental filmmakers and had little acceptance or support in official art institutions. I had some quite close, if occasional, contact with him in the early 1970s whilst he lived in Cologne with Birgit and Wilhelm Hein who, it must be recorded, constantly gave him both material and artistic support during some difficult years. I also visited him in Houston, Texas when, in his fifties, he made his living as a security guard in the Museum of Fine Art by night, sleeping in his car in the park by day. Fortunately, for a short period before his death in 1998, he enjoyed some belated but proper recognition in Austria and internationally through exhibitions, books and a small state pension.

Kurt Kren

First published in *Studio International: Journal of Modern Art* (London), November/December 1975, volume 190, number 978, pages 183–188.

The temptation in writing about Kurt Kren is to present him as some kind of father of European avant-garde film. His work is certainly held in very high regard by almost all the filmmakers this side of the Atlantic involved in so-called structuralist film. At 46 years old (born in Vienna on 20 September 1929), beginning his experiments with film on 8mm as early as 1953 and completing his first 16mm film in 1957, he has at least a ten-year start on those like Birgit and Wilhelm Hein, Peter Gidal, Werner Nekes, Peter Weibel, Valie Export or myself who otherwise have been the main generation initiating the 'formal' direction outside the US.

However, to see Kren in this way is somewhat misleading. Though his historical role is of great importance he should in no way be condemned to the history books, as he continues to be a leading figure of the avant-garde. Secondly, none of the innovators who started work later, in the mid-sixties, was a follower of Kren. Most, like myself, had already started in this direction before encountering Kren's films. The lack of information here about the American underground film was matched by a similar lack of exchange within Europe itself. I first saw a Kren film in 1967 or '68, during one of the early presentations of the London Film co-op. It was in a programme dominated by some very poor and obscure films from the US. (The first American works to be distributed here came mostly from Robert Pike's Creative Film Society catalogue, and my reaction was very unfavourable to what I came to realize later were films quite unrepresentative of the New American Cinema.) The Kren film, *10/65 Selbstverstümmelung*, was one of his less evidently formal works, but even so, I recognized a close affinity in filmic concept with the work I was doing. This was borne out by seeing some of his other films soon after, particularly *15/67 TV* which remains for me his most influential film.

In many ways, in post-war Vienna, the art scene revived as an independent force more quickly than it did in most other European centres. It was also less dominated by the powerful new movements originating in the affluence of post-war America. Though the development of the Austrian Direct Art and Material-Aktion movements of Brus, Mühl and Nitsch parallels the Happenings movement and has similar roots in *Abstract Expressionism*, the Viennese development was an independent growth from the already strong expressionist tradition of Klimt, Schiele or Kokoschka. Film experiment in Vienna also significantly preceded any other similar development in Europe and was likewise completely independent of the American Underground cinema. Apart from Kren's early 8mm films, which he does not consider as 'public' work, the first important post-war experimental film from Austria was *Mosaik im Vertrauen*, made jointly in 1955 by Ferry Radax and Peter Kubelka. In 1957 Kubelka made *Adebar*, Kren made *1/57 Versuch mit synthetischem Ton* and Marc Adrian began work on *Black Movie*. Though Kubelka collaborated with Radax on the one film, these four Viennese filmmakers were not a group; they worked separately and had no significant influence on each other. Kren and Kubelka, whose respective films represent the most radical innovation in film thought at that time, demand some comparison. By 1961, both filmmakers had produced at least three films, which together with contemporary work by Brakhage (particularly *Sirius Remembered*, 1959) and a little later Warhol (*Sleep*, 1963) brought about the biggest changes in concepts of film form since the early experiments of Man Ray, Leger, Eggeling, Richter et al. As such, I see these four filmmakers as the main precursors of the current direction of avant-garde cinema. In the case of Kubelka, the three films are *Adebar* (1957), *Schwechater* (1958) and the exceptional, blank screen, alternating black-and-white *Arnulf Rainer* (1960). For Kren they were *2/60 48 Köpfe aus dem Szondi-Test, 3/60 Bäume im Herbst* (both 1960) and *4/61 Mauern pos.neg. & Weg* (1961). Perhaps Kren's first 16mm film should be included as it certainly breaks significantly new ground, but it is not as clearly successful as the other three.

Though, unlike most other commentators, I have never considered Kubelka's *Unsere Afrikareise* to be more than a well-made but ordinary film; his three earlier films are rightly recognized as major points of reference, and it is a source of consternation and surprise to myself and many of my contemporaries that Kren's work is not similarly recognized by American critics. An atmosphere of recrimination has come to surround the comparison of these two Viennese innovators, and it is difficult to maintain an impartial stance, but my concern is with the contribution they make through their films.

Kubelka's best film remains the imageless, cinema-concrete *Arnulf Rainer*. Considering the time at which it was produced, it makes an extreme and surprising challenge to preconceptions about film content, eliminating both photography and representation. *Adebar* and *Schwechater* are also important and accomplished works, but their concept of abstracting kinetic qualities by high contrast printing and the use of negative, and counterpointing this with the orchestration of the montage, can be seen to fulfil a graphic function similar to certain abstract avant-garde films of the twenties (i.e. sequences from

Hans Richter's *Film Studie* 1926). Through the image contrast and the editing rate, the photographic trace is separated from the identity and association of the image. Movement and rhythm are thereby abstracted into the visual-musical play of forms, consistent with the often explicit aims of early abstract films. The development of this graphically abstract aesthetic in film had lagged behind through the lack of experiment between the wars. But by the late fifties, in comparison with contemporary developments in the other arts, it no longer represented as fundamental an aesthetic challenge as *Arnulf Rainer*, or posed as complex artistic problems as the Kren films of the same period. In fact, a major distinction in Kren's work is the broad rejection of the abstract-graphic solution to the search for new film form. The image never becomes divorced from the thing filmed or the processes of film. His work maintains a constant, tense dialectic between conception and structuring on the one hand and experience in the subjective, existentialist sense on the other.

With thirty-one 16mm works to date Kren's historical role in Europe is comparable to that of Brakhage in America, as is the way in which they each historically represent some aspect of the transition from the existential to the structural within their work. Though Kren's work chiefly initiates and contributes to the formal/structural axis, and my own bias will tend to stress that contribution, it is very complex at the imagist/associative level. The fullest examination of Kren as an artist needs to ask questions about the psychological basis of his imagery, through which biographical details would inevitably become significant. Though his films are in no way 'diarist' or directly autobiographical, not even to the degree to which Brakhage's are, he has always maintained an extreme existentialist stance which integrates all levels of his work with his life experience. I do not feel well qualified to deal with this aspect in the detail of psychological interpretation, but I cannot avoid some speculation or at least some general consideration of the work's functioning on this level.

As a Jewish child in Vienna, Kren grew up with the spreading anti-semitism of the emerging Third Reich and was sent to spend all the war years hidden in relative safety in Holland. He rejoined his family in Austria in 1947, but seems never to have been able to recover a satisfactory emotional contact with them. He became a cashier in the Austrian National Bank, continuing to work there until 1968. Since his first 16mm film, *1/57 Versuch mit synthetischem Ton* (all his film titles are methodically prefixed by the number of the work in complete chronology, followed by the year of Realization; thus, 1/57 denotes film no 1, 1957), there have been three distinct phases in his work. The first extends from 1957 to 1962 during which he completed five films; the second from 1964 to 1967 when he made eight (6/64 to 13/67), all based around the work of other artists, particularly the actions of Otto Mühl and Günter Brus, though 11/65 is based on an Op-art picture by Helga Philipp; and the third is from 1967 to the present, continuing individual film work (14/67 to 31/75). But it has extended to include the production of drawings, collages, prints and in particular five limited edition boxes, each containing an 8mm copy of one of his films, facsimiles of the preparatory diagrams, documentation and photographs, sold in the same way as prints. In the last phase there have been further collaborations

with Mühl – but in the more clearly defined role of cameraman or participant in Mühl's work – and with Brus, where Brus has been simply a participant in a Kren film.

In many ways the work divides more simply in two, the wholly individual films and the two years of deep involvement with Mühl and Brus. The notoriety of the Mühl actions, and the overwhelming content in the films which are based on them, perhaps explains some of the lack of understanding of Kren's work in America. Even amongst English filmmakers there is a tendency to dismiss this period as irrelevant to Kren's main contribution. This is short-sighted, since the films stand as satisfactory works and certainly have an important bearing on his work as a whole. Though out of chronological order, I shall consider Kren's involvement with the Direct Art, Material-Aktion movement first.

It is evident from Kren's films of the Mühl actions and from statements made by Brus that some of the initial impetus for the movement was an extension of the expressionist, action painting concept into performance and away from a static end product. Brus, for example, took the psychological analogy between the therapeutic action of dripping paint and shitting, to the logical conclusion of shitting 'on-stage'. As the painterly component of the actions gave way increasingly to the bodily function component, issues of inhibition and common morality grew unavoidable. The work became concerned with presenting the less acceptable (if ordinary) bodily functions, and with extending awareness of the range of sexuality, violence, sadism and masochism. In the repressive public atmosphere in which performances took place, there was a constant danger of criminal prosecution, and the work consequently developed a strong political and didactic character. In the historical sense, this direction is consistent with an existential concern with the basic materiality of human experience, and with the aims of psychoanalysis through bringing to 'public' consciousness, sub- or un-conscious tendencies and connections. It is also consistent with de Sade through the amoral exploration of human capability, wherever that project might lead.

Considering the particular historical and geographical situation of Vienna, after the war, it is not surprising that the Austrian psyche was much preoccupied with accommodating the shared responsibility for the atrocities of the Nazi era. It is quite wrong to see Brus, Mühl or Nitsch as simply expressing this guilt or as therapeutically catharsizing it. However, in addition to the relatively less contentious material-body-psychology element, the growing engagement with violence, sexual sadism and sexual masochism confronts some of the major emotional responses to the war. Kren's involvement with this direction of 'enquiry' is not arbitrary or peripheral, as can be seen in what I consider to be his best film of the period, *10/65 Selbstverstümmelung* (Self-Mutilation),[1] which is based on a Brus action. As in all Kren's work, though not immediately evident in this film, it has a strong, underlying system for the montage. Even on the surface, there is a quite clear formal play between the white identity of the cinema screen and the white face covered in dough and pigment, filmed against a white floor. But the expressionist symbolism of the action and objects is unavoidable. Surgical knives, scissors and pins pull and distort the dough-flesh of the face, and drawn gashes are confused with the holes of mouth and

eyes. The cruelties of Dachau and the torture of the medical experiments of Dr. Sigmund Rascher are unavoidably implicit in the images of this film.

With Kren a Jewish child in Holland, it is absurd to consider him sharing public responsibility for these events. At the same time, the mechanisms of accommodation are complex. Supported by the evidence of two of his later films, *20/68 Schatzi* and *24/70 Western*, which have clear references to images of war atrocity, Kren's attitudes and responses are, like Goya's, ambivalent. There is no simple condemnation but a seeming search for identification with both victim and protagonist – in the Brus film, characterized by the symbol of self-violence. The ambivalence is indicated in a different way in *Schatzi* and *Western*. *Schatzi* is based on what is presumably a concentration camp photograph of a uniformed officer (nationality undefined) surveying a heap of bodies, and *Western* on the anti-Vietnam poster *and Babies*. In both these films, the closest Kren comes to a simple political content and direct reference to this underlying element of his imagery, the recognition of the image is withheld. In the earlier film this is done by the superimposition of negative and positive, making an almost undifferentiated grey surface, and in *Western* by an exploration of the poster in such extreme close-up that it is again the surface rather than the 'message' which forms the dominant experience. The ambivalence – first choosing the material for its connotations, then denying simple interpretation by withholding early or, at any stage, certain recognition – is evident through the irony of a 'formalist' presentation of emotionally loaded images. At the same time, the irony is not a satire: it is a device for confronting the viewer with a complex response even where simple condemnation would otherwise suggest itself as a self-evident reaction.

Another aspect of Kren's later work which extends his involvement in the direction he shared with the Direct Art movement can be seen in two other films, one of which, at least, displays a similar psychological ambivalence. They are both concerned with the existential question of bodily function. The first of these, *16/67 20th September*, is a relatively simple didactic work using rapid interchanging montage to establish an experiential link between the acts of pissing and drinking, and shitting and eating. But the more recent *26/71 Balzac und das Auge Gottes* (Balzac and the Eye of God) cannot be so simply explained by its evident content. This is simple enough, confronting the spectator with the facts of sexual response to strangulation. In turn, both a man and a woman hang themselves. The man has an erection and ejaculates (a normal response in hanging and the basis for a not uncommon but risky sexual deviation) into the woman's mouth. After a conventional fuck whilst still hanging, he comes down. She is then strung up and fucked from behind, after which she proceeds to shit copiously into the eye of God in one corner, whilst the caption 'Aber Otto' ('but Otto', a cryptic reference to Mühl) appears in the other. The whole film is over in 30 seconds and is hand-drawn animation, originally made directly, frame by frame on 35mm (reduced to 16mm for the projection version). As one would expect from the technique used, the film has the visual comedy of a Popeye cartoon, counteracting the psychological weight of the imagery. This film

illustrates Kren's extreme self-irony and the ambivalent attachment-detachment of his accommodation structure. In the Mühl-Brus axis of his work, this element of content is more accessible. But in a way more difficult to define, such ambivalence imparts a charge, through a knife-edge of rejection, to the imagery in all his work.

The psychological approach is inevitable for many of Kren's films, but almost all his work raises philosophical questions about the relationship between experience and structure. Almost all, including the middle period, have used systems to govern either the editing or shooting. In most cases this has taken the form of preparatory diagrams and graphs drawn with mathematical precision, indicating the various correlations of shots and their durations. Whatever the general implications of using mathematical systems for ordering experience, considering how, with constant projection speed, the single frame unit of cinematography provides a simple link between duration and number, in film, system becomes particularly apt. In his attempts to order experience through film, Kren has made this number-duration correlation basic, discovering for it a variety of functions and potentialities. The germ for most of these functions can be traced to his first four films, but because the development is not tidy and some films characterize a direction well, whilst others contain a number of directions in one film, I will not take the work chronologically.

In classical montage, shots follow each other in a combination intended either to maintain the illusory flow of action, or as in the Eisenstein sense, to maximize the dramatic, expressive collision between them. From his first 16mm film, Kren has counteracted both the narrative and expressive concepts of montage through mathematically organized montage configurations. Consequently, many of his films make use of a limited number of repeated shots in various combinations and lengths, though some of his films, like *3/60 Bäume im Herbst*, employ system at the shooting stage. In these the connection between shots should not be considered as montage in any sense, a problem to which I shall return when considering the structuralist question.

I will again begin with some of the middle period films, for whilst I find the Mühl action films, like *6/64 Papa und Mama*, *7/64 Leda und der Schwan* or *9/64 0 Tannenbaum*, quite satisfactory works as a whole I find their use of system the least aesthetically challenging. In spite of the strong content, it is in these films that the montage is most abstract, in a sense, with the greatest divorce between image and system. As in most of his work, these films are constructed from shots fragmented into very short lengths, rarely longer than one second, and frequently as short as a few frames. In the Mühl action films, the result of this fragmentation is to minimize recognition of the objects in favour of increasing attention to their abstract qualities of colour, texture and movement. The systems explore an intricate network of links based on these abstract qualities. In addition, the rhythm of the montage itself in these films tends to work as a 'musical' composition, the system giving an overall coordinating shape. Although the rhythm of movements within the shots in these films may combine with the rhythm of the montage, because Kren more typically uses fairly static images and camera, the montage rhythm is frequently a dominant feature

of his work. Kren has developed a considerable control over visual rhythm in this musical sense, the concepts being comparable with the note-row techniques of Schoenberg rather than with more classical compositional ideas. As with Kubelka's *Adebar* and *Schwechater*, this visual abstraction of the shots and musical concept of montage is consistent with the aims of the early avant-garde abstract films, though in Kren this never becomes a graphic light-play, and always maintains some link with associative identity, particularly in these films with tactile, body associations.

Even though initiated within a similar compositional concept of system, certain of his works lead in another direction. In *20/60 48 Köpfe aus dem Szondi-Test* and *11/65 Bild Helga Philipp*, for example, the element of perceptual enquiry becomes dominant. Watching the films provides the basis of information about optical and cinematic functioning, which becomes the films' chief content. Especially in *48 Köpfe aus dem Szondi-Test* where a set of still photographs of faces (the contents of a box originally intended for an obscure psychological test) are sequentially permutated using different rates of image change, the system provides the visual changes in information but does not constitute a unifying composition in the classical sense. This shift in attitude, where the film becomes, as it were, perceptual raw material, makes way for a reflexive engagement by the viewer, where his own, rather than the filmmaker's perception and reaction become the primary content.

Kren's use of system provides an opportunity to look for some clearer edge to the loose terminology of structural film. In my view, there are very few cases where any useful relationship can be drawn between the so-called structuralist films and the broad field of structuralism in general. System and structure should not be used synonymously. Almost all Kren's films are systemic, but only a certain group raise structuralist questions. (Though in the loose concept of structuralist film which persists, all his work would be classed as structural.)

Broadly, I see structuralism as a result of the dialectical problem of the concept of order (ordering) in relationship to experience. In this respect, far from being in conflict with existentialism, it can be thought of as a development from it, making extreme subjectivity compatible with order by removing from the notion of structure either an a priori or authoritarian implication (the main bases of existential rejection of order). Order is no longer seen as a fixed, immutable condition of the world, but the consequence of changing and developing acts of ordering. Whilst there is a recognition that no fixed structure for experience exists, there is also a recognition that there can be no neutral state of unconditioned experience. The development of experience depends on developments of structuring. I see the movement from Cézanne to Analytical Cubism as the historical basis of visual structural art. Structuralism in art would seem to imply a broadly representational, or more accurately, homological, condition. This 'homology' is defined by Lévi-Strauss as an analogy of functions rather than of substance. In *The Structuralist Activity*, Roland Barthes talks of a process whereby the structuralist decomposes the real and then recomposes it. The reconstructed 'object', which I take to imply mainly the structuralist art object, is described as a simulacrum of the 'natural object' and is seen

as 'intellect added to object'. He stresses that 'between the two objects, or two tenses, of structuralist activity, there occurs *something new...*' (Barthes' italics).

Structuralist art can be thought of as the material formation of experience through the explicit incursion into the thing (event) observed by the mode of observation. In this sense, structuralist art does not *express* experience derived from the world: it *forms* experience in the trace of a dialectic between perceiver and perceived. It is perhaps this concentration on structure as process or activity which most recommends the project to the time-based film medium at the present time. However inadequate it might be later, I would like for now to confine the use of the term 'structuralism' in film to situations where the space/time relations of a filmed situation are reformed or transformed through a definable structuring strategy into a new 'experiential' (as opposed to didactically conceptual) homology. In this notion of structuralism, whilst the shape or wholist element of Snow's films, most evident in *Wavelength*, would not constitute a structuralist problem, the transformation (or fusion) of time/space in the experience of his ⟷ (*Back and Forth*) and *Central Region* would. In both cases, the space/time experience can be thought of as a homology brought about by the consistent application of a camera strategy.

Kren's first structuralist film then is *3/60 Bäume im Herbst* (*Trees in Autumn*, incidentally the first film in general I would call structuralist). Its structuralism is a result of the application of system, not to subsequent montage of material already filmed with an unconstrained subjectivity, but to the act and event of filming itself. This limitation, by narrowing the space and time range of the shot material, gives rise to a greater integrity in the film as homologue. In *Bäume im Herbst* the new space/time fusion of the experience of branches shot against the sky IS the plasticity of the shooting system become the relations of the objects-shots, and their space/time observational relations are inseparable. Structural process becomes object. This prefigures Snow's ⟷ and echoes the plasticity of time/space relations in a Giacometti painting. Though similar conditions occur in a number of Kren films, particularly the window sections in *5/62 Fenstergucker, Abfall etc.* and *17/62 Grün-Rot*, it is most perfectly illustrated in *28/73 Zeitaufnahme(n)*, a film which has a striking relationship to a Giacometti portrait (I would cite Giacometti as the clearest example of a contemporary structuralist painter).

Kren's preparatory drawings for the shooting of this 'portrait head' film show how he sees filmic space as a result of the interaction between various focal lengths of lens, the minimally changing camera position and the rates of change of both. Sections of the film have successions of single frame shots made with small changes of viewpoint, and other sections superimpose viewpoints on each other. In the film, the transparent, vibrating head defines its space/time image as a function of the filming procedure. As in *Bäume im Herbst*, it is the separate 'shots' (significantly different in kind to montage relations through editing) which determine it as a structural homologue. In a sense, what is represented in these films is neither the trees nor the head (as Strauss's 'substance'), but instead, the space/time relations of the film viewing and shooting process (as 'functions'). Objects are seen as an amalgam with their space and especially with their time as the process of

their accessibility through acts of perception. So again, what is 'represented' in the films is not a tree or a head but a filmic act of perception. It is also not represented in the sense that the film becomes a description, expression or even model for the generalized act of perception existing prior to the 'representation'. The films are acts of perception taking place under particular constraints of procedure and medium – acts of film-perception. The result of this activity is a genuinely new 'object' (the film being Barthes' second tense of structuralist activity) wherein certain 'postulates' of time/space procedure have been added to the 'natural object' (Barthes' first tense of structuralist activity).

The reason that film structuralism, structuralism in literature or structuralism in anthropology differ, relates to the specificity of the medium. In the same way in which a Truffaut or Godard film, illusionistically portraying an existentialist hero, is because of its interior filmic relations not an existentialist film, so a structuralist film is not defined simply by the structuralist attitude of its maker. There must be an integrity between the capacities and material properties of the medium and the structural procedures adopted. That these procedures are not confined to the application of numerical system, but can be achieved through other strategies, is evident through films like *Bedroom* by Gidal or Snow's *Central Region*. However, I have drawn the structural definition in this instance in a very narrow way, including the provision that the work should have a homologous relationship with a particular observational situation, so that the two tenses of structuralist activity may be appreciated within the film.

Some of the difficulties of maintaining this narrow definition in the light of some recent conceptual and reflexive works are also raised in Kren's *15/67 TV*. Although the filming situation is narrow in this film, being confined to five short sequences all filmed from within a dock-side café, the work does not aim to be a homologue of the space-time relations intrinsic to the situation and procedure of the filming itself. The filmed sequences are largely separated from their representational function, to become the subject of subsequent systematization where their relationships within the film-presentation are much more significant than the procedural relationship with their origin. The broad effect and historical significance of this film lies in shifting the emphasis of structural activity away from the filmmaker's ordering of his filmic subject to that of the spectator's structuring of the filmic presentation. The film's viewer must engage in a speculative, reflexive structuring of the film as it proceeds. There are of course a number of other undeniable levels of content in the work. These include the subjective choice of situation and image by the filmmaker, his attitude to the act of filming, and the similarly subjective choice of mathematical system and its application in the film. But by far the most significant level of content in *TV* is the viewer's awareness of his own behaviour in structuring the experience of the film itself. This is not simply an attempt to elucidate the filmmaker's hidden system, but an experience of the various phases, stages and strategies which are encountered in the act of attempting to structure the events of the film.

The five sequences (each appears 21 times in all) are sufficiently similar to each other to ensure that the initial problem faced is the discrimination of the shots themselves. All

the shots, which are about one-and-a-half seconds long, are separated from each other by periods when the screen is black. Again the viewer begins to discriminate the differences in black duration, becoming aware that there is a consistent pattern and that this forms a system of punctuation, first separating the shots, then longer gaps between the 'sentences' (groups of five shots) then even longer gaps marking the ends of the 'paragraphs' (which vary in length). At a certain stage of discrimination and recognition of the shots and their pattern of combination, the viewer begins to speculate, attempting to predict the development; and this prediction is subsequently confirmed or denied by the film. Though the system is basically logical, it is not ultimately consistent as a permutation or symmetrical structure. In some more recent films like Bill Brand's *Moment* and even Hollis Frampton's *Zorns Lemma*, a similar concept has tended to become a more mechanistic puzzle, encouraging the viewer to identify content with a specific solution to the 'scrambler'. The inconsistency in Kren's system eliminates any simple goal for the viewer's reflexive, structural activity. In *TV*, the viewer is drawn into a mode of behaviour by the systemic aspect of the film, but not permitted to identify 'content' with a systemic abstract of the work. The content, which continues to develop after repeated viewings and even when fully aware of the system, lies in the experience of the stages of a structural activity from perceptual discrimination, to awareness of a rhythm of repetition, to the conscious use of memory and prediction in conceptual patterning.

In the same way in which I would quote *Bäume im Herbst* as the first structural film, I would quote *TV* as the first thoroughly realized work of reflexive cinema transferring the primary arena for structuralist activity to the viewing of the film itself.

From *Abstract Film and Beyond*

(London: Studio Vista, 1977, pages 96–104).

[Peter] Kubelka's reputation outside Europe is vast compared with that of his fellow Austrian Kurt Kren. But for European filmmakers the work of Kren has had a more significant influence. Unlike Kubelka, who has spent much of his time in the US, Kren remained in Europe and has made films consistently since 1957, to date completing about thirty 16mm works. Again compared with Kubelka, his work is more involved and varied, initiating a wider variety of formal issues and basic philosophical questions. There are broadly three phases in his work. The first is highly systemic; the second, beginning about 1964, is no less formal, but works in relationship to the Material-Actions of Otto Mühl and Günter Brus, bringing a new set of issues not easily relatable to his formal notions; and the third starts around 1967, where the formal notions are again dominant but often combined with a more expressive or provocative content. As his work continues to develop in tune with current directions, he should not simply be seen in his historical role.

There are two factors in the work of Kren which are of importance in the present context. First is a comparatively simple one, his initiation and consistent use of systemic structures; and second, a more complex set of questions concerning the relationship between structure, image and existential attitude. Possibly because his best-known films are those which were made with Brus or Mühl, exponents of the Direct Art movement, he is often wrongly assumed to be primarily a documenter of that work. It is little realized that even these films were either shot or subsequently edited to mathematical structures.

Following early experiments on 8mm between 1953 and 1957, he made his first 16mm film *Versuch mit synthetischem Ton* (1957), including a drawn soundtrack beginning to develop the notions of formal relationships between simple images. But his next three films, made between then and 1961, showed the systemic direction of his work most clearly: *48 Köpfe aus dem Szondi-Test* (1960) and *Bäume im Herbst* (1960) being shot according to system, and *Mauern pos.-neg. & Weg* (1961) being edited that way. It is also evident in these films and is confirmed in his next, *Fenstergucker, Abfall etc.* (1962), that even if Kren rejected poetic or narrative intention, the images of his work were in no way neutral, arbitrary or convenient fillers for a mathematical system.

Kren, like Brakhage, must be seen in his relationship to existentialism. Certainly with Kren there is no autobiographical intention, but like Brakhage, his images derive essentially from his passage through the world as an individual, so that for both, the chief protagonist of the films is the person behind the camera. In the extreme of existentialism, choice is a result of immediate subjective response. Speaking of the French existentialists, including himself, Jean-Paul Sartre said: 'What they have in common is simply the fact that they believe that existence comes before essence – or, if you will, that we must begin from the subjective.'[2] This existentialist intention is central to the underground film. When filmmakers like Godard, who derive from the commercial, narrative cinema, portray existentialism, their cinematic form is not existentialist, because it lacks the crucial 'first person' viewpoint. It is only in the underground film that this form has been developed, albeit slowly, against the background of cinematic conventions which have contrary purpose.

In the context of an existentialist attitude to cinema, and in the work of Kurt Kren, a new issue emerges. This can be seen as a dialectic between existentialism and structuralism, centring on the relationship between concept or pre-concept and subjective experience. In rejecting essence, and with it philosophical hierarchy and transcendence, existentialism is suspicious of all forms of structure on the grounds that they prevent immediate experiential relationship. Alternatively it sees structural order as authoritarian, a reflection of the dominance of the current social and environmental condition. This can also extend to a suspicion even of psycho-analytical order. However, there need be no fundamental conflict with order or structure, merely with the concept of order as an immutable condition – either existing a priori within phenomena, or as an accepted authoritarian determinant of choice. Particularly in art, order or, more precisely, ordering, becomes compatible with existentialism when that order is considered as temporary, local, provisional, fortuitous or arbitrary.

Perhaps the greatest conflict between existentialism and structuralism arises in the work of Lévi-Strauss, who is concerned with models to describe underlying 'deep structures' in dynamic social relationships. For dealing with complex phenomena, he maintains the classical concept of analytical reason, but with improved tools like transformational and matrix algebra. The conflict stems mainly from his maintenance of a priori assumptions about the structural relationships of phenomena.

On the other hand, some concepts expressed by Roland Barthes have the advantage of being more easily applicable to plastic art, and the virtue of showing a possible continuity between existential and structural art:

> The goal of all structuralist activity, whether reflexive or poetic, is to reconstruct an 'object' in such a way as to manifest thereby the rules of functioning (the 'functions') of this object. Structure is therefore an actual simulacrum of the object, but a directed, interested simulacrum, since the imitated object makes something appear which remained invisible, or, if one prefers, unintelligible in the natural object.

> (Barthes 1967)

He then makes it clear that what results from this activity is something new, describing the resultant simulacrum as 'intellect added to object'.

This postulates the creative aspect of structure, for whilst it sees the structural activity taking place in relationship to the current state of phenomena, it sees the product as a specific new phenomenon. Compatibility between existentialism and structuralism therefore derives from the dialectical creation of structure for the perception and experience of existence. In effect, structuralism in art can be seen as a consequence of the awareness that concept can, and perhaps must, determine the nature of perception and experience if it is to avoid determination by existing convention and habit.

The first embodiment of this concept of structural activity in cinema comes in Kren's *Bäume im Herbst*, where the camera as subjective observer is constrained within a systemic or structural procedure, incidentally the precursor of the most structuralist aspect of Michael Snow's later work. In this film, perception of material relationships in the world is seen to be no more than a product of the structural activity in the work. Art forms experience. Barthes echoes this 'no more than' and says of it:

> Structural man takes the real, decomposes it, then recomposes it; this appears to be little enough (which makes some say the structuralist enterprise is 'meaningless', 'uninteresting', 'useless' etc.). Yet from another point of view, this 'little enough' is decisive: for between the two objects, or two tenses, of structuralist activity there occurs something new and what is new is no less than the generally intelligible.

> (Barthes 1967)

Though some subsequent works by Kren can be considered in directly similar terms, like *Grün-Rot* (1968) and a film portrait of Peter Kochenrath (1973), and while certain aspects of his other systemic work may function similarly, other aspects of it are not easily relatable to structuralism. Structuralism in cinema is certainly not to be defined simply as the application of system to experience. As we get closer to contemporary work, there are formal developments which it would certainly be misleading to overanalyse in structural terms. I have already pointed out that Kren's images are in no way 'detached' – the image is not only a point of contact with the phenomenal world, but with Kren's particular experience of it. Another consequence of his subjective existentialism is an unwillingness to engage in large-scale, long-term works so that all his films have been short and succinct, dealing only with a range within which he can achieve an internal precision.

Although an approach to the imagist aspect of Kren's work is out of the scope of this book, we must look at some of the other contributions he has made to new formal developments. The systems of his early films were largely built on interchanging shots of relatively short duration, frequently a range of from one to twenty-four frames, that is, various fractions of a second. Sometimes the changes are linear and, even more frequently, they involve acceleration or deceleration of the rate of change, creating waves of interaction between shots. In *Mauern pos.-neg. & Weg*, Kren introduced the interchange of negative and positive versions of the same image. As in Brakhage's *XV Song Traits, Michael McClure* (1965) in which he superimposes the negative and positive of the same image, the introduction of the negative in *Mauern* is not a graphic device for the transformation of image into abstract shape as it is in Kubelka's *Adebar* or in Richter's *Film Study*. Instead it opens up the possibility of seeing negative image as an element of the material process of cinema.

Following these two films and *Bäume im Herbst*, Kren's next important systemic film is *TV* (1967). In *TV*, the system is different in kind and pace to that which exists in much of his other work. Instead of operating primarily at the kinetic level, or with rapid perceptual rhythm, this film involves the audience in a conceptual and reflexive process. Five short sequences each about eight frames long (⅓ second) are all shot from the same viewpoint in a quay-side café. They show a window, broken by the silhouettes of objects and people within the café and by the passage of people and a ship outside. Each shot containing some small movement is repeated in the film 21 times, in mathematically determined order. They are separated by short, equal sequences of black spacing, except that longer black sequences separate larger phrases of repeats from each other rather like punctuation. Sometimes the same shots follow each other, sometimes all five shots occur in one phrase. The significance does not lie in the mathematical sequence as such, but in how the viewer attempts to decipher the structure.

This overtly reflexive attitude to structure became important in a number of European films about this time (notably by Hein, Nekes, Gidal and myself), often incorporating image repetition. But none as clearly shifts the structural activity away from the interior

construction of the film towards the deliberate exterior reflexiveness of the audience than that of *TV* (incidentally prefiguring Frampton's *Zorns Lemma* of 1971). An additional value which TV has as a film (over *Zorns Lemma*) is the depth of its control of image and motion at levels other than the systemic. The qualities of motion within the shots, and their pace, relate directly to the duration of the shots and the duration of the spaces between. The nature of the similarities between the images and motion is such that the reflexive mode of the viewer is taken through a number of distinguishable phases, as first the images themselves are recognized and defined, then remembered, then their sequence noted and compared via memory. The reflexive activity constantly interacts with the kinetic and associative aspect of the images and their distribution.

The next year, in 1968, Kren made *Venecia Kaputt*, which lasts only six seconds, and utilizes scratching on film to erase an image of Venice. And in the same year he made *Schatzi*, which explored the irony of a formal image device, the interplay of negative and positive superimposition, involving the viewer in the material interaction only to reveal finally that the picture is of an army officer surveying a field of corpses. In many respects, Kren's work continues to express the tension between the existential and the structural. His formal inclinations and systemic structures never become formalist or a formula unrelated to the existential aspect of image.

Reference

Barthes, R., 1967. The Structuralist Activity. In: *Essais Critiques*, Editions de Seuil, 1964. English translation by Richard Howard, *Partisan Review* (Winter), 34(1).

Notes

1. Kren has recently released another Brus 'action' film, *Silberaktion Brus* (Silver action) completed at the same time. At the present both films are confusingly numbered *10/65*, though they are quite separate works.
2. In 'L'existentialisme est une humanisme', a lecture given in 1946, translated by Philip Mairet.

Reviews of *31/75 Asyl, 15/67 TV* and *28/73 Zeitaufnahme(n)*

31/75 Asylum (1975, 8:26 min, colour, silent)

15/67 TV (1967, 4:08 min, b/w, silent)

28/73 Time Exposures (1973, 2:56 min, colour, silent)

A. L. Rees

First published in the British Film Institute's *Monthly Film Bulletin*, September 1983, 50(596), p. 254, p. 258 and p. 259.

31/75 Asyl

Every day for 21 days, a landscape is shot from a fixed position with the same three 30-metre (100 ft) lengths of film. A different mask, with four or five small apertures, is placed over the lens each day. All 21 masks and their apertures, when combined, make up a complete picture. Despite the continual re-filming, the systematic changes of mask allow only parts of the film emulsion to be exposed on any single run-through. The whole scene, made up of all the apertures of all the masks, appears near the end of the first roll. The unmanipulated, unmasked landscape is seen towards the end of the film.

Asyl was shot silent in the changeable weeks of March and April, giving variations of brightness and dramatic shifts of weather from sunshine to snowfall. At first, small fragments of distinct, soft-edged images appear out of the dark screen. The seasonal mix is indicated in the isolated squares of wintry whiteness, russet-brown earth and sunlit sky – shown together, but shot at different times. A high vantage point gives the effect of a fragmented panorama, adding a 'magic lantern' quality to the inset matted shots that flash on and off in the palimpsest of the screen. As the apertures build up and coincide, more of the landscape is seen until the screen is full of images. These contain adjacent or overlaid details shot days apart from each other. A brown, trampled path in early spring abuts snow-covered fences and fields. Snow falls from the sky, but not on the sunny meadow below, nor on the rain-soaked bushes. Slight mis-registration of adjacent images makes them hover where they join (despite Kren's note of using a 'secure tripod').

Transitions reveal form. In frosted light, the far field resembles a glittering sea. Towards the end of the film, there is a lovely clear shot of the scene in dim, sparkling light: brittle, shadowed and almost completely tonal (since the winter light has 'removed' colour). An overlay transforms the shot into warmer shades, and then into a wintry scene in harder light. Two walkers follow the furrows of a track, superimpositions giving them a ghostly drift. The end contains more 'all-over' screen images, before fading into roll flare. Kren matches perception and rhythm by varying how much he withholds (isolating items in the masked screen) and how much is released (when images are overlaid or massed). The rhythmic structure results from internal constraints, such as editing in the camera, and external ones, such as climatic changes. This process is seen in a late section of the

film which alternates passages of masked-out and superimposed images, a section which moves between darkness and light. Through the subtle duplications of this landscape, the rhythm of change is used to open the scene to the multiple camera-eye.

15/67 TV

TV consists of five silent sequences filmed inside a dockside cafe. The similar shots each contain small distinct movements – a man leans across a table, people pass by outside, a boat moves in the harbour, three girls playing on the quay change position. The shots, each about one-and-a-half seconds long, are combined and repeated in 21 cycles, using a serial permutation in which each shot appears 21 times. The shots are briefly separated by black leader, with longer pauses between cycles and between groups (a group being a series of consecutive cycles all beginning with the same shot). Sometimes all five shots are shown in a row, but often a shot is repeated; for example, the first cycles are shots 1, 2, 3, 4, 5; 1, 1, 1, 4, 1; 1, 1, 1, 4, 5 …. The final order is 5, 4, 3, 2, 1.

While the film is clearly systematic, its exact mathematical structure can only be gauged by looking at Kren's graphic score rather than at the screen. The point of the system, however, is visually clear; it directs attention to the rhythm and movement of events as they interlace between shots. Contrasts of gesture and direction can be picked out – small human actions that cross the deep space between a foreground table, a middle-plane window, the jetty and a distant harbour wall.

TV is also a study in photogenic variety of tone and surface – as seen in the distribution of lights and darks, glass, wood, fabrics and reflections. The people in shot are also contrasted, from the silhouettes of near figures to the more evenly lit distant ones. The viewer is directed to an awareness and memorization of these relations, as events are connected, reassembled and repeated from one shot to the next. Comparison renews perception.

While the five shots might possibly be segments of a single take, Kren's literal 'shot breakdown' questions the standard time of the sequence-shot to emphasise the flicker between perception and memory. *TV* is about interchange. The cafe is a simple, casual framework for a surprising variety of forms and events (like the film itself). A dockside cafe is bound to be a place of passage. Kren preserves the informality and transience of a few seconds of the passing scene, by the paradoxical means of repeating them. Nothing is added except attention.

28/73 Zeitaufnahme(n)

A man's head is filmed in silent close-up, using single-frame shooting and time exposure. Small movements of the head are registered in each frame, so that in projection even slight gestures produce a shaky, jittery image. There are also perceptible variations of angle and

focal length, when the face moves in relation to the steady lens. The head swings faster from side to side, appearing squashed, flattened and more sculptural. Different intervals of single-framing, coupled with variable timing of the shots, make the images resemble futurist photography (which found similar means to capture a 'dynamic' effect).

The face becomes blurred, spread, unbounded; its edges broaden, and the sparkling bridge of the man's glasses becomes a coil of abstract colour movement. As the pace quickens, optical superimpositions cause the head to blur into a mix of colour. As its swinging slows, the head moves towards the lens rather than from side to side. Rapid eye blinks are echoed by several black frames inserted to alter the rhythm and allow some pause. In a final burst of speed, less reflected light on the face flattens its features, stressing eyes and nose but not the broader curves.

Distinct clusters and contrasts of scale, distance, depth, colour, shape and movement are created – the result being a paradoxical 'echo' of camera movement, even though the camera does not move. Some sections contain small shifts of direction, while others superimpose different images and viewpoints of the head over each other. The representational image is shown to be part of a process in which space and duration are tightly linked in mapping out a visual field. The title, like the film, plays on the concept of 'time exposure'. Time is, literally, taken.

Interview with Kurt Kren

Daniel Plunkett

First published in Austin, Texas: *ND* 5 October 1985.

ND

2

Kurt Kren
Guy Bleus
Hungary
usw.

KURT KREN MOVED TO AUSTIN IN NOVEMBER 1981. A
COMPLETE RETROSPECTIVE WAS SHOWN AT THE CALIF
ORNIA HOTEL AND ANOTHER AT THE UNIVERSITY OF
TEXAS. KURT KREN HAS BEEN ACTIVE IN UNDERGROUND
FILM SINCE THE LATE FIFTIES. FOLLOWS IS AN INT
ERVIEW WITH KURT KREN BY DANIEL PLUNKETT FOR
N D.

K U R T
K R E N

ND: About what time did you first start working with Otto
Muehl?
KK: Around 1964. Muehl wrote a paragraph about how he met
me in a cafe. It;s kind of funny. Might have appeared in
Wien Buch or Mama und Papa. I'm not quite sure now. He
was at the time I met him in a cafe helping a student and
we were all drinking beer.
ND: What films had you made before your work with Muehl?
KK: Right before was "Window Lookers, Garbage, etc..." ,
"48 Heads from the Szondi-Test" was much earlier, also
"Trees in Autumn" and "Walls pos. neg."
ND: These earlier films, did you have them shown at that
time?
KK: In Vienna there was a progressive gallery called Gal-
lery St. Stefan. A gallery somehow connected with the
Catholic church. A Monsignore managed the gallery and al-
so preached in the church. Gallery St. Stefan was the only
gallery that exhibited progressive artists. After a few
years it became known as Gallery Nächst St. Stefan. The
clergy were reluctant to be connected with the gallery.
Nitsch, Muehl, and Schwarzkogler did actions there al-
though they were soft. Nitsch pulled a chicken behind him,
Schwarzkogler built himself in like children would do,
and Muehl did something with toilet paper. I'm not sure
of what Brus did. I also did sort of an action there by
tossing left over footage around. Gallery St. Stefan be-
gan with painters like Arnulf Rainer who at that time
would take pictures and paint over them(Übermalung).
ND: What made you to become involved doing short films?
KK: In Holland we had a children's projector 35mm. The
kind you had to crank yourself. It was always my plan to
hold old film above boiling water, then the imulsion would
fall off so you could paint something on it. I always want-
ed to do this, but never did. I always was facinated by
film. I made a short film in 1957 with a brick wall, cac-
tus, and moving scissors. In the early 50's I bought an 8mm
camera. I made some films already then, but they either got
lost or fell apart.
ND: Did you ever have any showings together with Peter Ku-
belka?
KK: Well Kubelka arranged the first showing of mine in the
Gallery St. Stefan. I had the first showing in 1961. I
showed three films; "Trees in Autumn", "48 Heads from the
Szondi-Test" and the one I made in 1957. The three films
would be shown several times as they are short films.
ND: Did Kubelka like your films ?
KK: Yeah, he liked them or so he said. The fucking thing
was that in the early 60's he went to the U.S.A. to show
his films, and then he said he was the only existing Euro-
pean filmmaker. That was shit somehow. Then came that kind
of tension. I don't mind it so much now though. When I show-
ed my films at MOMA(Museum of Modern Art) a guy from the
museum came up and asked if I was still quarreling with Ku-
belka. I said 'not from my side', he said 'oh I'm so glad
about it !'(laughs).

6

Ana Aktion-Brus

It's all history to me now and I don't care, yet somehow it's still there.

ND: About your work with Muehl. What was 1st aktion by Muehl that you filmed ?

KK: "Mama und Papa" . There was also a book published by Muehl of the same title. There were about 2,000 copies and was illustrated.

ND: What did you think about Muehl's work when you began to film his aktions ?

KK: What he did in public at that time was really not so exciting at that time. Like when I made the film 'Mama und Papa', it's much more alive than the performance, but that's my opinion. The shooting was great fun. We had alot of double liters of wine, quite drunk. I kind of flew over the table to take pictures. I wondered afterwards if it would even be in focus.

ND: Your second aktion you filmed by Muehl was "Leda with Swan" ?

Silber

KK: "Leda with Swan" was not really finished because the model got pissed off. I used other scenes from "Mama and Papa" as filler

ND: Did Muehl ever get involved in any trouble because of his aktions ?

KK: Yes, I think very early even before 1964. He pronounced that he would throw closets filled with paint from the 5th floor(laughter). So people were waiting for it. It was quite an uproar. The street was full of people then the police came and charged him with disturbing the public order. He went to jail for it, but he didn't do it.

ND: How did you come to film "Ana Aktion-Brus" ?

KK: Muehl asked me if I would film a Brus aktion. Muehl kind of pushed me. Brus was depressed with no kind of exposure. I had only on roll of positive film. Very low light sensitive. I told them to do it very slowly as I planned to film single frame, but they forgot all about it. My films were kind of an advert for Muehl and Brus. Brus became better know to people because he couldn't

do his aktions everywhere.

ND: Who was in the film ?

KK: Günter Brus and his wife Ana. Before doing aktions Muehl was a color painter, and Brus was an aktion painter. On a clothesline Brus would hang white paper and run through with a black paint brush. In "Ana" it's curious that in the end he comes back to that black and white aktion painting.

ND: Did Brus ever have any gallery showings ?

KK: Oh sure, several. The strange thing was that in 1979 he had an exhibition at the Vienna Opera which is absurd somehow. The Vienna Opera is the most bourgeois institute in Vienna. He also had aktions in Munich that were real intense. Then in Berlin he began to draw with a story. At Gallery Van De Loo(Munich) he made several drawings like a children's story, but more adult with drawings and a story that went with it. They were very good.

ND: Why did Brus go to Berlin ?

KK: There was a mistake when he was to be in jail for 6 to 8 months. After the sentence was spoken they forgot to jail him. It took the whole night to flee. We drove him in two cars to West Berlin, with Ana, his family, and Peter Weibel. He was boarded by Margaret Raspé. Kind of his asylum. There he began to make films. He made "Impudance in Grünewald" there.

ND: When did you first come in contact with Hermann Nitsch ?

KK: More I came in touch with him when I made films about Otto Muehl. I was not together so much with Nitsch. I filmed an aktion of his outside Vienna, but the footage got lost.

ND: Did Brus or Muehl do any work with Nitsch ?

KK: Yes, there was some collaboration. When Nitsch did a show at the Destruction in Art Symposium(D.I.A.S.) in London we all participated in it. Something to do with a lamp, trumpet, and noise. Brus did the most collaboration, Muehl not so much. Nitsch inherited an estate called Printzendorf with an immense layout. He would invite people and do aktions there.

ND: What all did OM(Orgy Mysterium) actually mean ?

KK: It's kind of like an old mystisim. Slaughtering of a lamb. I was forced to get fed up on religion, so I had a prejudice to the work of Hermann Nitsch. Work done with eating, exhibition sex and genitals. All done afetr a kind of lethargy. I was fed up on religion from Holland so at that time I didn't like his work so much because of it.

ND: What was 'Blut Orgel' ?

KK: A small pamplet, kind of a manifesto by Nitsch, Muehl, and Dvorak. The first time 'Blut Orgel' came out on one occassion they walled themselves in a cellar. In this cellar there was alot to drink, also there was a second door that was between brackets of which the audience wasn't supposed to know of.

ND: Where did you meet Schwarzkogler ?

KK: Schwarzkogler...it's really strange. He was kind of at random. See Muehl was open armed, Brus not so much, but Schwarzkogler was in

hintergrund bleiben(stayed in the backgound).
Was a pity because I never came close to him.
ND: What about the story that he had cut his
penis off ?
KK: No, that's not true. It was someone else. A
Viennese painter. I still don't remeber his name
...ah! Gerstl, Must have been right after the
1900's.
ND: Did you ever see any of Schwarzkogler's
work ?
KK: Actually in a way I first began to see some-
thing after he was already dead.
ND: How did he die ?
KK: He wanted to fly from the 5th floor. Wanted
to see an indian guru or something. He was strange
in the last weeks, trying to prepare for it, fast-
ing and so on.
ND: So who documented his work ?
KK: A gallery in Innsbruck called Galerie Krinzin-
ger. Hoffenreich made photos. So when he died his
widow got hold of the negatives. It's kind of sad
that Schwarzkogler became known after he died.
ND: About what time did you stop filming aktions ?
KK: After "Cosine Alpha" That was my only compro-
mise. Therefore I don't feel so fairly good about
it. I didn't want to lose all that footage so I
made it about two seconds too long.(laughs) Muehl
thought he found someone to buy the film. We
always needed money. Then we didn't even sell it.
When Brus did "Selfmutilation" the shooting was
miserable mostly because Muehl was pissed off,
this kind of competition. My editing saved the
film though. After that I said I wouldn't do
films anymore. So I made photos for Brus. Muehl
already began to film for himself.
ND: Was "September 20th" something special be-
sides being your birthday ?
KK: Yeah, with "September 20th" I wanted to do
something with shitting. But I didn't have a plan
yet. Then in a cafe I met Brus and Schwarzkogler
together. I sat down and Brus said 'would you
like to photo while I shit ?' Then we talked.
Schwarzkogler, Brus, and me talked about it. So
it kind of came together. We also talked about
jacking off, but just used eating, drinking, piss-
ing, and shitting. It was quite a coincidence.
There was an article in the Village Voice in 1968
when the interviewer asked me about "September
20th" and asked 'it was your idea wasn't it ?' So
I just said 'yes' which pissed Brus off. So in a
filmography Brus called the film "September 27th"
as that is his birthday.
ND: You filmed at Brus' apartment ?
KK: Yes.
ND: Where did the other two small scenes come
from ?
KK: Brus had a balcony with a soccer field below.
When he shit it really stank so I fled to the
balcony. By chance I saw these two old women
pissing and another time two little girls shitt-
ing. Quite a coincidence.
ND: When did Brus shit in public ?
KK: That was in 1968. After the occupation of the
Burg Theatre didn't work out Ossie Wiener arrang-
ed with the students to perform Kunst und Revolu-
tion in the University. The participants were

Muehl, Brus, Bauer, Weibel, Wiener, and others.
Brus sang the Austrian national anthem and at the
same time shit in the auditorium which was full
of people. There were also some other events. At
the end it became quite chaotic.
ND: Was he arrested ?
KK: Not immediately. Anyway from the press came a
kind of witch hunt which increased day to day.
Pictures came out in the papers and it escalated.
Bauer wanted to but a ticket in a street car and
the conductor said 'We don't sell tickets to the
Uniferkel(university pigs)' By public opinion the
police were forced to act. Wiener, Muehl, and
Brus went to jail. A Viennese paper called the
Blaue Montag(this paper made a fusion with a very
right wing paper) wrote on the front page in bold
print 'UNIFERKEL JETZT AUCH IN KINO'.They quot-
ed the 'Süddeutsche Zeitung that had reported
about a showing of mine in Munich, especially
about "September 20th". Just a few days before
the court judge was pissed as he didn't have any
hard evidence. So someone told him about "Sept-

Selfmutilation

ember 20th". I had a house search but they did-
n't find my films.
ND: So how did all this affect you ?
KK: The newspaper came out on a Monday and on
Wednesday I was suspended from my job at the bank.
In April/May 1968 I was in the USA, I had always
wanted to get out of the bank. So when I came back
I resigned for the end of 1968. I was suspended
until my resignation would come. I could have
fought against it, but with my nerves I couldn't
stand it anymore.
ND: Let's talk a bit about the Destruction in Art
Symposium. Who went with you ?
KK: Peter Weibel, Muehl, Brus, and Nitsch.
ND: What all did you do over there ?
KK: I showed my films. But I didn't film..oh..no
I actually did film there. That's in 'Sinus Beta"
the public aktion with Muehl, Brus, and she was a
swedish poet I think.
ND: What else went on, and how long did it last ?
KK: It lasted about a week, 10 days or so. Alot
of talking. Brus did something with a pillow. I
have no idea what Muehl did now. Nitsch did a
kind of Orgy Mysterium and someone announced it
to the police. So some of the arrangers had to go

to court.

ND: Who put the show on ?

KK: Better Book Store. We were all invited. It was strange I came to so many places to eat and drink(laughs) eat and drink.

ND: What do you think when people call your film 'structural' ?

KK: That's the trouble with names. To put it in a drawer. At that time I liked 'underground' much more. 'Structural', I don't know. I think P. Adams Sitney brought it up. Sometimes good because talking about my film is difficult as it's so visual. So one could say sometimes 'Oh! It's a structural film'. It's just a name.

ND: Talk about your graphs some.

KK: The first time was with '48 Heads' That was a coincidence. There were two numbers on the back of the photos.

ND: The pictures came from a test box ?

KK: Yes I asked all my friends, asked around for pictures of heads. A friend said there was a test So I went to a medical book shop and bought this test. There were 48 plate cards with pictures of heads. There were 6 groups with roman numerals and each group had eight types that had arabic numbers. Also the amount of single frames I was to use varying from one to eight. So I had three numbers to make into order. That was the first kind of score. After this came 'Trees in Autumn' I did it in numbers by how many single frames.

ND: Did you do this before or after shooting ?

KK: Sometimes I had to make the score before where I could film by them. Then at times it wasn't necessary to do it before. But I liked the look of them, like a drawing.

ND: When did you do your boxes ?

KK: That was around 1970. Wolfgang Ernst helped with the first three. There were five different boxes.

ND: I've seen the third and fifth what did the others relate to ?

KK: one was "Mama und Papa" two was "Selfmutilation" three was "48 Heads" four was "Leda mit Schwam" and five was "Zeichenfilm"(drawing film). I made 50 of each.

ND: Whose idea was "family Film" ? It's always kind of funny.

KK: Mine, there was Wolfgang Ernst, Brus, and Ana Just a walk on the Pfaueninsel like snapshots.

ND: Where did you film "An W+B" ?

KK: That was in Munich 1976. I shot it through a black and white negative of the same image in front of the lens and then changed the focus back and forth. The print I have been showing is much too dark though.

ND: What does "An W+B" stand for ?

KK: Dedicated to Wilhelm and Birgit Hein(German filmmaker couple in Cologne).

ND: How did you film 'TV' ?

KK: I was waiting for a friend in a cafe in Venice. So while waiting I took 5 sequences from inside the cafe to the outside. When I returned to Vienna I multiplied the 5 shots 21 times and prearranged them in a sort of order.

ND: In your film "Shatzi" of the picture of the SS officer. Did you focus back and forth ?

KK: No, I had a positive and negative slide of a photo. I put these two slides over each other and put them on the window. During shooting in single frame I would move them slightly.

ND: How did your showings of this period go ?

KK: In Cologne Wilhelm and Birgit Hein hired a normal cinema for night shows. I just took films there and let them run. and people would come... but at that time people longed to see a prick, a cunt or something.

ND: What was "Western" from ?

KK: Massacre at Mai La. A guy in New York made that poster so I did single frame up and down.

ND: Concerning your later films like "Breakfast in Grauen" youv'e taken longer shots compared to most of your earlier films. What would you like to do with it now ?

KK: I don't know anymore. Which Way?(laughs) also

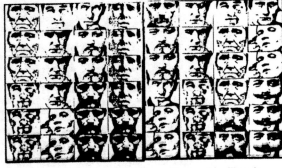

48 Heads From the Szondi-Test

the camera is such shit. I don't even see what I
get on it and I can't get the camera to hold still
ND: Have you finished your roll in your camera now ?
KK: No, it's still sweating in the sun.(The film
is now being developed in New York)
ND: Do you think your better know in Europe ?
KK: You see in the late 60's or even the early 70's
that was quite a different time. There was much
showing. Now not so much. I was known in Europe. I
have no idea now. Probably think I'm dead.
ND: Where did you go when you first came to the US?
KK: New York and Canada.
ND: You did a show in Lawrence also.
KK: Yeah there was a show in Norman also, but later.
Also did shows in Houston, Denver, Boulder, Minnea-
polis, and somewhere in Ohio. Once when I showed at
MOMA I later recieved a check for 1,000 from someone
in New York with a note saying they enjoyed my films.
ND: So you've been here in Austin since November of
last year.
KK: Yeah, maybe it's time I went somewhere else.

You can write Kurt c/o our
address here in Austin

IN JANUARY 1983 KURT KREN MOVED TO HOUSTON

Kurt Krens films are available from:

FILM MAKERS CO-OP
175 Lexington Ave
New York, NY 10016
(212) 889-3820

LONDON FILMMAKERS CO-OP
13 Prince of Wales Cres.
London NW1
ENGLAND

and maybe some at:
P.A.P.
8 München 50
Abbachstr 33
W GERMANY

15/67 TV

F U R T H E R R E A D I N G

David Curtis-'Experimental Cinema-A Fifty Year
 Evolution'(1971)
Stephen Dwoskin-'Film Is...The International
 Free Cinema'(1975)
Malcom LeGrice-'Abstract Film and Beyond'(1977)
Malcom LeGrice-'Kurt Kren' Studio International
 London nov/dec 1975
Birgit Hein- 'Film als Film-1910 bis Heute'
Peter Weibel and Valie Export-'Wien Bild-Kompen-
 dium Wiener Aktionism und Film'(1970)
Birgit Hein- 'Film im Underground'(1971)

O T H E R

Architecural Review-'Destructin in Art' pg441-444
 (London dec 1966)
Lea Vergine-'Il Corpo Come Linguaggio'(1974 Milan)
Wolf Vostell-'Happening und Fluxus(Cologne 1970)
Adrain Henry-'Total Art Environments, Happenings,
 and Performance '(1974)
Genesis P. Orridge and
Peter Christopherson -"Annihlating Reality' Studio
 International july/aug 1976

Notes on Kren: Cutting Through Structural Materialism or, 'Sorry. It had to be done.'

David Levi Strauss

First published in *Cinematograph: A Journal of the San Francisco Cinematheque*, 1985, 1, pp. 3–14.

… Kren's historical role in Europe is comparable to that of Brakhage in America, as is the way in which they each historically represent some aspect of the transition from the existential to the structural in their work.

(Le Grice 1975)

Regarded by many as 'the father of post-war avant-garde cinema', certainly one of the most important and influential of contemporary film artists, Kurt Kren is still too little known in the United States. His work has been left out of many 'comprehensive' film histories and critical anthologies. The significance of his work has been substantially addressed in English by only one serious writer on film, Malcolm Le Grice.

The reasons for this neglect are perhaps more sociological than aesthetic. Kren's activities as an artist have always gotten him into trouble with the 'authorities'. He's never had the slightest interest in 'promoting himself' or in promoting an easy understanding of his films – and then there is the Kubelka factor.

Peter Kubelka actually arranged the first showing of Kren's films, in 1961 at the Gallery St. Stefan in Vienna (*1/57 Versuch mit synthetischen Ton, 2/60 48 Kopfe aus dem Szondi-Test* and *3/60 Bäume im Herbst*). Shortly thereafter Kubelka moved to the United States. The story I've heard, repeated several times from several different sources, has it that when Jonas Mekas asked Kubelka about other European filmmakers, Kubelka replied, 'There *are* no other European filmmakers', thus effectively erasing Kurt Kren from European film history in America.

As far as I can tell, the source of this story is the interview Mekas conducted with Kubelka on 1 October 1966 in New York. It was first published in the Spring 1967 issue of *Film Culture*, then reprinted in the *Structural Film Anthology* (Peter Gidal, editor, British Film Institute, 1976). The interview begins with these lines:

Jonas Mekas: Should one concentrate specifically on your latest film, *Unsere Afrikareise*, or should we also talk about the European avant-garde?

Peter Kubelka: No, I cannot talk about the European film avant-garde at all, because there is nothing there that I respect.

Kubelka's subsequent popularity as commentator, administrator and consultant kept the door closed on Kren for the next 20 years.

The Kren/Kubelka story is like a 'demon brother' tale. Though they couldn't be further apart in terms of personality, their films show strong affinities. Both make short, highly concentrated films, which rely on precise editing to question and extend the act of seeing. Perhaps the biggest irony is that in the future their films will undoubtedly be shown together. In fact, this is already beginning to happen. Kren's films will last, and time will right the balance. The only reason it matters at all now is that the films would be shown more often if the balance hadn't been rigged.[1]

Kren's films are most important as investigations into the relationship between structure and experience. They are radical investigations, in that they uncover and draw from the roots of the film medium, and of perception itself. It is especially significant that Kren's structural investigations did not arise as formalist reactions against expressionism, but rather as progressive developments within an expressionist involvement.

Kren was born in Vienna in 1929. When the Nazi push began, he was sent away to Holland. He returned to Vienna at age 18. In the early 1950s he began to work with 8mm film (this early work has apparently all been lost). In 1957, he made his first 16mm film, *1/57 Versuch mit Synthetischen Ton* (Experiments with Synthetic Sound). (Kren's original labelling of his films was numerical/chronological – 1/57 marks the first film in the oeuvre, completed in 1957. Verbal titles came later.) By 1963, Kren had produced four more films: *2/60 48 Kopfe aus dem Szondi-Test* (48 Heads from the Szondi-Test), *3/60 Bäume im Herbst* (Trees in Autumn), *4/61 Mauern pos.-neg. & Weg* (Walls, Pos(itive), Neg(ative), and Way) and *5/62 Fenstergucker, Abfall, Etc.* (Windowlookers, Garbage, Etc.). These early films explore the formal, structural relationships among simple images (tree branches, mottled walls, portrait heads, etc.), and are all either shot or edited according to precise mathematical systems. Le Grice has called *Trees in Autumn* 'the first structuralist film'. Peter Weibel identifies the first generation of post-war Austrian experimental filmmakers (1951–1963) as consisting of Herbert Vesely, Curt Stenvert, Ferry Radax, Peter Kubelka, Kurt Kren and Marc Adrian (Weibel 1976). Weibel then describes the second generation (1964–1971) and notes, 'Kren linked these two generations. The first culminates at the end of the '50s, the second at the end of the '60s.'

Although Kren worked mainly alone during the 'first generation', he was already beginning to associate with other radical Viennese artists. In the second generation, collaborations began. In 1965, Kren participated in an eight-hour-long outdoor ritual *aktion* organized by Herman Nitsch, in which a lamb was crucified and totally destroyed, with blood and flesh thrown over the participants. Nitsch's 'Orgy Mystery Theatre' aimed

at 'catharsis through fear, terror and compassion', by means of a 'visualization of the suppressed' (Tsiakma 1976).

These bloody, Dionysian ritual-*aktions* grew out of the emotional and psychic fallout of the war, and were profoundly existentialist in conception.

> We are ever more attracted by our own existence. Every work of art is nothing but the mystique of the being. The aesthetic which pushes us until horror.[2]

In September 1966, the Vienna Institute for Direct Art, founded by Nitsch, Günter Brus, Otto Mühl and Kren, took part in the *Destruction in Art Symposium* in London. One commentator wrote:

> The Austrian events by the Institute for Direct Arts have a strange gothic quality, with carcasses, food, blood, wounds, images of crucifixion and plaster-covered figures. These manifestations are extremely ritualistic and contain an ingredient of sado-masochism and brutality which is absent from the happenings of other national groups.

(Reichardt 1966)

This same writer recognized the true nature of the gathering:

> The title DIAS is not altogether appropriate to the exhibits and activities demonstrated in London this year – a title used by the French, 'Festival de la Libre Expression', would seem more in keeping with both the manifestations and their underlying intentions.

(Reichardt 1966)

While Nitsch's ritual happenings were ultimately coherent in their religious/magical symbology and intent, the *Materialaktions* of Mühl and Brus were purposely chaotic descents into regressive behaviour. They involved Mühl, Brus and others in outrageous acts of sado-masochistic horror and defilement. Eventually, they stopped just short of murder in their 'amoral exploration of human capability' (Le Grice 1975).

> If these are works of defilement – as they surely are – they reflect a society of defilement; they capture its essence by means of harrowing violence and perverse sexuality. To Mühl, the only way to exorcise this cruelty is by recreating it in the protected environment of theatrical space, cruelly confronting the spectator not with fraudulent, fictionalized simulations but with the act itself.

(Vogel 1974)

Kren made eight films based on the *aktions* of Mühl and Brus. Far from being 'documentaries', these films take the image material of the *materialaktions* and transform it into the quite distinct, separate action of the film itself. The film acts stand beside the *materialaktions* as co-equal investigations.

Whereas the *materialaktions* of Mühl and Brus were time- and site-specific, drawing their power and significance from the immediate situations of their enactments, Kren's responses are formalized in filmic time and distanced in space and time through repeated enactments (film showings).

Kren's working method would no sooner take the material structure of the film medium for granted than it would the image material. The three-minute film, 6/64, based on Mühl's *materialaktion* 'Mama und Papa', is constructed of short shots (less than one second, often only a few frames), combined according to a pre-arranged 'score'. The emotionally charged images of contortions are counterpointed by their rapid and regular recurrence within the mathematically precise system of editing. This produces a compelling tension in the resultant film.

10/65 Selbsverstummelung (Selfmutilation) is based on a Brus *materialaktion* in which Brus, covered with white dough, writhes about and inflicts wounds on himself using surgical instruments, scissors and pins. The expressionist symbolic imagery is conversely acted on through the imposition of surgically precise montage configurations.

Structure is usually perceived through processes of abstraction. An event is slowed down, rearranged, analysed, represented. Experience is continuous, relentless. Simultaneous, contradictory acts sometimes bring the two together long enough to break through the assumptive haze of the spectator.

According to Sidney Peterson, Max Frisch once defined technology as the 'knack of arranging the world so that we don't have to experience it' (Peterson 1980). In Kren's work, the systemic strategies are ways *into* experience, not away from it. Kren uses the technology of film (the most recent and most primitive technology) to break through 'consensus reality' to experience. The counterpointing of agitational, provocative image material with strict formal structures is a strategy to this end.

Someone writing in the future will place Kren's work within the context of progressive Viennese art, tracing the lines of connection from the Vienna Secession of Klimt, Josef Hoffmann, Moser, Olbrich, Otto Wagner etc., through the late Modernists Kokoschka and Egon Schiele, and the Second Viennese School of Schoenberg, Berg and Webern, to the Institute for Direct Art and beyond, following the diaspora out (Rein 1984).

In two of the films Kren made after the Direct Art period, the image is literally 'masked'. In *31/75 Asyl* (Asylum), holes are progressively cut in a mask fitted over the camera so that pieces of the image pop into view as new holes are cut. In *32/76 An W&B* (To W&B),[3] a cemetery is filmed from out Kren's window through an enlarged photographic negative, producing a strange netherworld which is neither life nor death.

In *24/70 Western*, recognition of the image being filmed (an anti-war poster picturing the My Lai massacre entitled 'And Babies') is withheld, through close-up filming of the surface of the image, never stepping back to reveal the whole. The method in this film (as in *20/68 Schatzi*) acts to subvert the quick responses of viewers to loaded imagery.

In all of Kren's films, the images are variously covered and uncovered, hidden and revealed, never taken for granted.

Kren's filming has always been marked by an extreme economy of means. A great deal happens in a small number of frames. Some films are made entirely in the camera, using the frame-counter on a Bolex to measure the film according to the orchestration in the scores. The films that are edited outside the camera often still amount to a 1:1 shooting ratio. Shots and phrases are repeated within the film. Others have speculated that this economical use of film stock is wholly practical. Kren has always lived with a minimum of money and this has not allowed him to use a lot of film. When I asked him if he'd ever had the luxury of plenty of film, he replied, 'If I had, I wouldn't use it. The longest film I've made is ten minutes long, and I've always thought that it is a few seconds too long.'

Godard, in a recent interview, said, 'It is not true that only if you have a great deal of money can you make a film. If you have a lot of money it is just a different kind of film that you will make. If you have no money you can still make a film ...' (Bachman 1984).

This economy leads to (or results from) a concern with compressed time relations and limitations (Kren's mathematical editing systems) and with beginnings and endings, in a wider sense, from scatology to eschatology.

A human life is a measure. This measure is further divided by periodic bodily occurrences into smaller measurements – sleeping and waking, eating and shitting, the pulsing of the blood, breathing, menstruation, etc. Film is measured by frames and shots, over projection time. Kren repeatedly counterposes the measures of these measures.

The relation was made explicit in Kren's 'concept' piece, *5/71 Klemmer und Klemmer verlassen die Welt* (Klemmer and Klemmer leave the World), in which he threw the film he had made into the grave of a friend, so that it was buried with the friend.

42/83 No Film is three seconds long and consists *only* of its measure in time.

Kren's ultimate scatological film, *16/67 20 September*, made with Günter Brus, is not *primarily* confrontational, though it's certainly been taken as such by many viewers. It is a simple, very direct, study of the repetitive measures in a life in a body: eating and drinking, shitting and pissing. Beginnings and endings. Inevitabilities. These common periodic events are counterposed by the periodicity of the film itself, that is, the frame count over time.

The film was *not* well received in certain quarters. In a characteristically joyous note to Stephen Dwoskin, Kren anticipated these reactions: 'The next week I'll finish a new film: *16/67 20 September*. It is very dirty being about eat-drink-piss-shitting. Many friends will hate me after having seen that film. Sorry. It had to be done!' (Dwoskin 1975).

Kren is a naïve artist, recognized in that of which terms its Latin origin in *nativus* (native). He is native to film. There are things he does not find necessary to question because he *lives* there. Dwoskin, in *Film Is*, wrote: '(Kren) loves making films and has made a very large number despite the difficulties of having no money, no job and no home.' Kren's home has been his films, his native habitat. When he speaks about the properties of film, his speech is characterized by the delight of a child and by the quiet authority of one who has lived in an area for a long time.

Kren directs a great deal of attention to the basic elements of the film medium. Each time he picks up a camera, it is as if he's never seen a camera before. How does it work? What are its special properties? His approach to image is equally unprejudiced.

(An Argument of Sorts)

'Structuralist' film began to distinguish itself from 'poetic' or 'visionary' film about ten years after Kren made his first film. At some point in the mid-1970s, 'structuralist film' supplanted the 'New American Cinema' (in the United States) as the dominant 'avant-garde' movement in independent film. Within this movement there arose a neo-orthodoxy of 'Structural/Materialist' film. Peter Gidal's 'Theory and Definition of Structural/Materialist Film' was first published in the November 1975 issue of *Studio International* and reprinted in his *Structural Film Anthology*, British Film Institute, 1978.

At the outset we are told that Structural/Materialist films are 'anti-illusionist', anti-representational, anti-documentary, even anti-Structural ('…Structural/Materialist film in fact demands an orientation of definition completely in opposition to the generally used vague notions concerning "Structural Film"').

The movement here is defined as a reactionary one, arising in reaction against existentialist and expressionist tendencies. 'The SM film must minimize the content in its overpowering, imagistically seductive sense, in an attempt to get through this miasmic area of "experience" and proceed with film as film.'

Gidal's righteously indignant railings against the evils of narrative, representation, ambiguity, and other 'incorrect' practice reminds me of nothing so much as the preaching of religious fundamentalists. In Gidal's fundamentalism, thou shalt *not* tell stories; thou shalt not *represent* or *document*; thou shalt not *reflect* or *express*; and above all, thou shalt not *create illusion*.

Gidal engages in the kind of disintegration of method which is useful in theory, but absolutely fatal to the work itself. At one point he comes very close to arguing the supremacy of theory over the mere *making* of films.

After laying out the terms of his proscriptive schema in exhausting detail, Gidal lists some films that have made it through his sieve and earned the title, 'Structural/Materialist'. The list includes four films by Kurt Kren (*Trees in Autumn, TV, Szondi-Test & Auf der Pfaueninsel*), as well as work by Le Grice, Michael Snow, Raban, Kubelka, Frampton and others.

Kren's films burst through Gidal's contraceptive theories with the explosive force of a renewed heretic. Kren's films never deny representation. Illusion (from the Latin against + ludere – to play: to play against) is used in ways both simple and complex. The films are not strictly reflexive. Kren's attitude towards image precludes fixed strategies. Kren's innovations are radical and exploratory, not dogmatic.

The other filmmakers tarred by Gidal's SM brush don't deserve such treatment any more than Kren does. Michael Snow has spoken of the inspiration of Cezanne in decidedly un-SM terms: 'The complicated involvement of his perception of exterior reality, his creation of a work which both *represents* and *is* something, thus his balance of mind and matter, his respect for a lot of levels is exemplary to me' (Snow 1967).

Compounding these terms, one could say they exemplify a perception of the world as what *is* and what *does* one do in response. You see something, you make something, and this is one act. This is so simple, it is almost always invisible. One situation where it is not invisible is that of a child at play. Another is in Kren's films. There is a vitality here that is unmistakable, and very rare, in any medium.

Another filmmaker named by Gidal as committing SM films is Malcolm Le Grice. In addition to producing his own fine films, Le Grice has written brilliantly on the work of others. In *Abstract Film and Beyond*, Le Grice recognizes the true importance of Kren's work:

In the context of an existentialist attitude to cinema, and in the work of Kurt Kren, a new issue emerges. This can be seen as a dialectic between existentialism and structuralism, entering on the relationship between concept or pre-concept and subjective experience. In rejecting essence, and with it philosophical hierarchy and transcendence, existentialism is suspicious of all forms of structure on the grounds that they prevent immediate experiential relationship. Alternatively it sees structural order as authoritarian, a reflection of the dominance of the current environmental and social condition. This can also extend to a suspicion even of psychoanalytic order. However, there need be no fundamental conflict with order or structure, merely with the concept of order as an immutable condition – either existing *a priori* within phenomena, or as an accepted authoritarian determinant of choice. Particularly in art, order or, more precisely, ordering, becomes compatible with existentialism when that order is considered as temporary, local, provisional, fortuitous or arbitrary.

(Le Grice 1977)

Kren's orchestrations of the film frames are not immutable – 'I make a kind of order, then I go beyond it,' he said. This ordering does not get in the way of subjective, associative image play.

> Compatibility between existentialism and structuralism therefore derives from the dialectical creation of structure for the perception and experience of existence. In effect, structuralism in art can be seen as a consequence of the awareness that concept can, and perhaps must, determine the nature of perception and experience if it is to avoid determination by existing convention or habit.

> (Le Grice 1977)

In Kren's work, the perceptual – the eye, the orders of seeing, are always predominant. The conceptual, the orders of intellect, are circumscribed with mathematical precision. A great deal of what we watch when we are watching a Kren film is the erratic dance of the two orders, from the concept to the percept.

Kren's most recent films are more 'diaristic' than any of his previous films. *39/81 Which Way to CA?* (3 min), *40/81 Breakfast im Grauen* (3 min) and *41/82 Getting Warm* (3 min) are all composed of 'home movie' footage, edited to articulate certain relationships among the images. Now that home movies are no longer made at home (post-video), a 'home movie style' can be abstracted for use.

Which Way to CA? reflects a tourist's view, which is perhaps the only view anyone of European descent can have of California, having arrived here only recently (10 minutes, 200 years) from somewhere else. The film begins with freeways and cemeteries under freeways. Someone with a camera in one hand checks his watch – an allusion to Kren's systemic timing techniques, absent here. Then come generic baby pictures; bouncing baby, baby mugging for the camera, changing after shitting, Santa Claus. Japanese tourists are frozen forever, anonymous and calm under the Golden Gate Bridge, the ultimate camera culture. Other unidentified movements. The film is laced with surrogate self-portraits involving a '68 Chevy Bel Air: Chevy with Seagull, Chevy at the Beach, at Valley Ford Market, at Jensen's Oyster Bar. See the USA in your Chevrolet. There are some places one just can't get to on public transportation.

These 'ordinary' images are combined in ways that cause us to question their value as representation. How is 'the baby' different from 'the 68 Chevy' or 'the Japanese tourists'? Within the reconstituted 'home movie' frame, these subjects are reduced to generalized signs. The process is ironic, in that the original intention of 'recording' these images was to 'remember' specific events and individuals. Through what processes do they lose their identity? What new significance do they acquire?

Breakfast im Grauen is another 'diaristic' film, featuring a wry homage to Manet's *Le Déjeuner sur l'Herbe* (Lunch on the Grass), which so scandalized 'official' taste in Paris in the 1860s. 'Grauen' has a double meaning in German. It is both 'dawn(ing), daybreak' and 'horror, dread'. The verb 'grauen' also means 'to grow grey' or to have a horror of or aversion to – I dread. Breakfast in Grey (the film is in black and white) or Breakfast in Dread may yet find its way into a *Salon des Refusés* of film. Appreciators of Kren's earlier films may find it too loosely constructed, too reliant on the individual image.

The homage imagery involves a crew of workmen eating breakfast on the job. The camera angle is low, subordinate. After a bit, Kren climbs into the image from below, abandoning the camera, drinking from a half-gallon of milk. He is barechested, thus replacing the nude in the *Déjeuner sur l'Herbe*. In the same way that the fact of the nude woman among proper gentlemen in *Le Déjeuner* was unsettling to nineteenth-century Parisian viewers of painting, Kren's direct, even crude representation will disturb many sophisticated structuralists.

By actually entering the image himself, Kren confuses the issue of 'reflexivity'. He enters the image as a worker. From the interview (conducted by Strauss and David Gerstein, published in the same issue of *Cinematograph* and reprinted in a longer version in facsimile in this volume), I learned that this imagery dates from Kren's days of working for a New England wood salvage company. He worked as a 'denailer', removing the fasteners that hold structures together.

The film also includes more 'meta-film' footage, of a film crew setting up, sound people with mics etc., filming in a garbage dump with a cast of thousands of seagulls. In the film being made, Kren plays the garbage collector, who tells the film crew to look elsewhere for their material.

Getting Warm begins with a leader countdown ending in a small fire. The picturing then proceeds with building a house, lying on a bed before a TV, a grocery store day and night, a car being towed away, the Salvation Army, Winchell's Donuts, an unemployment line, more day labour… – all acts of 'getting warm', staying warm, staying alive. One also thinks of the colloquial sense of 'you're getting warm', meaning 'you're getting closer', echoing the search implied in *Which Way to CA?*

In these latest, post-structuralist films, Kren allows the individual images, the signs, to come forward, with less apparent manipulation. They are composed (quoted) and then combined in ways that lead us to question them as representations. In a recent article dealing with several post-structuralist photographers, James Hugunin and Lew Thomas wrote:

The point is that, for the above artists, representation is not rooted in the naïve assumption of mere resemblance to nature. What these photographers depict are the very *modes of representation* themselves, a task accomplished by appropriating, quoting, from already existing systems of signs. They attempt a deconstruction of the system of representation through a double operation: by producing simultaneously a

representation (the quotation) and a critique of this representation which deconstructs the notion of representation at the very moment of elaborating it.

(Hugunin and Thomas 1984)

This is not unlike what Kren does in these most recent films. He appropriates 'already existing systems of signs' in order to reveal certain conceptual assumptions and perceptual blocks through subtle manipulation of these signs. In the process, he takes pleasure in making something which both *represents* and *is*.

References

Bachman, G., 1984. The Carrots are Cooked: A Conversation with Jean-Luc Godard. *Film Quarterly*, Spring.

Dwoskin, S., 1975. *Film Is: The International Free Cinema.* Woodstock, NY: The Overlook Press.

Hugunin, J., and Thomas, L., 1984. In the Beginning Was the Word – and Since Then There's Been the Quote. *U-Turn Supplement 1*, LA.

Le Grice, M., 1975. Kurt Kren. *Studio International*, London, Nov/Dec.

Le Grice, M., 1977. *Abstract Film and Beyond.* London: Studio Vista.

Peterson, S., 1980. *The Dark of the Screen.* New York: Anthology Film Archives and New York University Press.

Reichardt, J., 1966. Destruction in Art. *The Architectural Review*, London, Dec.

Rein, I., 1984. On the Couch: The Vienna Secession. *Artforum*, Sept.

Snow, M., 1967. Letter. *Film Culture*, 46, Autumn.

Tsiakma, K., 1976. Hermann Nitsch: A Modern Ritual. *Studio International*, London, July/Aug.

Vogel, A., 1974. *Film as a Subversive Art.* New York: Random House.

Weibel, P., 1975. Austria: Current Activities. *Studio International*, London, Nov/Dec.

Notes

1. The important survey film exhibition now being circulated by the American Federation of Arts, *The Other Side: European Avant-Garde Cinema 1960 – 1980* is a step in the right direction. The program includes five Kren films (catalogue available from Film Program/The American Federation of Arts/41 E. 65th St./NY 10021).

2. Hermann Nitsch, statement from *Il Corpo Come Linguaggio*, Lea Vergine, Milan, 1974. Quoted by Genesis P-Orridge and Peter Christopherson in 'Annihilating Reality', *Studio International*, London July/Aug. 1976.

3. To W&B – to Wilhelm and Birgit Hein, West German filmmakers and teachers of film, who published *Film im Underground*, the first book on the subject in German. Writing about their film, *Structural Studies*, in his 1974 *Village Voice* column, Jonas Mekas could have been describing Kren's work: 'a work which is at once very formal and very innocently simple, almost primitive … I had a feeling of being excited about cinema, discovering the seeing, discovering the optical illusions.'

Interview with Kurt Kren

David Levi Strauss and David Gerstein

First published in San Francisco, *Cinematograph* volume 1, 1985, pages 14–17.

In addition to the limiting fact that English is not Kren's first (or second)
language, and that I don't speak German, further difficulties arise in transcribing
his highly elliptical, gestural speech. The following transcription is edited from
an interview lasting nearly two hours. I have occasionally supplied connectives and
filled in blanks for continuity's sake, but have tried to otherwise stay out of the
way.

Since Kren is not altogether comfortable with English, he tests each word,
often questioning usage and sytax. He's also very playful. His voice is gentle,
continually softened by laughter. I'd like to think of this as a snapshot, an
'impression' of Kren at a specific time-- September 22, 1984-- in a specific
place-- David Gerstein's apartment on Treat Street in San Francisco.

STRAUSS: At what point in the process do your "scores" come in?

KREN: It's different for different films. Some are made after shooting and
 before editing. Many others are made before shooting, and the films
 are edited in the camera. This one (10/65-67 Selfmutilation) was or-
 iginally scored by numbers only and later I translated it into this
 form to see what it would look like. For Trees in Autumn, I edited it
 in numbers on a piece of paper, then I walked around in Vienna and shot
 the trees.

STRAUSS: What determines yr rhythms? Are they always mathematically derived and
 pre-arranged?

KREN: Sometimes they develop. I begin with a score and then I modulate it,
 change it a little bit, depending how it looks.

STRAUSS: So when you have a score before you shoot, do you always stick to the
 score?

KREN: Sometimes I have mistakes. It's to make myself a kind of limit, but
 I can also go beyond.

STRAUSS: What is "Rischart"? (36/78)

KREN: It's the name of a bakery, where I take coffee. This film is also shot
 in the camera, always rewinding, fading in and fading out. I would shoot
 at 21 metres, wind it back to 2 metres, ahead to 19 metres. . . But it
 isn't always exact, I have to estimate.

KREN: Tree Again was also done in the camera, one of the more recent. It was
 made with infrared color film and the film was outdated more than five
 years. I shot it in fifty days and every day I said to myself I'm crazy,
 I even don't know if there's anything on the film. Because normally you
 have to get it from the film plant, put it in the camera, shoot and run
 back-- it's very sensitive.
 This score is a sort of translation. I made one frame, then I made
 a black frame (not exposed), two frames exposed, one not exposed, three
 frames, then I rewound it-- eight frames, five frames,. . .

STRAUSS: Did you shoot a certain number of frames per day, in the fifty days?

KREN: That varied. How I was feeling. How the day was.

STRAUSS: And that was shot in Vermont?

KREN: Yes.

STRAUSS: In the Spring?

KREN: It was nearing Fall.

GERSTEIN: So with this film (Keine Donau- "No Danube") , you rewound the camera
 five times and ran the whole film through five times?

KREN: Yes, using the film counter on a Bolex.

STRAUSS: The rooftops are in Vienna?

KREN: Yes.

GERSTEIN: Why the title?

KREN: Yes, well, I thought because I always make a title of what is, I decided
 this time to make a title of what isn't.

 But it's strange, because I started the film in Munich, where there is
 no Danube anyway. (Laughter).

STRAUSS: When do the titles usually come? Before or after?

KREN: Well, actually, I started with numbers only, the chronological number
 of the film. I started with number one, and then a slant, and the year.
 But after awhile this became confusing. Then I began to make films of
 other people's aktions, and titles began to show up. Then even the
 first five films began to be titled for films that had none. "Mahogany
 Moon", they called one film.

STRAUSS: But then you started to play around with the titles yourself, like
 "Getting Warm."

KREN: Yes, or like "Breakfast im Grauen." You have this French Impressionist painting, Dejeuner sur l'Herbe, and the German word Grauen has a double meaning, "in the gray" and "horror."

STRAUSS: How about Asyl?

KREN: That was done in 21 days.

GERSTEIN: Really? I always thought it was shot over a number of seasons.

KREN: It was Spring, and it rapidly changed. I always wound it back at night when it was dark and started over the next day. I glued black plastic contact paper over glass and cut out, the first day, four holes, then at night I rewound. The next day I cut eight holes and this went on and on.

STRAUSS: The images seem to pop into. . .

GERSTEIN: . . .because you wind the film back and when you shoot the next time, all of a sudden, there's this hole where previously there'd been black plastic, so all of a sudden this image pops right onto the screen.

KREN: There's this ideal of it, but it couldn't be done so exactly with the camera.

GERSTEIN: Registration is off, and. . . Which actually for is one of the things that I like about the film. It doesn't have that mechanical precision. It gives it this impressionistic quality.

STRAUSS: It's also vibrating all the time, as if its ready to fly apart at any time, the particles are just barely cohering.

GERSTEIN: It doesn't appear precise. It's all being invented in the viewer's eye anyway.

STRAUSS: When these kinds of things happen, when something doesn't fit the plan, does it oftentimes lead to other things? Do you use the error?

KREN: Well sometimes errors give it a new life. But, that's kind of included.

STRAUSS: And the title, "Asyl"?

KREN: I lived for awhile in the country, near Saarbrücken. I'm not very country. It made me crazy. Asylum means retreat, but it also means the mental hospital.

STRAUSS: But you have this thing for trees. . .

KREN: Trees have an impact on me. In a mystic sense, it's quite a symbol.

STRAUSS: In Tree Again, especially, one gets a strong sense of how the tree is alive in the image, since it moves all the time, only coming to rest at

the end of the film.

KREN: What strikes me personally. . . I see trees all the time, but it's always a new perception of it. I see it new, kind of different, again.

STRAUSS: What about other titles, like "Western"?

KREN: We have this expression, "to shoot the film." I got this poster from the Guerilla Art Group in New York, of the My Lai massacre. I shot it in single frame, it was like shooting again. Therefore, I called it "Western".

STRAUSS: There are red letters that appear but are not finally legible. . .

KREN: It's a question. "And Babies. . .?"

STRAUSS: Has there always been a good deal of continuity through the years in the Viennese Underground?

KREN: Well, actually I don't know what's going on there now. Vienna is a kind of wierd place. That Freud came up there is no coincidence. It just had to be. (Laughter.)

STRAUSS: It's a very closed society?

KREN: Well, there is a parallel with Berlin. Once it was a big metropole, a real world city. Then after the First World War there was a breakdown, now it's nothing anymore. But people still have that. . . "Oh, we are Viennese, we are somewhere." So the average people are still very hooked on that authority. Once I went with a dog in a park. I was on the sidewalk, but the dog was just going on the grass, and it was forbidden on the grass, and all the people came out, they nearly lynched me. . .

STRAUSS: Or lynched the dog, ...

KREN: There is a kind of Austro-fascism, and it's very strange. People would be very angry if you mentioned it, but. . .

STRAUSS: You've always worked against that, I mean many of your aktions, . . .

KREN: It was aggression against repression from outside.

KREN: There is a film I didn't show here, because for American people, it just doesn't say it. I made a drawing film. Like a cartoon. It's a sort of chauvinistic joke. There is a symbol in it, a triangle with an eye in it, the eye of God. In the USA, people don't. . .

STRAUSS: Except that we have that on our money, on the dollar bill.

KREN: It was in Munich, which is very much Catholic, and a friend had a serial

called "Sex and Film", and the police raided it, and took the drawing film, actually a whole reel of film. . .

GERSTEIN: But not because of the sex, but. . .

KREN: . . . It was incredible. The police made a description of what happens in this one minute film (26/71 Zeichenfilm: Balzac oder das Auge Gottes-"Balzac or the Eye of God"). I got to read it, it was pages long. The charges against me were bringing uproar, public uproar, and offense of . . .

STRAUSS: Against Church & State.

KREN: You see how film and life, . . . I went to the USA in 1978, and there were a lot of films I couldn't bring over, because the police took a whole reel, on which were many short films. I didn't have Asyl, or. . . I was very frustrated. I nearly didn't want to go, but I thought I must go to show the other films. And I'm still here (Laughter).

STRAUSS: What did you have to go through to get them back?

KREN: I don't know exactly what then happened with them. I made new prints of the missing films.

GERSTEIN: So they still have them.

KREN: I don't know. . .

STRAUSS: You should list that in your filmography: "In the Collection of the State Police of Munich."

—————————

STRAUSS: In one of the bios I read it said you made some 8mm films before beginning to work in 16mm. Do they exist?

KREN: Oh, perhaps, somewhere. But they fell apart. The splices didn't hold. It's kind of a mess.

STRAUSS: Did you ever consider using 8mm again?

KREN: It is tempting, to use Super 8, because it's easier to have with you. I didn't do it yet, but I might.

—————————

STRAUSS: Where all have you lived in the U.S.?

KREN: First in Vermont.

STRAUSS: In Thetford?

KREN: Yes, it was. . .

GERSTEIN: How did you wind up in Vermont?

KREN

KREN: I got married! (Laughter.)

GERSTEIN: Well, I know that, but you must have met this person somewhere. . .

STRAUSS: Your wife was from Vermont?

KREN: No, she was from Chicago.

GERSTEIN: She was a student someplace up there.

KREN: Yes, well, she came from college.

 And then I lived in San Francisco in what? 80, 81? Then we went for
 awhile, in summer, to New England, where I did this 'wood salvaging'
 which you see in the film. When houses were torn down we salvaged
 and sorted the wood. I was a denailer. In New Hampshire.

STRAUSS: What other jobs have you had?

KREN: Well, then it got cold, so I started Getting Warm. I went to Austin.
 I had a show in Houston, someone from Austin saw it and invited me to
 Austin. There I did day labor sometimes. I went to the Texas Unemployment
 Office at 7 o'clock, and. . .

STRAUSS: That's the footage in Getting Warm. The Unemployment Office. That light
 only occurs in Unemployment Offices.

KREN: And you waited and sometimes jobs showed up. Many jobs were really
 terrible, bone-breaking, dangerous. So then I was invited to come to
 Houston. That was set up by a group called Really Red, a punk group.
 It was a benefit concert and film showing, and a lot of money came in.

STRAUSS: Are they the ones that did a song about you, called "Kurt Kren"?

KREN: Yes, they're the ones. 45 seconds. It's on a record, a single. I'll
 send it to you.

STRAUSS: What's in the song?

KREN: It's about a guy who makes very short films.

STRAUSS: And in HOuston, now, you're a museum guard?

KREN: Yes, at the Museum of Fine Arts. People I think have the impression
 that being a museum guard, you have time to think about art, but it's
 not that way. Actually, it kills your brain, turns it into limburger.
 And you are just waiting. You watch your life go by and you can't go
 out there.

 The funny thing is, in Vienna, I worked in a bank for a long time. There
 I made scores, I even edited films there! Mama und Papa was edited in the
 bank. There were thousands of splices.

GERSTEIN: Made <u>in</u> the bank?

KREN: Yes, at my desk.

STRAUSS: That's very likely the only film that has ever been made in a bank.

KREN: I was always handling a lot of money in the bank, but it wasn't money
 anymore. It was just heavy weights.

 There was an extremely good kitchen in the bank, also, especially for
 employees. Fantastic food, better than the best restaurant.

 But I always had this feeling that I couldn't get out of there, because
 I was so used to living without money, I couldn't exist outside the bank.
 Then I made my first trip to the U.S., in 1968, I went to New York. I
 also had a showing in St. Louis. After that trip I knew I had to get
 out of the bank. The other problem was I had a lot of <u>debts</u>, with the
 bank, because you only had to sign your name and they'd lend you money.

 Then there was, at the University, a series called "Art & Revolution."
 Muehl and Brus were there. Brus sang the Austrian National Anthem while
 shitting on stage. The press went crazy. Witch-hunting. House-searching.
 My film, September 20, was shown in Munich and the press wrote about it.
 There was a Viennese newspaper called "Blue Monday" which merged, at this
 time, with a very right wing paper and on the front page was the headline,
 "Swinish Things Again in Cinema", with my picture, etc. So the next day
 I had to go to the personnel office in the bank and they told me I was
 suspended until I would quit. By this time I was "official", secure,
 I couldn't actually be fired, at least not like this. I could have fought
 it out with them, I might have even gotten a pension, but I was really
 just so kaputt with nerves. . . I heard it, I turned on my heel and
 said, "bye bye". I was so glad to get out of there.

GERSTEIN: Did you get a lot of political harassment while you were in Vienna, police
 harassing you,...

KREN: Well, the thing is I left in 71 or 70, I lived in Germany. And in Germany,
 I always had trouble with police.

GERSTEIN: Because you were Viennese, or because of what you were doing?

KREN: No, just because of my nose, or whatever. Always getting harrassed.

ANKER: Because of the art that you had made, or. . .

KREN: Well, it was. . . They were always looking for terrorist groups. . .
 (Laughter)

STRAUSS: More harassment in Germany than in Austria.

KREN: Well that's a great thing here in the U.S.A. Still sometimes when I see
 a police car, I duck, but they're never looking for me.

GERSTEIN: No, that's what the Blacks and Hispanics are here for. Do you think the harassment was partly because you're Jewish?

KREN: No, I think. . . I'm just a freak. Kind of suspicious. (Laughter)

STRAUSS: Have other strange things happened at screenings of your films?

KREN: Alchohol is the only drug that doesn't work with films. Smoking pot is good for watching films. For instance, in Baden-Baden, German t.v. wanted to make a documentary about underground film, so they invited all these filmmakers to a showing of their films. They had infra-red film to film the audience during the showings. Unfortunately, they also had big vats of red wine. I was lying on the floor, drinking and drinking, getting terrible drunk, and oh, there were fights, and screaming, And at one point, I looked up and yelled, "What a shit film is this!" and threw the red wine on the screen. After it was all over someone told me it was my own film I'd attacked! (Laughter)

STRAUSS: Many of your films seem to be taken 'out the window', like from where you live, to . . .

KREN: The funny thing is, there's a film I didn't bring this time, "Window-lookers, Garbage, Etc.", which pictures these old people, in Vienna they are everywhere looking out of their windows, and I hated these people. After awhile I found myself shooting out of the window.

STRAUSS: You became one of them. (Laughter) Do you take many still photographs? Sentimental Punk is stills.

KREN: Yes, 36 color slides. I also have an older film, "Walls, Pos., Neg,, und Weg", and this is house walls, textures, in still photographs, positive and negative. I also make still photographs with a very cheap camera, a 'disc' camera, and send these out as mail art.

STRAUSS: At the Art Institute the other night, when someone asked how many films you had made, you said 42, plus four or five 'aktions.'

KREN: Yes, there are 42 titles. The aktions include things like Danke which was a funeral where I threw the film into the grave. I shot footage of the funeral, then I took the film out and threw it in the grave.

STRAUSS: Whose funeral?

KREN: A Viennese painter, a friend of mine.

STRAUSS: The scene in An W & B, was that from somewhere you lived? across from a cemetery?

KREN: Yes, I made a still photograph from out my window in Munich, and had a friend make a large negative slide from it. Then I put it in the window, in front of the camera lens, so that it nearly corresponded with the 'real' image, outside.

GERSTEIN: And you moved the focus back and forth? So sometimes you're focused on the slide and sometimes on the scene outside.

ANKER: But the negative image is in front of the camera lens all the time.

GERSTEIN: Do you think in terms of what the meaning of a film like that is?

KREN: My big adventure is always to see what comes out of it, what, how will it be when it's finally thrown up onto the screen.

There is some connection, in films like Trees in Autumn, I think, with Pollock, this informal art.

STRAUSS: In one of the articles I read, someone actually called you an abstract expressionist.

KREN: Yeah, well. . .(Laughter). . . What's in a name?

GERSTEIN: They must not have seen the later films. But I was thinking that, in making films, you do it a lot to see what happens and to experiment, but there's also an idea behind the experiment, of trying to get across some kind of experience.

KREN: It is how I live, how I feel. It all comes together, but it's difficult to say it in words.

ANKER: You know that film by Brakhage called "The Dead"? It's very different from your film, he uses a different technique, but in some ways dealing with a similar metaphor, where he's got the negative and positive of the same image, in Paris, flirting with each other, and he calls the film "The Dead".

KREN: I have another film called Schatzi, it's a . . .

STRAUSS: "Schatzi" is. . .

KREN: It means "honey" or something.

STRAUSS: . . .a term of endearment.

KREN: Yes. It pictures an SS officer with bodies all around him. For this I had a positive slide and a negative slide and I changed the aperture between them.

ANKER: You had a score for An W & B?

KREN: No, that film had no score.

STRAUSS: There are also these 'gifts' in that film. I recall a child pedaling a tricycle across, and a red umbrella that goes across the scene. These

events gain a significance they would not otherwise have, moving through this charged scene.

Also in this film, the rhythmic pulsing that results from you changing of the focal length becomes a 'base line'. That occurs in many of your films. There is regular 'heartbeat', and then other things happen around this. Is that something you think about?

KREN: Yes, well, I just do it.

ANKER: Kurt, over the years, have you shot many rolls of film that you looked at and then discarded?

KREN: No.

STRAUSS: You use everything.

KREN: Well, mostly it happens that it comes out of the camera and it's ready.

GERSTEIN: What was it like to work with Muehl?

KREN: It was very. . .refreshing. We drank a lot of wine. I often was amazed that the film was ever in focus. But it's like when shooting, pistol shooting, and you are drinking a lot, there's a certain level of drunkenness when one is very precise, very accurate in shooting. But you have to be careful not to go beyond this level, otherwise. . .

GERSTEIN: The edge of spontaneous control.

STRAUSS: Is Muehl still alive?

KREN: Oh yes. Years ago he started a psychotherapy commune, with branches all over. It uses self-performance, and shout therapy,. . . It's kind of prosperous now. The commune has a gas station, and a cafe, a moving business, etc. And Muehl began to paint again-- landscapes, with pastel and oils, kind of expressionistic. And Brus makes drawings, wonderful tiny drawings, with stories to them.

STRAUSS: Where is he?

KREN: He almost had to be in jail for 8 months. We brought him over the border and he lived in Berlin. For years he had no passport even. Then the government changed, and everything was forgiven. In 79 I was at a film showing in Berlin. There I heard that Brus had an exhibition (of his drawings) in the foyer of the Viennese Opera, the most bourgeoise place in the world! (Laughter) He lives now near Gratz, in Austria.

GERSTEIN: What was he to be put in jail for?

KREN: For shitting while singing the National Anthem. The Viennese authorities really got mad!

STRAUSS: Do you see a lot of commercial films here?

KREN: Yes, I do now. Years ago I hated feature films. I refused to see them, but now I don't have that hostility. I've learned a lot by seeing films.

GERSTEIN: When did you first show your films in the U.S., actually?

KREN: In 1968.

GERSTEIN: Oh, so you did have some shows then.

KREN: Yes, and I didn't take the films back with me, but left them at the New York Film Coop.

ANKER: Did anyone pay attention to the films then?

KREN: Oh yes...

GERSTEIN: Because I think from all our perspectives, certainly from mine, the first I really knew of your work was when LeGrice's book came out, and then you came to the U.S. a year later.

KREN: There is also the story with Kubelka. We were kind of friends, acquaintances, in the late fifties. He even arranged my first show in Vienna at the Gallery St. Stefan, a very progressive gallery. The first time in the early sixties, he went to the U.S.A. and met Jonas Mekas and he was asked if he was the only filmmaker in Europe and he said yes.

ANKER: No, Mekas asked him what he thought of other European filmmakers and he said there are no other European filmmakers.

KREN: That still has an impact. There is a kind of blacklist, conscious or unconscious, it's still there. I had a show at MOMA in New York, and the man who organized it asked me, "Are you still in a fight with Kubelka?" and I said not from me. "Oh," he said, "then I'm glad you aren't." There is a world encyclopedia of underground film. Everyone is in it, even those who've only made one Super 8 film. Everyone is mentioned. My name isn't in it. I was always so mad about this book. Recently I looked it up in the public library in Houston and saw that Peter Kubelka was one of the people who helped put it together, and at that time he was the only filmmaker in Europe.

GERSTEIN: So this was in the early seventies?

KREN: Yes.

GERSTEIN: Because today that wouldn't happen.

KREN: There was a big film show in Hamburg, and it was really crowded. Everyone was a filmmaker. They are all mentioned in that book, but no Kren. It was Kunvlekner (?), he did a lot of damage.
Kunstlekner

GERSTEIN: He runs the Austrian film museum. He's not a fan of yours. When I was
Delete

¹. Delete

~~there a couple of years ago he asked me what you were doing and it was clear he didn't like you at all.~~ I thought it was some sort of class thing, that you were working class and he's upper class. Kubelka is also from an aristocratic background.

KREN: The baron! (Laughter)

GERSTEIN: He does actually have a castle outside of Vienna.

STRAUSS: Do you think that's a lot of the reason?

KREN: Well, like I said, there is a kind of unconscious conscious blacklist and it effects publication and shows and. . .

Kubelka has a way of making a 'charisma'. He can talk bullshit and people. . . it's like Reagan.

GERSTEIN: ~~They have similar politics, in fact.~~ *Leave this out*

ANKER: We were talking the other day about where you feel experimental film is at right now and you were saying there's no audience for film now and I'm wondering if you have any thoughts about whether that might change or if you're thinking yourself of trying to shoot video, or. . .

KREN: Well I said if I would make <u>political</u> films I would use video because it is immediately <u>there,</u> and you have the event and you can show it right to the people afterwards. Or if I had a stage, a theatrical situation, it would be useful for ~~actorsxand~~ actresses, they can have that feedback, they can see immediately what they are doing, on the screen. That is the immediacy. But I wouldn't make <u>films</u> with video, just to press buttons.

ANKER : So do you think there might again be more interest in film?

KREN: In the sixties, the situation was so very different. Economically, it was a kind of revolutionary situation, and that all changed.

ANKER: But there is still much more of an audience for independent film than is given credit...

KREN: You have to have a kind of 'schooling', how to <u>see</u> these films. It's not just that you sit there and you get it all. You really have to involve yourself in it and to find out what it's about, and you have to see it many times. The first time it's very hard.

ANKER: How did you feel about the audience the other night?

KREN: It was great. I was. . . astounded, really.

ANKER: If you saw more of that kind of an audience in Houston or in New York would you think the situation were improving?

KREN: There would have to be some people to sacrifice their time and work

like you do to show them.

ANKER: So why do you think people are not doing that?

KREN: It's just easier not to do it.

GERSTEIN: It's work to show the films and it's work to see them.

ANKER: But it pays off. The thing is, our attendance has been very good overall. The No Nothing people who, they don't charge, but they're getting good crowds. There are still people who want to see films and we always say, and they say, that we see different crowds, almost from night to night. So there are people there who still want to see film.

KREN: But you really have to continue to work on it. Because when you leave off, then it all suddenly stops.

On Kurt Kren

Peter Gidal

From *Materialist Film*, 1989, London and New York: Routledge, pp.6–8, 109–110 and 143–145.

Trees in Autumn is a series of shots, each shot a density of trees and branches, the rhythm of the montage combined with the rhythm of movement or stillness within each shot dominating any inferences (narrative or otherwise) from the represented space. This is also because the speed of shot following shot at half-second bursts flattens out the represented spaces seen. The relations of this film are shot-to-shot, rather than any internal editing complexities. A shot becomes a piece of time. A montage of shots in every film is a construction of duration and continuance in the face of the viewer's attempts to grasp and arrest the seen, attempts at making definition and meaning. When the film at hand refuses to fill those meanings with 'truth' or 'nature' or 'the real', meanings are unmade as quickly as made. The viewer is positioned to expect certain things, and to expect to be able to proceed with certain meanings (let's say about 'nature' when seeing 'trees' represented). The artifice and ideology of meaning is a process that can be constantly problematized in the realm, amongst others, of film. Representation matters, it is realism of another kind. A materialist experimental film practice engages on that level with the illusions of representation and the illusory (and real!) constructs of viewing film, or anything, as if it were natural.

Through such acts of perception, a new object results. This 'object' is a process, the process of materialist film. Yet this must not be understood to mean that the manner of viewing creates the object. What it means is that the film material and the process of viewing together transform film into a new object and process. Filmic 'trying to see' instead of seeing, trying to know instead of (the illusion of) knowing. Not believing what is seen.

The notion of post-Eisensteinian editing, with, for example, parallel montage (two things going on in different places at the same time, building suspense) is fundamentally opposed to film-as-duration as previously described. But the danger of such a concept is that it limits 'Eisensteinian editing' to the Eisenstein *form* of editing, as if that were mechanically applicable to any scenario, or film idea, or bit of film. It also does not take account of the strategies of editing in his early work *Strike* (1924) in which the techniques of montage (of collision) produced filmic montage-as-duration, the foregrounded setting up of artifice and form within structures *not* subsumed by narrative. This was why

Eisenstein at the time was accused of formalism! Kren's film is based on mathematical structures, which are utilized to montage the film, to systematize its 'putting together'. But such a construct has nothing to do with any *effect* of 'discovering structure' via viewing. It is a crucial misunderstanding of the notion of structure that led to the definitions of Structural Film in the United States in the late 1960s to mean a film wherein 'the overall shape predominates' (Sitney 1969). Such overall shape was seen to take precedence both over the functions within any internal segments and equally over all filmic processes. The viewer, viewer-as-subject, is left out completely as well, as the object for consumption in such an aesthetic, and its notions of the artist/auteur/voyeur, hardly differed from that of the ideologies of commercial narrative film. One does not read out the structure from *Trees in Autumn*, or puzzle together the elements. One does attempt to decipher constantly. To decipher what? The workings and transformations of the process of representation, the forms produced, the contradictions of filmmaking subjectivity in relation to 'representing the world'; all the latter are effects of specific usages. These inculcated attempts to decipher have to do with representation and repetition. Each film segment places itself both with and against the preceding and following, thereby disallowing any easy flow of the cinematic. Making difficult is one aesthetic process here. The question of *anything* being held, finalized, stopped is constantly problematic in such a film. No more the illusion of the end of movement produced *by* the movements of time and image. The relation of such structural/materialist films as *Trees in Autumn* and *Yes No Maybe Maybe Not* (Le Grice 1967) to structuralist activity in other fields is obvious, and also problematic.

Film-works can produce an analytic situation in the very processes of their procedure, not as an academic afterthought, not as analysis *versus* film-as-projected. If analysis is thus not interpretation/analysis-after-the-fact, then it is not a time-denying process, and the questions of memory and constant rememoration attempts, during viewing, become paramount.

With a materialist use of splice, moment of fusion and coherence are given as a construct; disfusion similarly. Thus no a priori metaphor is established for which this technical convention needs function as a quasi-narrative pretence.

What is also important when discussing the splice is that a film segment is marked by *two* splices, and it is simply a matter of the level of (conscious) suppression or (unconscious) repression of these. I am arguing against the notion of a solution being *applied* to this problematic.

Take Kren's film, *Trees in Autumn*, which is a sequence of durational segments, three seconds each, of branches, all differing, without loops or repetition. The splice mark is here an obvious cut per se due to the abrupt image change of each three-second strip. This is analogous to cutting on stillness, though it is not stillness in this film: trees and branches and camera *move*. Cutting on non-movement, stillness, is precisely the opposite of the first lesson in all film schools from Prague and Warsaw to New York and Los Angeles, the National Film School and the Royal College of Art: 'Always cut on movement.' For

conventional illusionism that is a first principle, though there are sophisticated ways of ensuring narrative's seamless continuum even whilst breaking such rules. It is the *degree* of movement in a film segment that is categorized as 'movement' or 'stillness', as there is, paradoxically, no ontological stillness in film. The term 'movement' within narrative codes means the movement of actors, cars and so on, within a framework of action, which by definition does not allow for the subtlety let alone the precision of minimalist movement of trees, camera, frame, such as exists in the Kren film. A *complex* set of other criteria operates, even where a film ostensibly taking a 'simply opposite' position from the dominant narrative codes. The 'other side of the same coin' syndrome is not an applicable critique with reference to, for example, *Trees in Autumn*.

Kurt Kren's *TV* (1966)

TV (1966) is made up of five shots, maximum four seconds each, repeated in various orders. No schema can be read off of this due to the seemingly random succession, and repetition, of shots. Expectancy can never be fulfilled as to what follows or what would logically come before any of the five shots. Whether or not an arithmetic 'system' preceded the making becomes irrelevant. It is only during, and some time after, the viewing(s) that the fact of its being made up of five shots becomes apparent, and even this is not as to the number 'five' but as to the fact of a specifiable, even if uncountable, number of (finite) sequences being variously repeated. Thus even the fact of a determinate number of repeats cannot, whilst the film is being viewed, be reduced to a mechanization which would state the number 'five' or would even certify an approximation. Additionally, black leader intervenes, taking equal power to the 'content'-shots. Whether the black leader is interruption or simply another kind of sequence remains a question which interferes productively with the possibility of (ac)counting.

The reading into deep space, possible when the shots are viewed frozen on an editing table, is impossible when viewing the projected film, due to the speed of movement, and the quick passing of each shot-length (each is no longer than four seconds!). Thus the shot itself 'abstracts' from documenting the pro-filmic, the extra-cinematic, what the camera is aimed at, into rhythmic fragments and montage. *But there are never fragments-of, i.e. of a whole*. We are confronted with the impossibility of adequately lengthy perceptual identification of the represented. In this film, a *process* made of durations, the quantity of time, is not sufficient for anything to proceed, here, as imaginarily communicated space into which one could somehow identify. The viewer as subject of the content is made impossible. Rather, the durational sequences become the subject/object *film* through repetition and the abstract. The distanciation process inculcated thereby produces a viewer who him or her self also then no longer can maintain an anthropormorphic self-identity. Rather, the *film* processes each 'him' and 'her', over and over. An equalization takes place between viewer's processes and film's. Repetition expels identity.

Humanism formulated through film-as-spectacle's anthropomorphisms is here countered. Again the uneasy motoring of the subject/object; no object is subjected *to* anything; no subject is instanced (or thereby objectified). The material of ideology covers all social practices, which, additionally, are *all* theoretical, and no less real for that.

Reference

Sitney, P.A., 1969. Structural Film. *Film Culture Reader*, New York.

Lord of the Frames: Kurt Kren

Peter Tscherkassky

First published in Secession, W. ed., 1996. *Kurt Kren. tausendjahrekino* [exhibition catalogue]. Vienna: Secession. pp. 5–13.

In 1964 Vienna's Wien-Film lab refused to print *6/64 Mama and Papa*. When Kren initially submits the original, one of the lab technicians compassionately expresses concern that the film will be illegible given its innumerable cuts. His worries prove unnecessary: when Kren returns to pick up the print, a pair of flushed characters storm out of the projection room demanding he never show his face at the lab again. A few months later, it is the film lab Listo that refuses to process *9/64: Oh Tannenbaum*. So Kren packs up his films based on Aktions by Otto Mühl and Günter Brus, and escapes to Vienna's 21st district in the middle of nowhere – commonly known as 'Trans-Danubia' – or to be more precise, across the river to Peter Kaiser Street in Jedlersdorf. There, on the most remote outskirts of Vienna, stands a house where film is processed and printed in homemade contraptions reminiscent of washing machine barrels. The one-man operation was reputed in the business of handling explicit imagery for customers in the sex film trade. This also explains the slight misalignment of the credits on some Kren works dating from this period, and why the 'Kren' next to the copyright sign partly disappears beyond the edge of the frame. The lab produced credits in-house on request, albeit using a camera without a viewfinder – a title card might have slipped time and again. In terms of content, Kren's films meet with complete acceptance; questions of form play a tangential role.

In fact, the '© Kren' that pushes past the edge of the frame offers a perfect metaphor for the avant-garde, and it can be seen as a harbinger of film beyond the screen, namely expanded cinema. Fittingly, it is during his Jedlersdorf period that Kren performs some of the most beautiful steps to be found in the dance of modernist cinema.

In his essay 'On the Problem of Form' written in 1912, Wassily Kandinsky proclaims the equivalence of 'grand abstraction' and 'grand realism'. Kandinsky's text marks the acme of a development in Western Art that finds its beginnings in the Late Middle Ages and can be consistently traced since the Renaissance. This development oscillates between two poles. On the one hand, there is painting that subordinates formal and compositional matters to the task of representing nature as precisely as possible. Its opposite is found in strictly formal painting that embraces a host of idealizing styles. This longing for an exalted representation of reality concurrently aspires to articulate what is hidden behind the visible, and it unites the most diverse artistic directions in a common developmental

cause: from idealizing Classicism, Gauguin, and Expressionism, to the extremely formalized phenomenal world seen in paintings by Mondrian. Kandinsky proceeds to trace the other genealogical line in modern art, originating with 'realistic' work that endeavours to be true to nature. As soon as this form of realism turns away from space to capture the *moment* as perceived, time is introduced into the visual structure of the image. This finds expression, for example, in a lighter application of paint or kinetic freehand sketches. Phenomena become ephemeral. Naturalism's intrinsic subordination of form, to represent appearance *as it appears*, ultimately leads, via Impressionism, to a final disintegration of form – namely in a two-fold way, resulting in the pure abstraction of Kandinsky *and* the extreme realism of ready-mades – or similar object collages produced in the workshops of Dadaism. 'Grand abstraction' foregoes the in-between of perceptual reality and presents the artistic medium itself; 'grand realism' foregoes representation by replacing it with the object itself.

To put it in a nutshell, modern art of the twentieth century unfolds in a territory paradigmatically staked out by Mondrian, Kandinsky and Marcel Duchamp.[1] Questions of aesthetics in the field of fine arts engendered by these conflicting standpoints reach the realm of film with some delay, as we know. But when the time comes, they impact cinema all the more intensely. It is also in this sense, as seen from a global perspective, that Kurt Kren's contribution is nothing short of tremendous.

Günter Brus and Otto Mühl both abandon the canvas to adopt the human body as the primary medium of artistic expression. This commonality partly obscures the fundamentally different nature of their Aktions. First, there is Brus, whose grandiose pathos falls in line with the tradition of Expressionism. And the way he uses colour maintains its central role, working as a connective link between the body, the surrounding space and its surfaces. Mühl, on the other hand, is the Dadaist of Aktionism. His realism declines the expressively charged double meaning of an autonomous sign system, such as that conveyed by Brus' scraps of gauze bandages, scalpels, scissors, razor blades and thumbtacks. Mühl's staged realities are energetically animated still lives consisting of colour, garbage, food, but devoid of symbolic or allegorical allusion. Where Brus sets a scene invoking creaturely suffering, Mühl is looking for the fun of the matter.

Enter Kurt Kren, who responds to these starkly contrasting Aktionist agendas in strikingly different ways. Ever since his second film, *2/60 48 Heads from the Szondi-Test*, Kren had organized his footage according to strict serial scores.[2] He counterposed the mimetic abundance characteristic of film with a rigid mathematical formula (the length of each shot was determined by the sum total of the two preceding shots: 1, 2, 3, 5, 8, 13, 21, 34 frames). Kren's early films were all edited in-camera, utilizing the single-frame shooting mode. It was with his fifth film, entitled *5/62 People Looking Out of the Window, Trash, etc.* that Kren developed his signature post-production, high-speed editing technique – and it made a lasting impact on film history: the film was edited down to intervals as brief as one frame at a time, while the sequences of frames continued to conform to a strict serial score.

Kren employs his serial, high-speed editing technique to counter the Aktions of Mühl the 'realist'. Compared to in-camera montage, post-production editing allows for a substantially stronger formalization within the sequence of images. Single-frame shooting of nature disallows for repetition, as with *3/60 Bäume im Herbst* – each frame holds something new in store. In contrast, Kren's first Aktion film *6/64: Mama and Papa* interlaces a host of continuous takes; he continually returns to significant shots as leitmotifs, establishing a network of images that circle one another for the duration of the film. Kren painstakingly weaves the frenzy of the Aktion unfolding in front of his lens into geometrically meticulous figures of compression. Alternating shot/counter-shot sequences jump back and forth between single frames edited by hand (!), transforming the Aktionist tumult into ornaments of strict temporal patterns – just as Mondrian once distilled spatial patterns on canvas.

And then comes the first film made with Günter Brus, *8/64 Ana – Action Brus*. Suddenly Kren finds himself confronted with an expressive pitch that provokes him to abandon serialism and high-speed montage. He responds with 'grand abstraction', using a wildly gestural camera that undercuts the Brusian pathos and infuses the filmstrip with images of Tachist disintegration. While high-speed editing was used to whip the Mühl actions into a frenzy, repetitive montage assured them the legibility of an ornament in motion. In contrast, Kren's signature single-frame shooting strategy nearly pushes the Brus Aktion beyond recognition; this is even more true of *10b/65: Silver Action Brus* which freely floats in a flux of non-representational gestural traces. On the rare occasion Kren holds his camera comparatively still, he is less inclined to focus on the Aktion and shows more interest in abstract marks left by acts of painting, such as splashes of paint on studio walls.

In summary: Where the Dadaist Mühl celebrates Naturalism taken to an extreme, Kren reacts with a strategy of condensation – like that found in Mondrian's work or Expressionism. But when confronted by the Expressionism in Brus' Aktions, Kren uses 'grand abstraction' to clear the scene of signs laden with meaning. (There are two exceptions to this rule. Kren employed a quietly held camera in single-frame mode to shoot *9/64 O Tannenbaum* with Mühl; *10/65 Selfmutilation* captures Brus in relatively long takes that follow a pattern of A-B-C-B-C-D-C-D-E-, etc. These two films forgo an aesthetically oppositional structure and in turn exhibit a relatively documentary character.)

The decisive part Kren played in shaping the dialogue between film and modernity can be observed in the majority of his 49 films. Even 'Dadaist Realism' is in evidence, to be found in *18/68 Venecia Kaputt*, *27/71 On Peacock Isle*, *29/73 Ready-made*, and in his expanded movies. But let us leap ahead 30 years, to one of Kren's final films.

In 1995, Kurt Kren converts the centennial celebration of cinema into a memorial. Commissioned by the centennial cinema bureau Hundertjahrkino, he produces a trailer entitled *tausendjahrkino* or *thousandyearcinema*.[3] Over the course of several weeks, Kren films tourists outside Vienna's Cathedral of St. Stephan's while they videotape and photograph the building. He shoots at two, four and eight frames per second, and strains

the limits of his lens by utilizing its maximum focal length (66mm) coupled with its minimum object distance (1.2 metres). The shots mostly consist of two to four frames; their duration does not obey any predetermined rule. For the soundtrack Kren uses a brief sequence from Peter Lorre's *Der Verlorene* (1951), a scene in which a drunken man recognizes a murderer protected by the Nazis, whom he repeatedly accosts: 'Hey, you, I know you … I don't know from where, but I know you ….' 'Toward the end of Kren's film, this voice is heard again as air raid signals sound, "Every man down into the heroes' cellar, every man down to die a heroic death." Kren associates the anniversary of cinema with Germany's Third Reich forecast to last a thousand years. The centenary of cinema represents 100 years dominated by images that have lost their referentiality and established hegemonic rule over reality. That tourists ever really "get to know" St. Stephen's Cathedral is questionable. Photos and video recordings have taken the place of encounter and memory. While the soundtrack summons everyone down into the heroes' cellar towards the end of the film, Kren tilts up St. Stephan's tower, scaling it with his shaky camera. It is as if Kren is searching for the lost reality of the cathedral. But the images have bombed it into oblivion' (Jutz 1996: 109).

Alongside such interpretations, the formal and technical specifications cited above are of interest. Tourists photographing cathedrals or buildings that consume comparable dimensions might spontaneously provoke the question, 'How do you get such a huge building to fit into your tiny box there?' The obvious technical response: Set your focus to infinity and use the shortest focal length possible – the wide angle setting. Unlike the tourists, Kren positions himself all the way at the other end of the scale. Not only that. Instead of seeking the clarity of a mimetically oriented long shot (focus set to infinity), Kren presses as close up to reality as his lens can handle. Plus, his shooting at a low-frame rate leads to longer exposure times: combined with a handheld telephoto lens this results in rather blurred images. Again we arrive at the signature style of the artist en route to Kandinsky's 'grand abstraction', and again Kren is looking to make another side of the image visible.

And what about the people whose outlines haunt Kren's blurry shots? All of them are peering through their viewfinders at a Gothic cathedral and the sculptures that adorn its facade. In fact, these three-dimensional sculptures of freestanding human bodies are exactly those objects through which art began to be invaded by perceptual reality at the end of the Middle Ages. They constitute the first formulation of an agenda that was to be fully realized in the Renaissance, its visual echo refracted by the lens of every camera on the face of the earth to this day. *thousandyearsofcinema* documents an encounter with the Lucy of the photographic, film and video generation: these gothic fossils are to photographic mimesis what the mother of mankind is to anthropologists. The only difference is that the participants at the family reunion on St. Stephen's square apparently do not recognize them as their relatives. 'I know you, I don't know from where, but I know you ….' Kren proclaims: *onethousandyearsofmimesis*, and no end in sight.

Translation: Eve Heller

References

Hofmann, W., 1966. *Grundlagen der modernen Kunst*. Stuttgart: Kröner [English: 1967. *Turning Points in Twentieth-Century Art: 1897–1917*. (trans. Charles Kessler), New York: George Braziller].

Jutz, G., 1996. Eine Poetik der Zeit. Kurt Kren und der strukturelle Film. In: H. Scheugl, ed. *Ex Underground. Kurt Kren seine Filme*. Vienna: Sixpack Film.

Tscherkassky, P., 1995. Die rekonstruierte Kinematographie. In: A. Horwath, L. Ponger, and G. Schlemmer, eds. *Avantgardefilm. Osterreich 1950 bis heute*. Vienna: Wespennest-Film

Notes

1. For his brilliant analysis of the development of modern art, see Hofmann 1966.
2. For a detailed analysis of Kren's first, pre-serial film *1/57 Test with Synthetic Sound*, cf. Tscherkassky 1995: 41–44.
3. For some time, Kren gladly produced films that were commissioned: *44/84 foot'-age shoot'-out* was the first, followed by three trailers (*45/88 Trailer; 46/90 Falter 2; 49/95 tausendjahrekino*), and an episode for the compilation film *Denkwuerdigkeiten eines Nervenkranken, part 3*, written by Ernst Schmidt jr., directed by Peter Tscherkassky. Moreover, in 1996 Kren appeared on screen playing a hard-rocking bishop who also happens to be an expert stripper, in a trailer directed by Franz Novotny for the movie magazine *Meteor*.

Interview with Kurt Kren

Peter Tscherkassky

This is a new translation of an interview from 1988, originally published in: A. Horwath, L. Ponger, and G. Schlemmer, eds., 1995. *Avantgardefilm. Österreich. 1950 bis heute.* Wien: Wespennest

Tscherkassky: What form did your first forays into filmmaking take?

Kren: That's so far away ... I began with Regular 8 and shot an awful lot of it; it was cheap after all. That was important to me, also because it let me learn about how things look on screen. What you see and what you shoot aren't one and the same. Back then I started doing fast-paced editing using green and red leader; I did insanely short cuts. In 1955 I bought my first 16mm camera, a Pathé, but I broke it the very first night – I ran it at high speed without any film loaded in the camera. So it was in the repair shop the first year.

PT: What classic avant-garde films were you familiar with at the time?

KK: French films from the 1920s: Fernand Léger, René Clair and the like.

PT: How did you decide to make films?

KK: Oh, it wasn't like with Hitler, 'Then I decided to become a politician.' As a child in Holland I had a toy projector for 35mm film – hand cranked. I cooked the emulsion off Wild West movies and drew little stick figures on the base – in some sense that was the beginning. In our village near Rotterdam, there were people who drew abstract shapes onto clear leader. In 1947 I returned to Vienna, and in 1950 I began with Regular 8. Already back then I was constantly going to the cinema. I went to see commercial movies. You learn the most from the bad ones – you don't get as sucked in.

PT: What was the climate like for film in Vienna at the time?

KK: Well, we were a handful of people: Ferry Radax, Marc Adrian, Peter Kubelka. Vienna was especially interested in film, maybe because it's a city of music. In 1960, Kubelka organized my first film show at the Galerie Naechst St. Stephan. A giant crowd came. There was an incredible amount of interest.

PT: Today when you watch the first films made by these pioneers, the differences are astounding. In your first film, *1/57 Test with Synthetic Sound*, objects appear out of focus and shots look like they happened by chance – but this has no precedent in classical avant-garde cinema.

KK: Those images were very carefully selected. Nothing was left to chance until *Szondi-Test* (*2/60 48 Heads from the Szondi-Test*). I wanted to make a film with human heads and stumbled on the Szondi test. It is divided into six sets consisting of eight different types and everything is numbered. So I simply started playing with the numbers, developed a notation system, and filmed accordingly – shooting in single-frame mode. In other words, I translated the mathematical series of numbers into images.

PT: What was audience reception like?

KK: Good! There's always been interest.

PT: Your first and third films have sound, but the others don't. Why is this?

KK: I'm less audio-, more visual. Those soundtracks I drew by hand weren't really ideal for 16mm film. Plus there's a danger image and sound will start to compete against each other. I've always been more interested in visual rhythm; it allows the viewer to grasp an inner music.

PT: Your rapid editing technique first surfaces in *5/62 People Looking Out of the Window, Trash, etc.* (*5/62 Fenstergucker, Abfall, etc.*) Would you like to tell us about it?

KK: I was already familiar with rapid cutting – I had tested it out. But with this film I took it down to the single frame. The rhythm was based on 1, 2, 3, 5, 8, 13, 21 and 34 frame durations. Like with my other films, the score was drawn out on paper – these drawings looked like rows of skyscrapers.

PT: How did you come to choose images of people looking out of windows?

KK: It began with my aggression towards the oglers. It really got on my nerves to be watched – so I watched back – and then I combined that footage with garbage, a dead pigeon and the rest. The funny thing is, I myself later filmed from out of windows. There are shots in *16/67 September 20*[th] I filmed from a balcony: Sometimes it stank so intensely when Günter Brus took a shit, I had to escape to the balcony. Those two older ladies appeared on the soccer field by chance, and a litter later, the two young boys – each answered the call of nature out in that field.

PT: That was filmed during the shooting of *September 20th*? I would have supposed the 'lady footage' constituted a point of departure, to contrast their desire to be discrete when relieving themselves against Brus' crass exhibitionism.

KK: Yes, yes, that was filmed at the same time and place.

PT: After the *People Looking Out of the Window* came your Aktionist films. These constitute a second period in your filmography, which clearly divides into two distinct phases.

KK: Those films weren't intended to be documentations, though Otto Mühl and Brus wanted them to be. Later they recorded or allowed others to record their Aktions. I actually undermined this in an effort to make an autonomous film out of the footage for myself.

PT: Were the Aktions public or staged just for you?

KK: Not just for me – there were also others shooting photographs. But I could call, 'Stop!' to reload, re-focus or wind up my camera.

PT: It's striking that Rudolf Schwarzkogler and Hermann Nitsch are missing from your films.

KK: In retrospect I often regretted I never had worked with Schwarzkogler. But he was even more introverted than Brus. I never saw a single one of his Aktions. And when it comes to Nitsch, I had issues with the religiosity of his Aktions because I couldn't relate to it at all. Once I did film a smaller Aktion by Nitsch in which Reinhard Priessnitz also participated, but the footage vanished into thin air. The Aktion films made the Aktions accessible to the general public. We even screened them at the Amerika-Haus in West Berlin, although it had to be kept secret from officials. That was in 1966 or '68. That was how it often was in Vienna too. The Künstlerhaus cinema was totally sold out, and even more people stood in long lines outside.

PT: How was your relationship with Kubelka and the Austrian Film Museum?

KK: Complicated. In the beginning, 1960, '61, it was pretty good. But when he went to the USA in 1964 the question came up whether he was the only filmmaker in Europe – a suggestive question. In any case, he said, 'Yes', and that was that – suddenly there were simply no other filmmakers. And this nimbus lasted a long time. Kubelka was always incredibly savvy at creating a nimbus. When he returned from Africa in 1961 everybody in Vienna was all excited, wondering what he was going to do next ... Back then I bought his last 13 rolls of film stock and used it to make *People Looking Out of the Window*. Kubelka later rented the film.

PT: A quick comment on your Aktion films: *13/67 Sinus Beta* signals a clear break. You mix other images with the Aktion footage, while Mühl, Brus and a female model are still seen in long takes, crawling and dancing about in a childlike way. It's as if you consciously refrain from intervening with your montage technique, and instead show things how they really...

KK: ... were. It took place at the 'Destruction in Art Symposium' in London. I'd been invited to show my films. I find the way I edited the footage was much more radical than the Aktions themselves. I stand by *Sinus Beta* and the combination of the other footage. It fits well together.

PT: If one sees this film in relation to your earlier work, then it's a logical development. It simply had to reach this conclusion, and this is in fact the end. And then those photographs of gestures are seen...

KK: That was from a book about facial expressions and gestures.

PT: Was that intended to be an ironic comment on typical and at that point already familiar gestures that the Aktionists were repeating over and over again?

KK: The film itself explains that. We were a loosely knit group. We defended ourselves against the outside world, but within the group there were pretty intense disputes. And I wanted to make other films, like *17/68 Green-red* (*17/68 Grün-rot*), the one with the shattered beer bottle – that's also a very erotic film.

PT: Yes, but with an aggressive eroticism, like the Aktions.

KK: I didn't make any more films with the Aktionists, just shot some photos of Brus and his daughter, and an egg – or something like that. But I wanted to make something about shitting. I happened to meet Brus and Schwarzkogler in a café. Brus asked if I wanted to photograph him taking a crap. I figured no, let's make a film instead. Together with eating, drinking and pissing, *September 20th* came out of that.

PT: It arouses strong reactions to this day. People laugh, however...

KK: Yes, but it's a really particular laughter, like with Pasolini's *Salò*. In 1968 there was that incident with the National Bank of Austria – where I was employed but never welcome. My father had arranged the position for me; it was a form of restitution – Austria's national bank, the Wiener Giro- and Kassenverein, had fired him during the Nazi period. I was a black sheep from the very start, but I had official status and couldn't be dismissed. Still, when I came back from my first trip to America I thought there had to be some way out, and I decided to quit by the end of the year. A little later in June, that 'Art and Revolution'

happening took place. The so-called 'university piggishness' event made the headlines of the newspaper *Blauer Montag* in giant letters, underneath which it read, 'Filmmaker Kurt Kren'. It included citations from the *Süddeutsche Zeitung* about 'girls from good families' running out of the movie theatre, vomiting in reaction to *September 20th*. That screening took place in Munich. On Wednesday I had to report to the personnel office. They had a letter ready for me, stating I was suspended with pay till the end of the year. At that point I should have withdrawn my resignation and sued them. Presumably they would have sent me into early retirement with a full pension, but I just wanted to get away. I turned on my heels and walked out of the bank. The thing is that was a job that allowed me to be myself. That's where I wrote my scores, and edited *Mom and Dad* (6/64 *Mama und Papa*) and *Leda and the Swan* (7/64 *Leda und der Schwan*). At night I'd return from work, dust myself off, and be free of the bank. It's totally different working as a museum security guard in Houston … Besides, at the bank they also had wonderful food. But at the time I figured things would work out somehow. The problem is nobody buys films – you can't hang a film on your wall as a status symbol. But I did make boxes with the painter Wolfgang Ernst, cassettes covered with serigraphs printed with my scores, photographs plus each box included a Super-8 print of one of my films. As of 1971 we sold them for 150 German Marks. I heard one was recently auctioned off in Düsseldorf for 1,800 Marks…

PT: How was it you went to the USA?

KK: After London, the 'Destruction in Art Symposium' was scheduled to travel to New York. It was cancelled due to the assassination of Dr. Martin Luther King. The organizers were scared about the show's title. But I had already booked my ticket, so I flew on my own and showed films. They were well received. New York's Film-makers' Co-op picked up every one of them for distribution.

PT: How did the Anthology Film group around Kubelka respond?

KK: In 1978 I had a retrospective at the Museum of Modern Art. Shortly beforehand, the programmer asked me if Kubelka and I were still not getting along. I said that was water under the bridge, to which he replied, 'Thank God!' Something was always up… There was this world encyclopedia of cinema that included an essay dedicated to underground film. It focused in particular on a 1968 film show in Hamburg. Everybody was mentioned, except Kurt Kren. For a long time I wondered about it. Recently in Houston I finally stumbled on a copy of the cinema encyclopedia – it happened to be lying around. I looked up Kubelka, and there in black and white it said there were no other filmmakers in Austria. So obviously they couldn't have included me in the essay. Yeh, there was always some kind of trouble … There were screenings back in the day where he said, 'Either you show Kren or me!' This situation only gradually relaxed with time.[1]

PT: How was the climate for avant-garde film in 1968?

KK: You have to consider the context: political revolution, economic prosperity, plus strict porn legislation – people were starving for nudity. So when 'X-Screen' opened in Cologne, huge crowds of people showed up. When the culture is lively, people get inspired. Back then a worker could tell his boss to 'Kiss my ass! Thousands of other jobs are waiting for me.' You weren't as dependent, economically speaking. Students also weren't under stress like they are today. It was a more vibrant period – like Mesopotamia, where everything first started … People had time to think, and they did. And they studied, learned new things. Some came to the films to see art, others to see a naked ass. But everybody got something out of it and they kept coming back again. Today times are bad and people have other problems to deal with.

PT: Your films also grew more subdued in the 1970s. *30/73 Coop Cinema Amsterdam, 31/75 Asyl, 32/76 to W + B, 33/77 No Danube*, etc. – the list is long.

KK: Yes, that was in West Germany (BRD), before my final emigration to the USA. In 1971 I was with Fritz Kracht at Cannes, and Fritz had purchased an especially nice suit for the occasion. There was a lot of carousing, and on the last night we got into a fight. I poured an espresso on his nice suit. He got angry and said, 'You're not driving back with me.' And so by chance, I travelled with Hans Peter Kochenrath to Cologne and I wound up staying. My apartment in Vienna was officially liquidated; the entire inventory was sent to an incinerating facility – it all went to hell. Cologne, Saarland and then Munich where I made *To W + B* (*32/76 An W + B*). It was shot from a gallery overlooking the Isar and beyond. I took a black-and-white negative of the identical view and mounted it onto a bellows in front of the lens, aligning it with the film camera's perspective. I continually shifted the focus back and forth between the still negative and the exterior landscape. Back then my films started getting longer and more static. A lot was executed in-camera. *No Danube* (*33/77 Keine Donau*) – that's the first time there were technical difficulties. The film has 13 different exposures. I miscalculated these by mistakenly using the European DIN standard. So at first there was absolutely nothing to see. Then I calculated the exposures using a formula based on the ASA standard. But my living situation became pretty tense, I got nervous and my Pathé camera jammed. So I tried shooting at another location in Munich. However I wasn't used to the camera and wound up with light leaks on both edges of the footage. Then I went to Vienna and shot with Ernst Schmidt Jr.'s Bolex. I wasn't used to the camera's automatic function and things went wrong. I only worked it out the next time around.

PT: These films strongly remind me of works by David Rimmer. They share the same style.

KK: Yeh, those are beautiful films.

PT: When did you finally emigrate to the United States?

KK: In 1978, from Munich. I had sent a card with a picture of heads from *Szondi-Test* to about a thousand addresses in the USA. I got some responses, so I crisscrossed the United States. Just before I left there was this 'Film and Sexuality' event. It was raided by the police who confiscated the films, including my *Cartoon Balzac and the Eye of God* (*26/71 Zeichenfilm oder Balzac und das Auge Gottes*). The public prosecutor took many pages to complete his description of what happens in this film – which itself only lasts a few seconds. In any case, it was deemed a Disturbance of the Peace and an infringement on religious whatever. In the USA the film didn't faze anybody in the slightest, because they don't recognize the triangle as the eye of God – even though it's printed on every dollar bill, right above the pyramid. In any case, at the time I assumed the police only got their hands on that one film. But the evening before my departure I discovered they had confiscated the entire reel I intended to screen in the US…

But none of this stopped me, and I even got married on tour, like some kind of American dream in the movies. We lived in Berlin for a year through the German Academic Exchange Service (DAAD), and after that we separated.

Touring with the films went well until Reagan became president. 'Less government, more privacy' has never worked – not in terms of social welfare nor cinema. The popular, so-called 'independent film' took exclusive upper hand, simply because it attracted bigger audiences.

PT: Your own films from this time also grew very melancholy.

KK: Yes, my personal situation was total chaos. I searched for order through the films. Back then I made my three 'bad home movies' as I call them. I always packed a story about my car into these films as well. *Breakfast in Grey* (*40/81 Breakfast im Grauen*) was shot during a wonderful time spent in New England with friends, tearing down wooden houses ripe for demolition. We'd then sell the timber. I was the nail remover – I pulled the nails out of the boards.

PT: To me these images are charged with an especially strong symbolic quality, like how the houses break down and collapse – this falling apart is very moving. Same with your film *41/82 Getting Warm*: there are those interiors that capture America just as one might imagine it, with a television in the middle of the room running non-stop next to an unmade bed. Sometimes somebody is lying in it, sometimes there's nobody there. It's all very sad, but at the same time evokes a kind of homesickness. At the time you were living in your car, weren't you?

KK: Yes. Reagonomics caused an incredible number of people to lose their homes, their jobs, their cars, and dumped them onto the streets with their families. And also me in

my car, it was strange … When winter came it got pretty cold in New England, so I drove via California to Texas, arriving first in Austin. That's where parts of *Getting Warm* were shot. As of 7 in the morning I would stand around waiting at the Texas Workforce Commission. People who needed cheap labour would call in. Back then I still had my 300-dollar Thunderbird. It looked pretty decent inside. Lots of times I got a job because I could take a couple of people with me – causing the underbelly of the car to scrape the road. But even those jobs became increasingly rare.

PT: *42/83 No film* – was that in reaction to Reagan?

KK: Yes, yes, exactly. That was already in Houston. Once in 1981 I was invited to Houston's Museum of Fine Arts – where I was eventually given a job. I had a retrospective. Ralph McKay was the program director. He found out about my misery in Austin – by then even my car was wrecked. Ralph was managing a punk band, Really Red. They threw a benefit concert for me, playing punk music to my films and selling T-shirts printed with a photo of me taken during a Bill Steen performance. After the performance they handed me $1000, which was incredibly great. When that money was used up, I went looking for a job. And that's how I wound up as a museum guard. That was 1983. And that's when I dropped out of filmmaking. Which raised the question: no film?

Wilhelm and Birgit Hein once made a film in which a newspaper is seen – it's completely static. The philosophy behind it was that the film is nonetheless a film. My comment to that was 'no film'. In 1984 I knew Reagan was going to win again. So for *43/84 1984* I filmed Democratic presidential candidate Walter Mondale during an election campaign debate, when he stated taxes had to be raised – that sealed his fate.

PT: And how about *44/85 Foot'-age shoot'-out*, your last film?

KK: It was like this: When I came home in the evenings I was completely exhausted and incapable of doing anything. I would lie down and could have slept till the day after tomorrow. But out of the blue a letter arrived from the San Francisco Cinematheque explaining they wanted to do a show at a Chinese movie theatre, and asked if I wanted to make a film for the occasion – within two weeks' time! A reel of colour negative was included with the invitation. So there I was, not knowing what to do. But the pressure made me increasingly angry: What were they doing to me?! It almost felt like a rape. And that's where the title came from: 'footage' is the name of the ammunition; 'shoot-out' is the duel. I was really pissed off. I met up with Bruce Connor who was shooting a film about Gospel singers in Houston. He said, 'Just forget it, they're out of their minds!' But I couldn't. So then I thought, 'Shit, just do it!' In my rage I shot the skyline. That's all there is to Houston anyway, Houston is a skyline. On top of it all, the camera jammed. I tore the film out of the camera and shoved it into the express envelope provided. It was pre-addressed to the film laboratory. I mailed it off. They added music from *Once Upon*

a Time in the West in 'Frisco. The music isn't famous in the States, though here in Europe everybody seems to know it – I hear they supposedly even use it in commercials.

PT: That music is a good choice. It enhances the film's desolation.

KK: Yeh, yeh, it fits well! But at the time I posted the film, I was so completely embarrassed I didn't even write my name on it – so they didn't even know it came from me! But they liked it a lot; it was a success.

PT: What do you think about the current situation for avant-garde film? Many people say it's in a recession.

KK: The movie houses don't have any money, so they're forced to be commercially oriented. Just now at my retrospective screening in Vienna's Stadtkino, I was totally surprised how many people came – I was scared nobody would turn up. Occasionally I still do a few shows at art schools, where young people also continue to be interested. Once I was hanging around in the hallways after a show. Somebody came up to me and said, 'That was fantastic,' and handed me two rolls of unexposed film. So young people are still interested, I definitely believe that's true.

PT: Couldn't you imagine yourself having a teaching job?

KK: I hate school a priori. Schools only give birth to more new teachers. All those art schools are just machines that produce new teachers. I would only advise the students to forget making films and go directly to the unemployment office!

PT: Would you like to return to filmmaking?

KK: That's hard to say. A lot has been damaged by my job. I'm completely outside of it. In my Cologne days I saw as many as five films a day! And nowadays, if I see one film in five weeks it's a lot. Recently they showed some Super 8 films in Houston. I set my alarm clock so I wouldn't sleep through the show. But I was completely out of it; all I did was sleep. That's what my situation looks like.

PT: In contrast to some of your colleagues, you've never tried to make a feature length film.

KK: In the late 1960s, the old Austria Filmmakers Co-op was interviewed on a street in the middle of Vienna. Kubelka was also there. We were asked, 'If you were offered the chance, would you want to make a feature length film?' Everybody said, 'Yes!' except Kubelka and me. I just don't have it in me. I like compression. I don't appreciate work

that's rolled out and stretched like strudel dough. I even sometimes think *12/66 Cosinus Alpha* is a few seconds too long.

PT: But it seems like people have to make feature length films to survive.

KK: It's crap things have to be like that – it shouldn't be that way.

PT: Are you actively looking for alternatives to your 'museum security guard existence', as you call it? Might you leave the USA?

KK: Yes … But once you've lived in the US, you can't leave so easily. I would like to be able to commute freely. We'll see how things pan out. Maybe times will get better.

Translation: Eve Heller

Note

1. In 1996 when Peter Kubelka conceived and initiated the Austrian Film Museum's perpetual film cycle, 'What is film', he devoted one of the 63 programmes to the work of Kurt Kren.

Apperception on Display: Structural Films and Philosophy

Jinhee Choi

First published in *The Journal of Aesthetics and Art Criticism* Volume 64, Issue 1, pages 165–172, Winter 2006

Both filmmakers and scholars have described structural films in terms relevant and important to philosophy. P. Adams Sitney, for example, characterizes the aspiration of structural films as 'the cinematic reproduction of the human mind' (1977: 370). Annette Michelson, in referring to Michael Snow's landmark structural film *Wavelength* (1967), describes Snow's camera movement as 'the movement of consciousness' (1978: 175). Even Snow himself compares his project with that of philosophy, claiming: 'If *Wavelength* is metaphysics, *Eye and Ear Control* is philosophy, and ↔ *(Back and Forth)* will be physics' (Sitney 1977: 382). Snow's bold statement in no way implies that he equates his filmmaking with philosophy. Rather, Snow underscores his preoccupation with some traditional philosophical questions: reality, illusion, motion, energy and velocity. But what, then, is the relationship between avant-garde films and philosophy? Do they merely share some interests of inquiry or does a more significant relationship exist between the two?

In this essay, I aim to delineate the relationship between avant-garde film and philosophy. Philosophers, concerned with unveiling the philosophical potential and limits of film, have primarily focused on narrative fiction film, putting aside alternative film forms or modes such as documentary or avant-garde films (Kupfer 1999; Russell 2000: 163–167; Light 2003; Hunt 2005). This may have to do with the fact that many locate the philosophical potential of film in its 'narrative', which contributes to the exercising and refinement of one's moral understanding of the world (Carroll 1998: 126–160). By shifting the focus from narrative film to avant-garde film, we should be able to examine how the non-narrative aspects of film may make a philosophical claim or suggest a philosophical hypothesis. I will first examine Noël Carroll's claim that avant-garde films are not theoretical. I will argue that although avant-garde films do not advance a film theory in a strict sense, their philosophical contribution can be found in their suggestion of new philosophical hypotheses regarding the film medium itself. I will then discuss the relationship between the cognitive value and aesthetic value of avant-garde film by focusing on Kurt Kren's *15/67 TV* (1967).

I. 'Avant-Garde Films Are Not Theoretical'

In his article, 'Avant-Garde Film and Film Theory', Carroll classifies four different ways in which an avant-garde film relates to film theory: (1) it can demand a theory expansion; (2) it can demand a theory contraction; (3) it can exemplify a theory; and (4) it can literalize a theory (1996: 162–168). A theory, for Carroll, should meet the following two criteria. A theory should first aim to provide a general framework that can be applied to a large group of films, not just to one particular film. This can be called the generality requirement. Second, Carroll claims that the validity of a theory should be tested by evidence (1996: 163). To demonstrate its validity, a theory should be able to present a reasonable amount of evidence or data that would support the theory. This can be called the verifiability requirement.

Carroll's first two postulations about the possible relationships between avant-garde film and film theory (those of theory expansion or contraction) reflect the fact that avant-garde films often challenge existing cinematic norms and conventions. Avant-garde movements in film, as well as in other art forms, prioritize a subversion of established norms and conventions by deviating from them. Thus, an avant-garde film often provides a recalcitrant example to an established film theory and brings to the fore the necessity to modify either the theory or a common conception of the film medium. The third relationship between avant-garde film and film theory, that of exemplification, Carroll defines as 'being a sample or example of the kind of film or work of art that a given theory either endorses, implies or stipulates' (1996: 164). For instance, *Zorn's Lemma* (Hollis Frampton, 1970) may exemplify Kantian aesthetics in the sense that its structure manifests the Kantian idea of 'purposeless purposiveness'. The film consists of three parts. In the first part, we hear only soundtrack of a woman reciting 24 rhymes from the Bay State Primer. The second part of the film – the major portion of the film – consists of images of words organized in alphabetical order. In this segment, each shot lasts for more or less one second (between 23 and 25 frames). As the film progresses, the words are replaced by images. In the last part of the film, we see a man, a woman and a dog walk from foreground to far background. This last portion is also accompanied by an audio track of six women reading a text (Gidal 2002: 274–276). The overall structure of the film is, to a certain extent, symmetrical, in the sense that the first and last portions of the film are accompanied by an audio track of female voices reading texts. The second portion of the film makes the viewer anticipate which letter will be displaced next, and as the 'C' is finally substituted by images in the last cycle of the film, it provides the viewer a sense of completeness and closure. *Zorn's Lemma* invites the viewer to contemplate both the unity of the film as a whole and the diversity within each of the three parts. Carroll claims that a film like *Zorn's Lemma* can be said to be theoretical, in the sense that it embodies a philosophical theory, the postulation of which provides the best explanation for the interpretation of the film. Frampton may or may not have intended to demonstrate Kantian philosophy in his film, but this postulation does illuminate both the structure and the spectatorial effect of the film.

The fourth relationship, the notion of literalization, is harder to grasp compared to the other three. As far as I understand it, a film literalizes a theory when it evokes or aligns itself with the theory by addressing issues associated with it. For example, in *Chelovek s kino-apparatom* [The Man with the Movie Camera] (1929), Dziga Vertov aligns himself with proletarian ideology by depicting filmmakers as workers, ones who gather and assemble fragments of the modern world. One of the differences between exemplification and literalization, according to Carroll, is that in the latter, the theory alluded to does not necessarily provide the best explanation for the interpretation of the film in question. Carroll makes an example of Bill Brand's *Works in the Field* (1978), which evokes information theory by superimposing a random dot matrix over images from documentary footage. According to Carroll, Brand somewhat misappropriates information theory's notion of the code to underscore the idea that the editing is coded because the referents of the code in these two cases seemingly differ.[1]

An avant-garde film, in Carroll's view, cannot achieve theoretical status proper by either exemplifying or literalizing a theory. According to Carroll, even if an avant-garde film alludes to a film theory by virtue of being an exemplification of the given theory, it is still far from presenting an actual film theory. Carroll readily acknowledges that many avant-garde filmmakers themselves often propose a film theory. Maya Deren, for instance, not only directed avant-garde films of various kinds, but also purported to define her filmmaking as 'vertical filmmaking', which de-emphasizes the linear logic of narrative or drama. Carroll's claim, however, is that the film in question – the film itself – cannot be characterized as proposing a theory. Such an attempt does not pass the second requirement for a theory: verifiability. In Carroll's view, an individual film cannot propose a general theory as well as provide evidence for the theory in question simultaneously. Such a theory would be either skewed or circular.

Carroll is also sceptical about the capability of avant-garde film to prove or disprove a theory by literalizing it. For example, Carroll claims that structuralist/materialist films appear to bring to the fore the idea of 'active spectatorship', but these films are unable to explain a set of correlations presupposed in advancing a theory of spectatorship. This, he argues, is because a film in and of itself does not provide a reason to accept a set of binary oppositions between narrative versus non-narrative, illusion versus anti-illusion and passive versus active spectatorship (1996: 166).

The way Carroll characterizes the theoretical arena of avant-garde films – or lack thereof – seemingly makes tenuous the notion of whether an avant-garde film can advance a philosophical thesis or theory. One of the assumptions underlying Carroll's claims is that in order for an avant-garde film to present a theory, the film should provide a theory as well as evidence of some sort to verify and justify that theory. It seems, however, that Carroll sets the standard too high. An avant-garde film rarely states a theory in such an explicit manner. However, this does not indicate that avant-garde film cannot make philosophical contributions, nor does this mean that avant-garde film cannot further one's knowledge. I would like to discuss two ways in which avant-garde films can make a philosophical

contribution through means other than advancing a theory: (1) by revealing a new possibility of the medium and (2) by providing experiential knowledge to the viewer.

Given the nature or agenda of avant-garde film theories, especially the ones promoted by filmmakers themselves, Carroll's assessment of the philosophical contribution of an avant-garde film appears to be a bit hasty. Avant-garde film theories advanced by filmmakers themselves are often prescriptive rather than descriptive. By making a film in accordance with the theory or theoretical principles in question, filmmakers propose to adopt and explore a new kind of filmmaking. Carroll entertains such an objection. He considers the possibility of whether making an avant-garde film of a certain kind can be seen as a theoretical recommendation of that type of filmmaking. He rather quickly dismisses this objection, however, by saying, 'making a flat film does not supply a reason for making other flat films' (1996: 166),

One might argue against Carroll that while the film in question does not provide an argument for the adoption of the film style employed, it reveals a new possibility for the medium. Despite the ambiguous connotations of the term, I adopt the notion of revelation to reassess some of the philosophical contributions that avant-garde film can make. Monroe C. Beardsley claims that the notion of revelation often connotes both the suggestion and confirmation of a hypothesis (Beardsley 1981: 379). For instance, if I say, 'His behavior at that party revealed something to me,' I imply not only that his behaviour afforded me an occasion to postulate a new hypothesis about him or his personality, but also that his behaviour constituted a strong case for that hypothesis. Beardsley, however, rejects the revelation theory of the cognitive value in art as a comprehensive theory for art in general. In fiction, Beardsley believes, the revelation theory faces a problem because while fiction may suggest a hypothesis about the world, or about the reality external to an aesthetic object, fiction cannot, due to its fictive nature, confirm such a hypothesis.[2]

However, avant-garde films, especially the structural films that I focus on in this essay, do not face the same kind of problems that concern Beardsley. Structural films are mostly nonfiction films. Furthermore, the hypothesis suggested by a structural film is usually not about the world or the reality outside the film; the hypothesis often regards the film medium itself.[3] An avant-garde film may not provide ample evidence for the new hypothesis suggested, since it is only one instance, but still can confirm the hypothesis by presenting a strong case that mandates the postulation of such a hypothesis. For example, Stan Brakhage's *Mothlight* (1963), comprised of insect parts, leaves and various debris inserted between two strips of film, refutes the idea that the film medium is a photographic record of an object or a pro-filmic event that took place in front of the camera. Objects here are literally transported into the filmstrip! In this regard, *Mothlight* does offer a case for a new hypothesis about the film medium.[4] The presentation or reception of such a hypothesis in and of itself may not constitute an act of knowledge. However, it does grant the possibility that avant-garde film can contribute to one's acquisition or expansion of a certain type of knowledge.

As I have mentioned earlier, Carroll denies the possibility that an avant-garde film can explicate any theoretical assumptions underneath a theory by literalizing it. However,

Carroll's view does not imply that avant-garde film cannot further one's knowledge: especially experiential knowledge. Snow's *Wavelength* is often addressed in relation to the famous debate in film studies between Stephen Heath and Noël Burch regarding the primary source of the 'subject effect', the viewer's impression that both the story world and its narration process are structured around him or her. Heath argues that the subject effect is rendered via the viewer's alignment with the narrative, while Burch claims that it derives from organized perception via a particular type of film style (Heath 1976: 68–112; Burch 1982: 16–33). The cognitive value of Snow's film does not derive from the fact that it provides such a crucial test case for these film theorists (on a personal note, and for the record, after reading so much about *Wavelength*, when I first saw the film, I thought to myself, 'Burch is right!').

Snow must not have made this film to prove or disprove either theory, since his film preceded both Heath's and Burch's writings. Nor did Snow make the film to illustrate some philosophical issues. Rather, its significance lies in the fact that a viewer comes to an understanding of the issue at stake via his or her own experience of the film. An experience of the film in and of itself does not constitute knowledge (or the expansion of one's knowledge) until it is combined with the rest of one's knowledge through inference and reasoning. In Snow's case, it is not merely the viewer's experience of certain cinematic effects that furthers one's knowledge about the filmic medium; it does so because it leads the viewer to examine his or her conception of the relationship between the perceptual effects that film as a medium is capable of rendering and the cinematic mechanism that achieves such an effect. James Peterson locates the cognitive value of avant-garde films in this very capacity: their capacity for the viewer to acquire both procedural knowledge and declarative knowledge. That is, the viewer comes to an understanding of filmmakers' concerns, including theoretical issues regarding the film medium itself, via his or her experience of the film (Peterson 1996: 110–111).

Avant-garde films, despite their associations with film theories, rarely satisfy the two requirements Carroll set out for a theory – generality and verifiability. To grant an avant-garde film its philosophical contribution, an important distinction should be made. One should note that a philosophical claim advanced by avant-garde film is something for the viewer to infer via his or her own experience of the film. Carroll is correct in pointing out that avant-garde film rarely presents a self-contained coherent film theory within a film itself. However, the philosophical significance of avant-garde film lies in the fact that it suggests new hypotheses regarding the film medium. That is, avant-garde film often presents a case in which the viewer must reconsider and revise his or her own conceptions of film, which can subsequently further the viewer's knowledge about the medium (see Carroll 1996: 166).[5] The film-viewing process of avant-garde films often demands philosophical reflection from the viewer, especially with regard to the film medium.

In the remainder of this essay, I will examine the relationship between the cognitive value and aesthetic value of avant-garde film. If we grant that an avant-garde film can make a philosophical contribution by suggesting a hypothesis regarding the medium,

a few questions still remain. To begin, how do we evaluate the cognitive value of films? Furthermore, does cognitive value necessarily enhance the aesthetic value of a film?

II. Apperception on Display

The heavy emphasis placed on the cognitive value of avant-garde films tends to neglect the importance of other values avant-garde films offer. In a classroom setting, students often admit that they 'get it', but they still do not enjoy avant-garde films. This brings us to an important question regarding the value of avant-garde film, especially the role of cognitive value in relation to the overall value that an avant-garde film embodies. Why is avant-garde film valuable to us? What are some of the reasons to cherish avant-garde films? Does the value of avant-garde film mainly derive from its cognitive value? Does the cognitive value of avant-garde film enhance aesthetic value in any way? I will first discuss ways we can evaluate the cognitive value of avant-garde films and then examine its relation to aesthetic value.

I have suggested in the previous section that the cognitive status of avant-garde film is comprised of its capacity both to suggest a hypothesis regarding the medium and to enable the furthering of one's knowledge of the medium. How, then, can we compare cognitive value among avant-garde films? It may be more difficult to come up with a list of objective measures to determine how much an avant-garde film expands one's knowledge, as individual viewers have different ranges of knowledge about the film medium. However, there appears to be some consensus in terms of how to evaluate the significance of a hypothesis suggested by an avant-garde film: originality and consistency.

The theoretical contribution of an avant-garde film is often measured against its originality within a historical context. That is, what is significant about an avant-garde film is not the presentation of any hypothesis, but the presentation of a new hypothesis and a novel possibility for the medium. For example, some may view that Brakhage's abstract-expressionist films are less original than structural films at the level of cognitive value, in the sense that Brakhage's conceptions of the filmmaker as the agent behind the camera and of film as a vehicle to express and convey the filmmaker's perception or vision are rooted in romanticism, already advanced in other art forms such as poetry or painting.

Conceptual consistency provides another criterion for an evaluation of the cognitive value of avant-garde films. If an avant-garde film embodies a philosophical claim, as with any other philosophical claim, it should be consistent. A lack of consistency at the level of the hypothesis inferred not only affects the cognitive status of the film, in that it is less coherent and thus less convincing, but it also can have an impact on the aesthetic value of the film (if, by 'consistency', we mean not only consistency at the level of the philosophical claim, but also consistency in the relationship between the hypothesis that the film suggests and the evidence that the film provides as an example of that hypothesis). Lack of consistency (or better coherence between hypothesis and evidence)

will have an impact on the unity of the work as a whole. In my view, consistency in the latter sense (in the assertion of a hypothesis and the providing of evidence) is worthy of further examination, in that it illuminates the relationship between the cognitive and aesthetic value of avant-garde film. In the remainder of this essay, I offer Kurt Kren's *15/67 TV* as a test case.

Kren, together with Peter Kubelka, is often considered to be the father of European structural film. Malcolm Le Grice praises Kren's *TV* as the first apperceptive film that transfers the primary arena of structuralist activity to the viewing of the film itself (Le Grice 1975: 188). Kren's *TV* is a black-and-white silent film with a running time of less than five minutes. It consists of repetitions of five different shots – most lasting less than two seconds – intercut with short black leader spacing. All five shots are of the same scene at a dock and are shot from approximately the same camera position. Each shot contains similar components with slight variation, as described below.

Shot 1: Through a window, we see three girls sitting on a pillar in the background with their backs to the camera. Additionally, two men sit in silhouette in the foreground, blocking more than half of the screen.

Shot 2: We see the same girls seen in Shot 1, but their positions have changed: the girls on the left and right in Shot 1 have switched their positions. The girl now on the left in this shot is standing and looking at the other two sitting on the pillar. The girl on the left then turns around and looks back toward off-screen left. We also still see the two men in silhouette in the foreground.

Shot 3: The same three girls are in the background, and we see a woman and child pass by in mid-ground. As the woman and the child walk toward off-screen right, one man in the foreground bends toward screen left and blocks most of the screen.

Shot 4: The three girls in the background watch a ship pass by in distant background. As the ship moves toward screen left, the second man in the foreground moves to left.

Shot 5: There is now only one girl on the pillar and she is looking off-screen left. A man with a child passes by towards screen left in mid-ground. The two men in the foreground are still blocking much of the screen.

These five shots appear to be simple, but each shot mirrors and complements the other by exploring different planes and differing movements in screen direction. In Shot 1, the depth of the field is established via lighting and staging. Shot 2 is a variation of Shot 1: the two girls on the left and right switch their positions, while the girl in the middle stays in the same position. Two girls are contrasted via their clothing, with one wearing a black top and a light-colour skirt and the other wearing a light-colour sweater and a dark-

colour skirt. In Shot 3, the middle ground is explored via the two who pass by outside the window. In addition, the movement of the man in the foreground contrasts with the screen direction of this couple in the middle ground. Shot 4 explores another plane – the distant background – via the movement of the ship. Shot 5 balances out Shot 2. In both shots, the middle ground is explored with figure movement, but in opposite screen directions. Among the five shots, Shot 3 is the most elaborate. In this shot, three distinct planes are explored and figure movement seems perfectly choreographed: as soon as the woman and the child walk by outside the window, the man in the foreground bends over and blocks the whole screen as if it were a wipe.

Each shot is separated by a black screen. There is a longer space after every fifth shot, which suggests the clustering of shots into five-shot sequences. Furthermore, there occasionally are even longer breaks between these five-shot sequences, which suggests an additional level of sequencing, which I identify as 'stanzas'. The chart below depicts the order, variation and grouping together of shots in the film. Although the ordering may seem mathematical, it is difficult to find a strict pattern, except that the first and last sequences are transposed. In each stanza, one shot, the first shot shown, becomes salient through repetition and builds up a visual rhythm.

One of the functions of this apparent mathematical structure, as depicted in figure 1 is to enable the spectator to reflect on his or her cognitive and perceptual processes while watching the film. First, the spectator tries to identify and differentiate the five different shots. As shots are repeated, the spectator can focus on the shots themselves, on details such as differing spatial planes, and notice the balancing and complementing of screen direction within a single shot or among shots. For instance, in the stanza dominated by Shot 3, due to the repetition of this single shot, we cannot help but notice how beautifully figure movement is arranged. In addition, the apparent systematic permutation of shots in the film engages the spectator in a mental game. After a few sequences pass, the viewer tries to predict which shot will come next. The mental game between the viewer and the film gives rise to pleasure, as well as frustration, in the viewer – depending on how close each guess is.

The aesthetic value, however, of Kren's *TV* does not lie solely in its systematic structure; consider also its poetic imagery. Other structural films often reduce visual components to abstract shapes. For example, Snow's *Wavelength* and Ernie Gehr's *Serene Velocity* (1970) feature a loft and a corridor, respectively, and the visual patterns of these two films become quite abstract, dominated by the rectangular shape of the windows in the loft or the door in the corridor. The images in *TV*, on the other hand, attract us not only as gaming elements, but as beautiful poetic glimpses – evoking Symbolist poetry's interest in the epiphany and the fleeting image as a source of insight and emotive impetus. Shot 5 certainly evokes a mood of loneliness by featuring only a girl with her back to the camera sitting in the background by herself, especially since the previous shots have all shown her in the company of two other girls. The fidgety behaviour of one of the girls in both Shots 1 and 2 not only provides rhythm upon the repetition of these shots, but also conveys a sense of boredom and the mundane.

FIGURE 1. Short sequences in Kren's *TV*.

12345	11345	22451	33512	44513	55313	55133	54321
	11145	22251	33312	44435	55513		
	11141	22252	33313	44434			
		22422		44144			
		23222		45555			

How, then, should we evaluate Kren's film? Is his film aesthetically inferior to *Serene Velocity* or *Wavelength* because his film falls short of living up to structuralist ideals and principles? Or, rather, does his film suggest a new hypothesis regarding the relationship between the representational content of photographic images and their structural system – that is, that the latter cannot completely overwrite the former? To put it differently, is Kren's film aesthetically astonishing – at least to me – despite its lack of theoretic consistency or because of its complexity? In my view, Kren's case falls under the latter.

As Le Grice notes, Kren's film is more concerned with the relationship between apparent mathematical structures, poetic images and moods manifested in images than with pure systematic structure (the film is not governed by real mathematical formula; Le Grice 1977: 98). Although Kren's *TV* invites the viewer to predict the logic of the permutation, it defies our capacity to grasp the formula. His film also resists the distinction between abstract expressionism and structuralism – hot versus cool – in terms of their emotive register. Despite the fact that structural films were developed in reaction to abstract expressionist filmmakers such as Brakhage, whose films manifest the presence of the romantic artist behind the camera, the images of Kren's films are in no way neutral, arbitrary or convenient fillers for a mathematical system. Images of Kren's films are, if not hot, at least warm. The very juxtaposition between poetic images and an apparent systematic structure adds complexity to his film. Despite the simplicity conveyed through the film's short duration and use of fewer than half a dozen repeated shots, a subtle emotive register certainly lurks in and enhances the aesthetic value of the film. Kren's film neither betrays nor fails to correspond to structuralist ideals. Rather, it makes a different philosophical claim: that is, the photographic content of a shot can defy the mathematical structure imposed on the image. The complexity of Kren's film, which I have attempted to demonstrate above, should not, however, be confused with inconsistency or contradiction. That is, complexity in this context is not opposed to theoretical consistency or correspondence as defined above, but is rather opposed to simplicity or obtrusiveness.

Certainly, one might question to what extent I can infer such a claim from Kren's film with any authority. Although I perhaps grant such epistemic difficulty embedded in the interpretation of individual films, including this one, such a concession does not seriously damage the point that I am attempting to make here: the cognitive value of an

avant-garde film can enhance the value, including the aesthetic value, of the film, but only if it is successfully manifested in the film. That is, the film in question must provide a strong case to postulate a new hypothesis. In this respect, one must suppose some sort of consistency (or coherence) between the theoretical or philosophical claim that a film embodies and the film as an instance or evidence in support of such a claim. If so, then when a student says, 'I get it, but I don't appreciate the film,' it means either that the film failed to provide a strong case to infer its claim – even though the claim can be detected – or that the fault lies with the student, who in fact did not 'get it'!

In this essay, I attempted to examine the relationship between avant-garde film and philosophy. Against Carroll's claim that avant-garde film should be distinguished from theory proper, I have argued that the philosophical potential or contribution of avant-garde films should be found somewhere else – that is, in their ability to propose new hypotheses about the medium and to expand one's knowledge of the medium by reflecting on one's own experience of the films. In the latter half of this essay, I have examined some of the ways in which we can postulate the relationship between the cognitive value and aesthetic value of avant-garde film: the former can enhance the latter only when the claim detected in the film is successfully supported in the film and thus augments the consistency of the film as a whole. In this respect, Kren's *TV 15/67* certainly proves itself to be of high cognitive and aesthetic value.

Acknowledgements

This essay underwent various versions, starting as a paper written for the avant-garde film class I took with Ben Singer. I thank Ben Singer for introducing me to the sheer beauty of Kren's films. I also thank Noël Carroll, Murray Smith and Thomas Wartenberg for their suggestions on subsequent versions of this essay. Vince Bohlinger proofread this essay numerous times whenever I changed its direction. I thank him for that.

References

Beardsley, M.C., 1981. *Aesthetics: Problems in the Philosophy of Criticism*, 2nd ed. Indianapolis: Hackett Publishing.

Burch, N., 1982. Narrative/Diegesis: Thresholds, Limits. *Screen*, 23, pp. 16–33.

Carroll, N., 1996. Avant-Garde Film and Film Theory. In: *Theorizing the Moving Image*. New York: Cambridge University Press.

Carroll, N., 1998. Art, Narrative, and Moral Understanding. In: J. Levinson, ed. *Aesthetics and Ethics: Essays at the Intersection* New York: Cambridge University Press.

Gidal, P., 2002. An Interview with Hollis Hampton. In: W. Winston and G.A. Foster, eds. *Experimental Cinema, The Film Reader*. New York: Routledge.

Heath, S., 1976. Narrative Space. *Screen*, 17, pp. 68–112.

Hunt, L., 2005. Motion Pictures as a Philosophical Resource. In: N. Carroll and J. Choi, eds. *Philosophy of Film and Motion Pictures: An Anthology*. Oxford: Blackwell Publishing.

Kupfer, J., 1999. *Visions of Virtue in Popular Film*. Boulder: Westview

Le Grice, M., 1975. Kurt Kren. *Studio International*, November.

Le Grice, M., 1977. *Abstract Film and Beyond*. Cambridge, Mass, MIT Press.

Light, A., 2003. *Reel Arguments: Film, Philosophy and Social Criticism*. Boulder: Westview.

Michelson, A., 1978. Toward Snow. In: P.A. Sitney, ed. *The Avant-Garde Film Reader*. New York: New York University Press.

Peterson, J., 1996. Is a Cognitive Approach to the Avant-garde Cinema Perverse? In: D. Bordwell and N. Carroll, eds. *Post-Theory*. Madison: University of Wisconsin Press.

Russell, B., 2000. The Philosophical Limits of Film. *Special Interest Edition on the Films of Woody Allen, Film and Philosophy journal, volume 4*

Sitney, P.A., 1977. *Visionary Film: The American Avant-Garde: 1943–1978*, 2nd ed. New York: Oxford University Press.

Notes

1. Carroll quickly adds two more possibilities in which avant-garde films are linked to a theory: answering and compatibility. With answering, films can answer or refer to other films. By 'compatibility', Carroll refers to the fact that a film may be compatible with various theories and invites multiple readings and interpretations. Carroll, however, dismisses the theoretical potential of these two, in that the films themselves constitute neither an argument nor evidence for a theory.

2. Bruce Russell finds the philosophical limitations of fiction film for a similar reason. That is, a narrative fiction film can provide a counterexample to a philosophical thesis, but it cannot provide evidence due to its fictional nature. See his 'The Philosophical Limits of Film'.

3. By this I am not suggesting that all avant-garde films are only concerned with medium specificity. The countercultural aspect, often evidenced in punk cinema and other transgressive films, constitutes one of the most important characteristics of avant-garde cinema concerning world and/or dominant culture.

4. In my personal conversations with Carroll, he has acknowledged that avant-garde films such as Ernie Gehr's *Serene Velocity* (1970) can make a philosophical claim, in that they encourage the viewer to postulate that what makes film a film is its moving image.

5. I do not indicate that Carroll denies such significance. His contention is rather that such reflection does not necessarily render an original philosophical argument or claim.

Filmography

Besides listing the films of Kurt Kren that are in regular distribution, and readily available on DVD (and indeed online), this filmography also includes reference to commissions, expanded film pieces, lost films, fragments and unrealised projects. It is a synthesis of the information provided by the primary distributor of Kren's films, Sixpack (Vienna), as well as the filmographies published in *Ex Underground. Kurt Kren, seine Filme* (1996) edited by Hans Scheugl and *Kurt Kren: das Unbehagen am Film* (2006) edited by Thomas Trummer, with additional information provided by Hans Scheugl and Peter Tscherkassky.

(All 16mm and silent unless otherwise stated).

Das Walk (The Walk) (1956, 7', colour and b&w, originally 8mm)

Rom (Rome) (1956, 1' b&w) Short, fragmentary shots from a visit to Rome.

Klavier Salon 1. Stock (Piano Salon 1ˢᵗ Floor) (1956, 1', b&w, originally 8mm)

Mobiles (1957, 10' b&w)

1/57: Versuch mit synthetischem Ton (Test) (Experiment with Synthetic Sound [Test]) (1957, 2', b&w, sound)

2/60: 48 Köpfe aus dem Szondi-Test (48 Heads from the Szondi-Test) (1960, 4', b&w)

3/60: Bäume im Herbst (Trees in Autumn) (1960, 5', b&w, sound)

4/61: Mauern pos. -neg und Weg (Walls pos. –neg. and Way) (1961, 6', b&w)

5/62: Fensturgucker, Abfall, etc. (People Looking Out of the Window, Trash, etc.) (1962, 5', colour)

6/64: Mama und Papa (Mum and Dad) (1964, 4', colour) Materialaktion: Otto Mühl

7/64: Leda mit dem Schwan (*Leda and the Swan*) (1964, 3', colour) Materialaktion: Otto Mühl

8/64: Ana (1964, 3', b&w) Action by Günter Brus

9/64: O Tannenbaum (*O Christmas Tree*) (1964, 3', colour) Materialaktion: Otto Mühl

10/65: Selbstverstümmelung (*Self-Mutilation*) (1965, 5', b&w) Action by Günter Brus

10b/65: Silber – Aktion Brus (*Silver – Action Brus*) (1965, 2', b&w)

10c/65: Brus wünscht euch seine Weihnachten (*Brus wishes you a Merry Christmas*) (1965, 3', b/w)

11/65: Bild Helga Philipp (*Helga Philipp Painting*) (1965, 2', b&w)

12/66: Cosinus Alpha (1966, 9', colour)

13/67: Sinus Beta (1967, 6', b&w)

14/67: Kurdu (Gebetsmühle) (*Kurdu [Prayer Wheel]*) An unrealised film project.

15/67: TV (1967, 4', b&w)

16/67: 20. September (20th *September*) (1967, 7', b&w)

17/68: Grün-Rot (*Green-Red*) (1968, 3', colour)

18/68: Venecia kaputt (1968, 20 secs, colour and b&w)

19/68: White-black (1968) A 'film action' realised on May 11, 1968 in Judson's Gallery, NYC, involving the projection of white light and a tape recorder playing a Mao quote (very loudly): "The revolution is not a coffee party". Finally, stretched strips of film and gauze bandage were set on fire.

20/68: Schatzi (1968, 2', colour)

21/68: Danke (1968) An 'expanded movie' the concept of which was to project porno-graphic films from the windows of moving trains onto the street. 'Thank you' is ad-dressed to the train company who would make the movie possible

22/69: Happy-end (1969, 4', b&w)

23/69: Underground Explosion (1969, 5', colour)

24/70: Western (1970, 3', colour)

25/71: Klemmer und Klemmer verlassen die Welt (Klemmer and Klemmer leave the World).
Shot at the burial of the artist Robert Klemmer and thrown into his grave.

26/71: Zeichenfilm – Balzac und das Auge Gottes (Cartoon: Balzac and the Eye of God)
(1971, 35mm, 31 secs, b&w)

27/71: Auf der Pfaueninsel / At the Pfaueninsel (1971, 1', b&w)

28/73: Zeitaufnahme(n) (Time Exposure[s]) (1973, 3', colour)

29/73: Ready-made (1973, 1', b&w, sound)

30/73: Co-op Cinema Amsterdam (1973, 3', colour)

31/75: Asyl (Asylum) (1975, 8', colour)

32/76: An W+B (To W+B) (1976, 8', colour)

33/77: Keine Donau (No Danube) (1977, 8', colour)

34/77: Tschibo (1977, 2', colour)

35/77: Dogumenta – A super 8 and slide projector loop shown at Documenta in 1977.

36/78: Rischart (1978, 3', colour)

37/78: Tree Again (1978, 4', colour)

38/79: Sentimental Punk (1979, 5', colour)

39/81: Which Way to CA? (1981, 3', b&w)

40/81: Breakfast im Grauen (Breakfast in Grey) (1981, 3', b&w)

41/82: Getting warm (1982, 3', colour)

42/83: No Film (1983, 3 secs, b&w)

43/84: 1984 (2', colour)

44/85: Foot'-age shoot'-out (1985, 3', colour)

45/88: Trailer (1988, 3', colour) A trailer for the documentary *Kurt Kren und seine Filme.*

46/90: Falter 2 (1990, 30 secs, b&w, 35mm)
An advertisement for the Vienna newspaper *Falter.*

47/91: Ein Fest (*A Party*) (1991, 2', colour, sound) Commissioned for the Austrian broad-
 casting corporation ORF.

48/94: Fragment W.E. (1994, 13 sec. film loop, colour, with live sound by Wolfgang Ernst
 on violin)

49/95: tausendjahrekino (thousandyearsofcinema) (1995, 3', colour, 16mm/35mm)

50/96: Snapspots (for Bruce) (1996, 4', colour, Super 16mm/35mm)

Notes on Contributors

Jinhee Choi is Senior Lecturer in Film Studies at King's College London, and the author of *The South Korean Film Renaissance: Local Hitmakers, Global Provocateurs* (2010). She co-edited *Cine-Ethics: Ethical Dimensions in Film Theory, Practice and Spectatorship* (2014), *Horror to the Extreme: Changing Boundaries in Asian Cinema* (2009), and *The Philosophy of Film and Motion Pictures* (2006).

Barnaby Dicker is a researcher, artist-filmmaker and curator. He lectures at the Royal College of Art, London, University of South Wales, Cardiff and University for the Creative Arts, Farnham. His research revolves around conceptual and material innovations in and through graphic technologies and arts, including cinematography and photography, with particular emphasis on avant-garde practices. He holds a doctorate in experimental stop-frame cinematography.

Abbe Leigh Fletcher is a filmmaker and writer. Her MPhil thesis *Between the Frames* (RCA, 2010) examined the role of the 'interval' in the work of Dziga Vertov, Stan Brakhage, Rose Lowder and Kurt Kren. As Senior Lecturer at Kingston University, she supervises practice-based PhDs and co-founded an MA in film-making. Her research interests include experimental and documentary film practice.

Peter Gidal's latest film is *not far at all* (2014). His book *Materialist Film* (Routledge, 1989) was re-issued (unchanged) last year. Recently he had a selected retrospective at Film Dok in Helsinki, Finland. The Tate has acquired four of his films for its collection in 16mm and digital formats. Re-Voir (Paris) is bringing out a 2 DVD box of ten of his films with a bilingual booklet, and his selected writings, *Flare Out: Aesthetics 1966-2016* is being published by the Visible Press, UK.

Nicky Hamlyn is Professor of Experimental Film at University for the Creative Arts, Canterbury, UK, and a lecturer at the Royal College of Art, London. His film and video work has been exhibited at venues and festivals worldwide, including solo shows at Pacific Film Archives, Ann Arbor Film Festival and the EXIS Festival, Seoul. Two DVD

compilations have been published by RGB editions, LUX and the Film Gallery, Paris. He has published numerous essays and reviews and his book *Film Art Phenomena* (2003) is published by the BFI.

Aline Helmcke is a Berlin based artist and filmmaker with a focus on drawing and experimental animation. She studied Fine Art at the Berlin University of the Arts and Animation at the Royal College of Art in London. Her films, drawing series and collages have been shown widely in Germany and abroad. Aline is currently working as academic assistant for Multimedia Narration at the Bauhaus University in Weimar, Germany.

Gabriele Jutz is a Professor for Film and Media studies at the University of Applied Arts in Vienna. She was a guest professor of film at the Freie Universität Berlin and at the Wolfgang von Goethe University Frankfurt. Her book *Cinéma Brut. Eine alternative Genealogie der Filmavantgarde* was published in 2010.

Malcolm Le Grice, was born in Plymouth on 15 May 1940. His film and video work has been exhibited at the Museum of Modern Art, Vienna, the Louvre Paris, Tate Modern and Tate Britain. His work is in permanent collections at the Centre Georges Pompidou, Royal Belgian Film Archive, National Film Library of Australia, and the German Cinematheque Archive. A number of longer films have been transmitted on British TV. He has published extensively on experimental cinema including the books *Abstract Film and Beyond* (1977) and *Experimental Cinema in the Digital Age* (2002).

David Levi Strauss is the author of *Words Not Spent Today Buy Smaller Images Tomorrow* (Aperture, 2014), *From Head to Hand: Art and the Manual* (Oxford University Press, 2010) and *Between the Eyes: Essays on Photography and Politics,* with an introduction by John Berger (Aperture 2003, 2012). Strauss was a Guggenheim fellow in 2003 and received the Infinity Award for Writing from the International Center of Photography in 2007. He is Chair of the graduate program in Art Criticism & Writing at the School of Visual Arts in New York, where he also runs the Art Criticism & Writing Lecture series.

Simon Payne's digital video works have shown at the Tate, Serpentine and Whitechapel Galleries in London, and various international film festivals. He has written widely on experimental film and video and recently presented programmes at Tate Modern, Tate Britain, The Hermitage Museum, St. Petersburg and Microscope Gallery in New York. He is Senior Lecturer in Film and Media Studies at Anglia Ruskin University, Cambridge, UK.

Daniel Plunkett founded *ND*, a contact/art-zine mostly for other artists in 1981. It ran for 20 issues, until 1997. After seeing Kurt Kren present his films in Houston in 1980, he wrote to Kren, asking whether he could interview him: 'Next time you're in Texas, let me

know.' Kren ended up staying with Plunkett for a year, during which time they conducted the interview here. Daniel Plunkett currently runs the record store *End of An Ear* in Austin, Texas.

Gareth Polmeer is an artist and writer. He studied Time Based Media at Kent Institute of Art and completed his doctorate at the Royal College of Art in 2015. He has exhibited video works internationally and published on artists' film and video and digital aesthetics. He is a visiting lecturer at the Royal College of Art, London.

A. L. Rees studied philosophy and politics at Lancaster University. From 1988-96 he ran the Time Based Media course at Kent Institute of Art, Maidstone and from 1996 to 2014 he was Research Tutor in the School of Communication at the Royal College of Art, London. He published extensively on all aspects of artists' film and video and his book *A History of Experimental Film and Video* was published by the BFI in1999, (2nd edition 2011). Al sat on the Arts Council of Great Britain's artists' film sub committee and the editorial board of *Undercut* journal from 1980-99, among others.

Yvonne Spielmann is the Dean of Faculty of Fine Arts at Lasalle College of the Arts in Singapore. Previously she was Research Professor of New Media at the University of the West of Scotland. Her book, *Video, the Reflexive Medium* (MIT Press, 2008) received the 2009 Lewis Mumford Award for Outstanding Scholarship in the Ecology of Technology. Her most recent book is *Hybrid Culture* (Suhrkamp, 2010/MIT, 2013). Professor Spielmann's work has been translated into French, Polish, Croatian, Swedish, Japanese and Korean.

Peter Tscherkassky was born in 1958 in Vienna, Austria. Since 1984 he has published widely and lectured on the history and theory of avant-garde film. In 1993 and 1994 he was artistic director of the national Austrian film festival "Diagonale". He edited the books *Peter Kubelka* (1995, with Gabriele Jutz) and *Film Unframed: A History of Austrian Avant-Garde Cinema* (2012). His films have been honoured with more than 50 awards, including the Main Prize at Oberhausen (Germany) and Best Short Film at the Venice International Film Festival.